IN HER HANDS

IN HER HANDS

CRAFTSWOMEN CHANGING THE WORLD

Paola Gianturco and Toby Tuttle

Foreword by Alice Walker

 powerHouse Books Brooklyn, NY

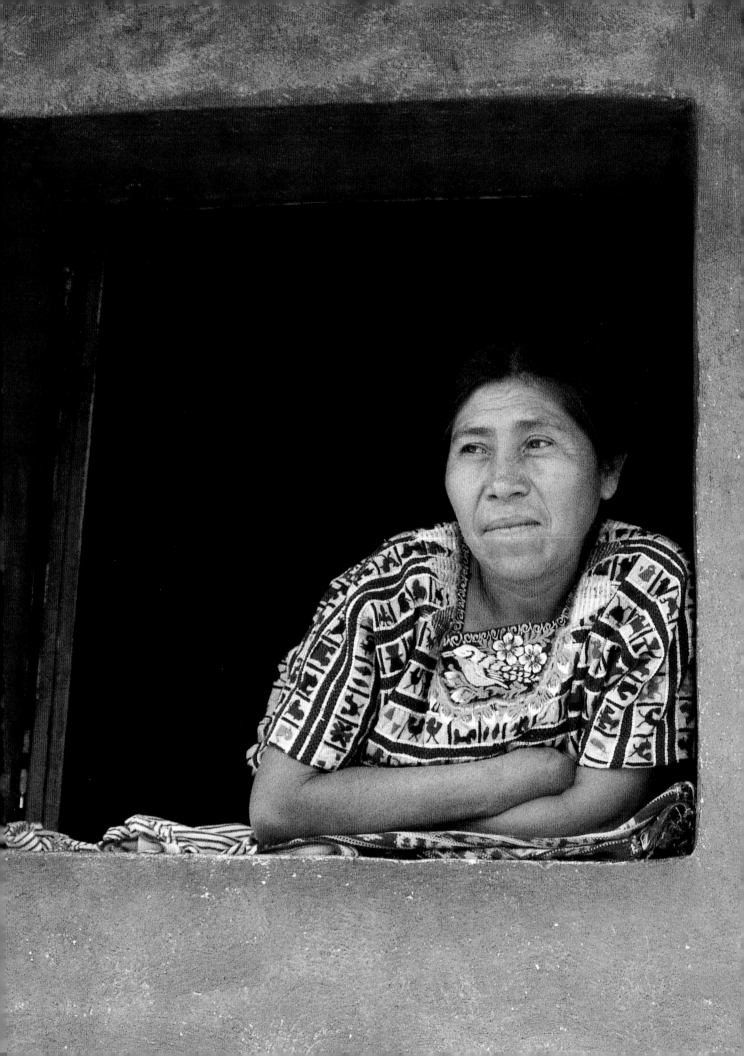

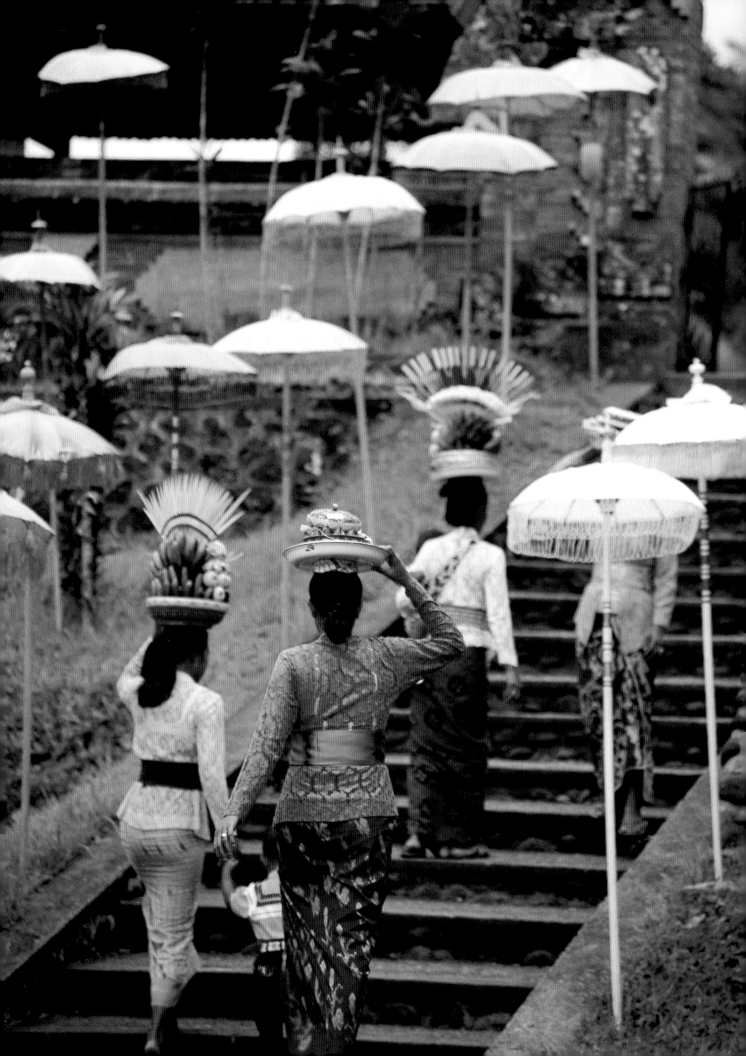

CONTENTS

Opening page: In northern Thailand, Lisu women's multistrand sashes drop from waist to hem.

Previous page: Women who live in Guatemala's San Francisco Atitlan weave intricately patterned *huipiles* (blouses) whose yokes are embroidered with flowers.

Opposite: During Galungan, a Balinese festival that welcomes ancestral spirits back to earth, women carry holiday offerings from their home temples to community temples.

"My girl child must have a voice
louder and clearer than mine.

She must be able to move
with certainty—shoes on her feet,
walking with dreams at her side.

The present I have given her
is not enough.

Her arms are different;
they will reach for the sky
where freedom lives."

—Nepalese mother's poem

EAGERLY, I READ THE NEWS about the 1995 United Nations Fourth World Conference on Women, in Beijing, where this poem was presented. The thirty thousand women who attended from one hundred eighty-five countries and many walks of life—as well as some important news—inspired this book.

The news: throughout developing and transitional societies, poor women use the money they earn to buy food and education for their children. Most men spend on other things. But indigent women invest in their daughters and sons—motivated, like the Nepalese mother, by knowledge that the present is not good enough. They are determined to make it possible for their children to move with certainty, with shoes on their feet and with dreams at their sides, toward better lives.

Books, uniforms, shoes, notebooks, pencils, and bus fare to and from school are almost out of reach for indigent women, even if tuition is free. Many are illiterate and their access to resources is limited; yet their energy, ingenuity, and commitment make it possible for them to earn the necessary funds, often by juggling four or five income-generating projects at a time.

Education enhances social and economic conditions. If these women succeed in creating better-educated new generations, they will improve the future for their families, communities, countries, and ultimately our world.

I wanted to meet these microentrepreneurial heroines. What were their dreams and disappointments, their triumphs and pleasures, their accomplishments and predicaments? How did earning money affect their lives and relationships? Did they have anything in common with the women in American corporations whom I worked with and taught?

I felt that these invisible women with their world-altering dreams deserved the spotlight. The idea for a photographic book began to grow.

My passion for folk art led me to focus on indigenous craftswomen. Like the women in the United Nations reports that were released in Beijing, many craftswomen live on less than one dollar a day in the global south and Eastern Europe. Because certain crafts are the province of women, it seemed appropriate to concentrate on crafts that mothers teach daughters, generation after generation.

So, I took a sabbatical from my consulting business to work on the book, but before I cashed in my frequent flyer miles to begin traveling, I worried about whether one person could complete such an ambitious project and whether it was appropriate for a woman to travel alone in certain countries. I invited my friend and former colleague Toby Tuttle to share in the project and she agreed without hesitation.

Toby and I had photographed together in Europe and discovered that we had complementary visual perspectives. Her infectious humor and ability to pantomime converted reserved strangers into people who wanted to be photographed.

The librarians at the Museum of International Folk Art in Santa Fe, New Mexico, helped me to identify villages where "women's crafts" are made; the Crafts Center in Washington, D.C., helped me to locate the places where they are made for sale. We selected villages that represent a range of traditional and contemporary crafts and cultures. I read the materials listed at the back of this book to help me frame our conversations with the craftswomen and inform the observations we would make.

People all over the world propelled our project. Friends offered ideas and introductions. Experts from non-governmental organizations, retailers, universities, museums, and collectors helped connect us with the craftswomen that we wanted in interview.

Toby handled trip logistics. Some of the places we visited were not even on our maps. Determined not to burden the craftswomen, we planned to carry our lunches and, in South Africa, to commute one hundred fifty miles to the nearest lodging. We carried two hundred rolls of film, not the ten that some countries allowed, causing intricate negotiations at entry and at potentially dangerous airport X-ray machines. We packed clothes and equipment in bags light enough to tote ourselves, tight enough to protect our cameras from the desert dust in India, and small enough to fit in a dugout in Panama. Toby's grandsons tested the games we bought to entertain children while we interviewed and photographed their mothers. We prepared emergency telephone lists of English-speaking physicians (whom we never needed) and authorized dealers who could repair our cameras. Toby prepared budgets in twelve different currencies.

Finally, we kissed our husbands and children—who, fortunately, shared our excitement about the project—and departed. We made six trips between August 1996 and August 1998. We interviewed ninety craftswomen in twenty-eight villages in twelve countries on four continents.

The book evolved as we traveled. For example, we discovered immediately that our plan to feature one craftswoman per chapter was unrealistic; indigenous craftswomen work in groups and were nonplussed at our plan to interview only one of them.

We spent about a week at each location, often talking with a craftswoman over several days. Most of our interpreters worked for local organizations that aid the craftswomen's income-generation efforts; they introduced us as friends. We asked all the artisans the same questions, plus some inspired by their particular cultures. Fifteen of our twenty interpreters were women, so even craftswomen in conservative cultures felt comfortable enough to volunteer personal information. We taped and transcribed the interviews, and sent each draft chapter to the local interpreter to check for accuracy.

I wrote the text, which describes our encounters with the women. Toby wrote the journal entries, which describe our other experiences, reactions, and feelings. We both took pictures using Canon EOS Elan IIE cameras and Fujichrome Velvia and Provia film.

In Her Hands tells the craftswomen's stories as they told them to us. We have included what seemed most provocative and interesting. Scholars might have bitten off a smaller bite, learned the local languages, placed the findings in a theoretical context, and reported systematically—but ours was a subjective approach born of wondering.

The women in this book became our friends and teachers. From them, we learned about creating an artistic, social, and economic legacy. And we learned that the world is smaller—and women's spirits are larger—than we had ever imagined.

—Paola Gianturco

"United Nations statistics tell us that in developing countries all over the world, women's income buys food and education for children."

WHEN I WAS A CHILD I sometimes washed my mother's feet. It was one of my favorite things to do. I don't know how this ritual came about. Perhaps I witnessed the monthly foot washing that occurred in my grandmother's Baptist church: an impressionable child, I would have been enthralled, profoundly moved, perhaps even shocked by the intense devotion such an act demonstrated. It would have seemed behavior out of time: there in the dim church made of warm, resin-scented wood; the hushed voices of the aging participants almost making one sleepy; the solemn singing of centuries-old Spirituals and the incessant fanning of the women in the congregation contributing a feeling of timeless, effortless community. These were some of the most oppressed people on the face of the earth, the literal sport of the white people who exploited their labor and stunted their lives. And yet, in this simple, sacred space, hidden far away from their tormentors (whose ancestors had bought and sold their grandparents), they reconnected to Spirit, unashamed, and humbly washed each other's feet. Each touch was filled with tenderness. Each glance an acknowledgement that "you are precious in my sight." I now realize it was this communion with each other, heart to heart and soul to soul, that kept my ancestors spiritually "safe" in the wilderness of the American "civilization" that prevailed for centuries in the Deep South.

Or maybe I washed my mother's feet, at first, because I saw how awkward it was for her to do it herself. She was a large woman; the tin basin she used, that we all used, was small. Sitting in a stiff, wooden, handmade chair she had to bend over, off balance and straining, to reach her feet. I would see her coming home from field or barn or other woman's kitchen, having been on her feet all day, while I had enjoyed the luxury, based on her labor, of going to school, and I would heat the water—or more than likely she would have heated it herself, for she was quick, and independent, and never asked for care—pour it into the basin, and after watching her enjoy a blissful ten minutes or so of soaking, I would wash her feet. Pat them dry with a towel, trim them of callus and corn, and oil them with Vaseline. I was always reluctant to let go of her feet, for the moment I did so, she seemed to bounce back into action; washing, ironing, scrubbing, quilting, cooking, gardening, taking care of her remarkably tidy and well-run household.

THE WOMEN IN THIS BOOK remind me of my mother, and they remind me of myself. Not one of them would think of herself as poor, for instance, just as my mother never would have, though she, like they, earned less than a dollar a day, when in fact money was even offered her for her work. And I would never consider myself poor either, because I had a mother who, like these mothers working for a better future for their children, gave her life for me. That I can see this now, clearly, as I sensed it as a child, is a blessing beyond compare.

"Having tried three times to bring the Ndebele people under their control, in 1882 Afrikaners [descendants of Dutch and German settlers] dynamited their food storage caves to starve them, killed their leaders, razed their crops, confiscated their land, and assigned them to five years of indentured labor—five years that, in fact, lasted over a century. Ndebele women reacted against the Afrikaners' efforts to decimate ethnic identity by resurrecting the distinctive beaded apparel that their foremothers began creating in the sixteenth century, when the Portuguese brought Czechoslovakian and Venetian beads to southern Africa to trade for slaves and ivory."

MANY YEARS AGO Margaret Courtney-Clarke's book *Ndebele* introduced me to the stunning creativity of the Ndebele women of southern Africa. In this book I saw the colorfully painted homes of Ndebele women for the first time; and learned that the instinct to create art was so strong the women painted their houses using whatever materials were available to them, and as brush, sometimes they used their own fingers. From the moment I read this something shifted in my soul. I knew these women to be ancestors and mothers and sisters, girlfriends and aunts; I knew they had been with me forever, because I recognized a dauntlessness of spirit that I also prize, and that from now on we would never really be apart. Seeing how smitten I was with these women, how happy in my reconnection, a friend gave me a poster of a Ndebele woman standing in front of her vividly painted house in the far outback of white-dominated South Africa. Every move I've made since (and I've moved house several times) I've carried her with me. She stands at the entrance of my house, which is always, some part of it, painted, in her honor, the color of the South African sky (a sky New World Africans lost forever because of the lure of glass beads) or, as I call it, Ndebele blue. It is these same women who today make beaded dolls and other artifacts for a tourist and export market. Their ability to work together

collectively is shared by all of the women artisans in this collection, from Turkey, Panama, India, and Zimbabwe to Czechoslovakia, Indonesia, Guatemala, and Peru.

THESE WOMEN, and their less fortunate sisters, are calling to us; and we must answer. They are, the ones from the southern hemisphere especially, with their earnings of less than a dollar a day, at the bottom of the feeding chain. Subsisting on tortillas and chilies. Porridge and millet beer. One meager meal a day. One bite of food per child per meal. Meal-less days. Every day 35,000 of their children die of starvation and malnutrition. It is a horror that has crept up on the world steadily over the last century. Too often our response has been to feel powerless, as if there is nothing we can do.

The age we are in now, however, *the Age of Knowing Who Does Not Eat, and Why*, does not permit us the luxury of inaction. Every child that starves to death should mean one less gold statue in the vaults of the church; but we cannot wait for that to happen either. What we can do is much more direct, compassionate, connected to our own Being. We can simply support Life, as these women reveal it to us. Who are they, after all, if not us in our guise as Starving Creator?

"Husbands buy cigarettes and beer; women buy food for their families."
"It is not uncommon for children's nutrition to deteriorate while wristwatches, radios, and bicycles are acquired by the adult male household members."

WHEN YOU READ this informative book you will see how inescapable is the connection between today's misery in the so-called Third World and the overthrow of the people's way of life one, two, three, four, or five hundred years ago. I believe you will have powerful feelings in response to learning how meanly the loyalty and faithfulness of women have generally been repaid. For having endured the near absolute oppression of a greedy, brutal, racist colonialism, which often included literal enslavement and removal from homelands, many of these women suffer just as cruelly under the domination of their own patriarchal societies. You will begin to fine tune your focus so that perhaps for the first time you will really see who these women are. The ones at the very bottom. The ones that are so low down in status, as much of the world defines it, that they seem to be part of the earth itself. It is my great privilege to say, to add my witness, that indeed they are part of it. For there they sit in their mud and straw huts, or on their bare earth patios, or on the naked ground, spinning and weaving and making pots out of the mud of the lake, and they are in relation to and in a flow of creation that is as old as the planet. I think of them as goddesses.

The children of these women do not have to starve. They have mothers, as you will see, who are giving Life everything they've got. And we must stand with them. Learning their histories, appreciating their artistry, acknowledging their worth. The world we live in, the rich, Western one, says these women owe us. That they are in our debt because we loaned their leaders (oppressors, as often as not) money to build dams or roads, or (most likely) to buy weapons. To force these women to sell their bodies, their children, and their health to pay a debt they did not themselves incur is the essence of evil. Meanwhile, the debts that they make for themselves, sometimes founding their own microbanks because "regular" banks consider women too ignorant to transact business, are scrupulously repaid. They place themselves in debt, not to buy weapons, or even beer and cigarettes, but to buy food, clothing, health care, and education for their children. They owe us nothing. And we must refuse to take the blood money our governments squeeze out of them. It is we who owe these women. We owe them for continuing to create art that sustains our spirits as surely as good food strengthens our bodies. We owe them for holding such an incredible place of suffering in this world, and for not giving up. We owe them for reminding us of the true meaning of love and of sacrifice. Of creativity and practicality. We owe them the rich nourishment we take from their courage.

Blessed be.

—Alice Walker
Berkeley, California

All quotes are from *In Her Hands: Craftswomen Changing the World*, by Paola Gianturco and Toby Tuttle.

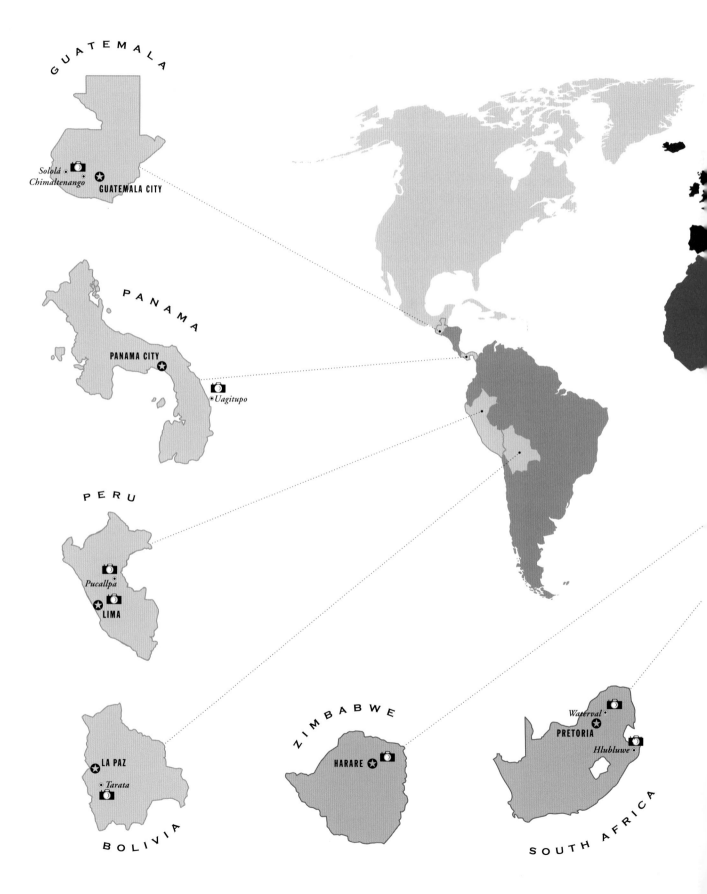

VILLAGES IN TWELVE COUNTRIES ON FOUR CONTINENTS.

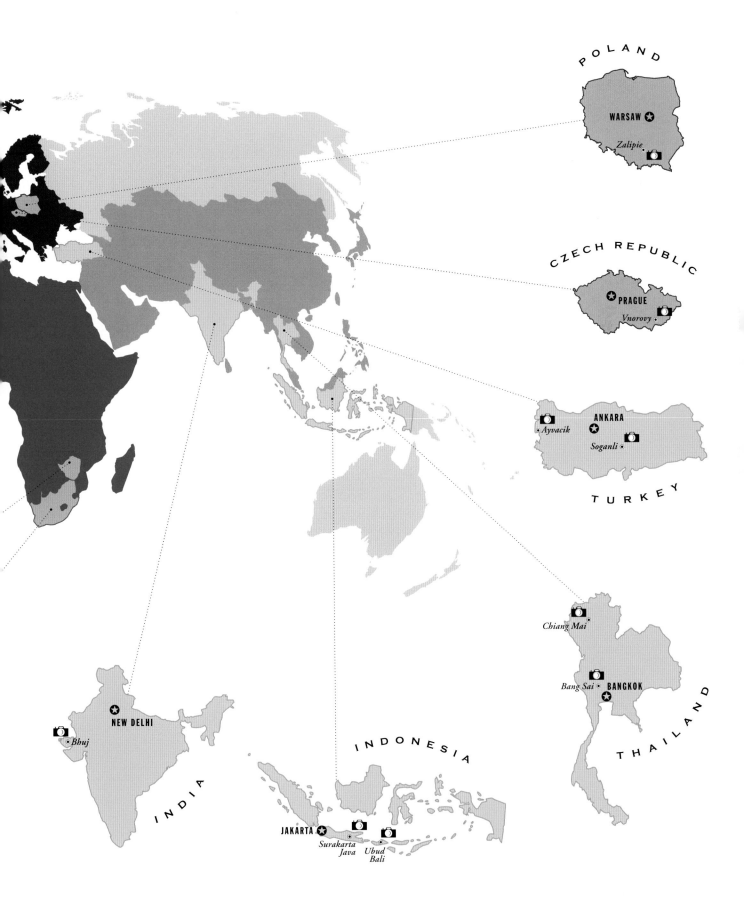

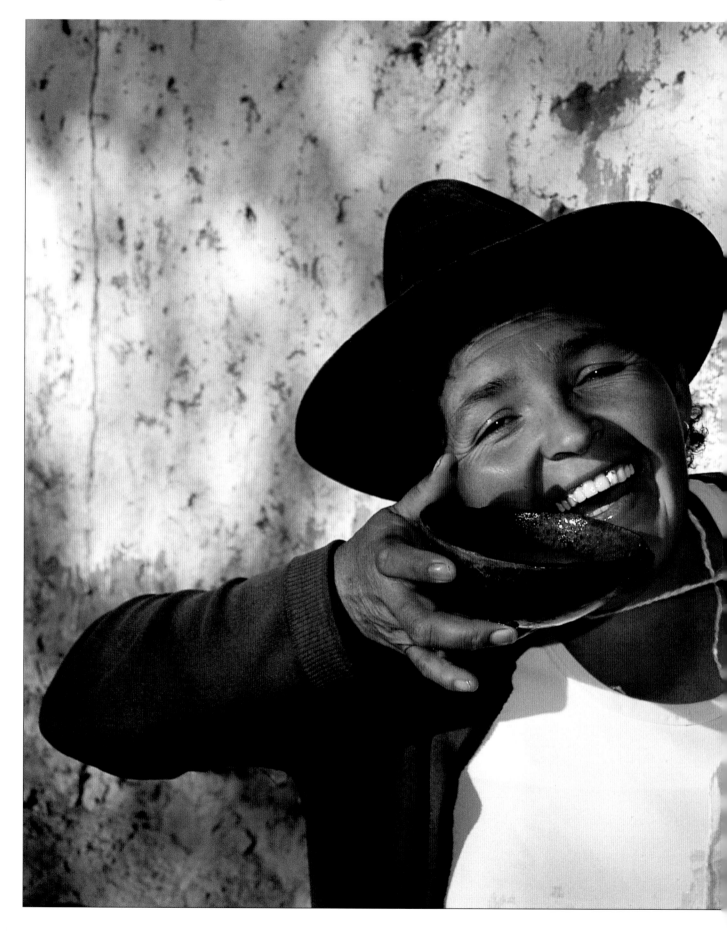

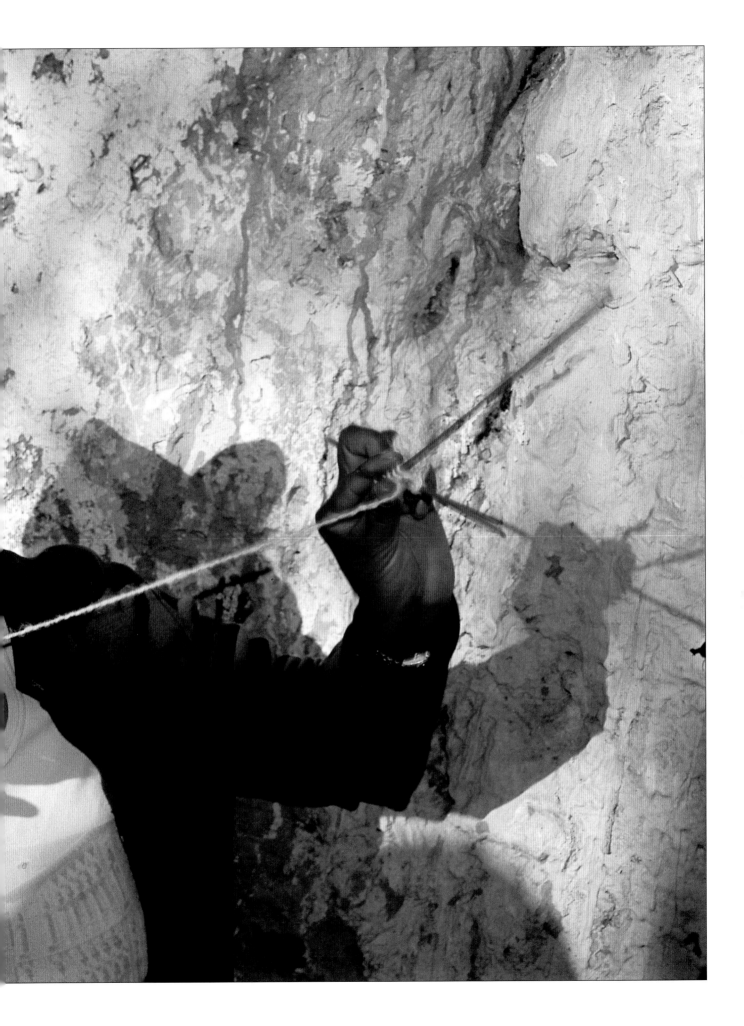

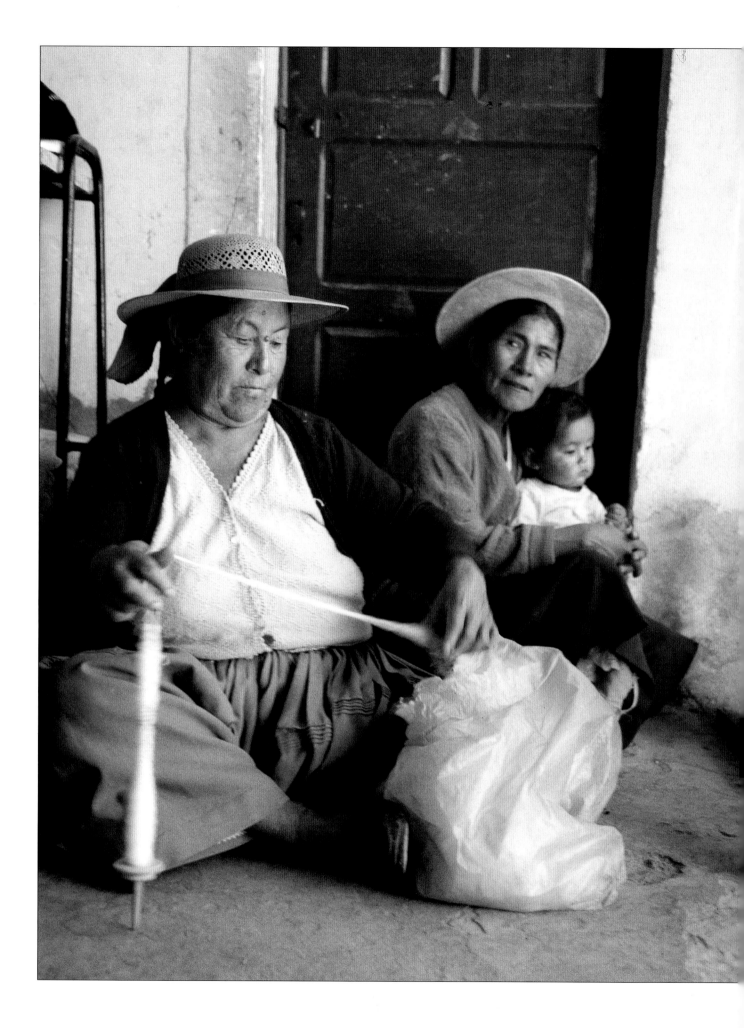

WE ENTER THROUGH A DARK STORE where bubbles slither to the surface of the corn beer brewing in black vats. In the main room of the house, turquoise walls bear watermarks of old storms and the roof is made of cane. We have been told that bugs drop from such ceilings at night, and that their venomous bites can damage a victim's heart thirty years later. But this is morning, we assure ourselves—the cane must be benign.

We load our cameras, unpack our tape recorders and notebooks, introduce ourselves, and wonder what a "loan generation meeting" will be like in Villa El Carmen, Bolivia. Quechua women, descendants of the Incas, gather, sitting on straight back chairs or on the floor. They spin, knit, talk, soothe their children, and wait to begin. All are members of a Freedom from Hunger credit association, a group that has never had visitors.

At eleven o'clock sharp the musical wall clock bursts into a breathy electronic version of "Santa Lucia." Suddenly, the lilting song is engulfed by thunderous blasts. Smoke from the patio fills the entire space. The family's scrofulous watchdogs howl. We are paralyzed—but everyone else is energized. The fireworks are a signal for the women to jump up and spray each other—and us—with the contents of beer bottles as if this were a fraternity party. They throw a blizzard of white confetti. They shake hands, hug, kiss the air, and then shake hands again. Women and children share bowls of popcorn and tankards of beer, some of which they pour on the ground as an offering to Pachamama, Mother Earth.

We are witnessing a *challa*, one of the parties that begin and end the credit association's sixteen-week loan cycles. This is the way the women bless the money. Stacks of bills on the table are now buried in confetti. Loan papers are so wet that they must be spread to dry on a heap of corncobs on the patio. As the loans are distributed, the women pick up their money, look at it, count it, look again, count again.

MARINA ORTIZ IS TREASURER of this credit association, whose meetings are held at her house. We have come to the Cochabamba region to interview knitters, but when we return the next morning to talk with Marina, we discover that she is not just a knitter but a one-woman diversified conglomerate. In addition to running a store and raising rabbits, pigeons, pigs, and cows for sale, she also spins acrylic. And knits.

With almost a high school education, Marina seems to be a born entrepreneur. "I joined the *banco* (credit association) because I wanted money to make business," she says pragmatically. "I started by buying ten pigs. Now I have twenty. I buy acrylic for three dollars a kilo and sell it for

five dollars." Five hours a week of spinning nets Marina ten dollars. She earns eighty dollars for a 120-pound pig. Marina dreams that in ten years she "will have two children, have visited my sister in Santa Cruz, and grown my pig business."

On a typical day, Marina tends her animals before lunch, after which she knits or spins. At about five o'clock, she makes a salad and hearty soup for dinner. Throughout the day, she tends to customers who shop in her store for *chicha* (corn beer), bread, sugar, Tide, spices, and other packaged products that she stocks from the market in Cliza, the next town. Her store closes only when she goes to bed.

Her husband, Vicente, twenty-eight, is a house painter who helps Marina when there are no houses to paint. She earns more than her husband, which apparently does not cause problems. "He runs the house because he is the man," she explains.

Marina, now thirty-four, met Vicente at a party. "I liked him immediately and wanted to marry him," she says smiling. The two lived together for four years, then were married six months ago in a Catholic church.

Marina shows us her wedding album. She is wearing a white wedding dress styled with the voluminous knee-length *pollera* (skirt) that all Quechua women wear. Her wedding veil drops from a halo-like tiara to cover her faux braids and ringlets. Quechua women have worn braids since pre-Hispanic times. An unidentified problem now makes many women's hair too brittle to support the braids, and many, including Marina's, are partly synthetic fiber. She looks like an angel.

Marina explains that this is the traditional wedding headdress. "*Madrinas* and *padrinos* (godparents) pay for parts of weddings. For example, my fifteen-meter train was paid for by the 'train godmother.' My ring was from the 'ring godfather.' The reception went on for three days with lots of feasting and drinking. On the third day, guests threw rice and confetti for good luck and pinned *bolivianos* (Bolivian bills) on our clothes. The 'money godmother' always doubles what other people give the bride and groom."

Among the pictures of the reception, where everyone is covered with snowy confetti, we see a calf that is decked out in a garland of flowers and ribbons. "That little cow was a gift from one of the fourteen godfathers," Marina says.

The final pictures in the album show Marina and Vicente with their friends at an amusement park, sliding down the

slide and cruising the pond in a pedal boat—still wearing their wedding clothes.

Marina's only disappointment about the wedding was that her mother had died six months earlier. "When I am alone, I think about my mother, a kind, good mama, and I am sad. She used to celebrate my birthday by cooking a nice meal of rabbit and pigeon and inviting the godmothers. On those days we laughed all day long."

FREEDOM FROM HUNGER has microcredit programs underway in many developing countries, and its goal is to serve over two million families around the world by the year 2005. The organization focuses on women who live on one dollar a day or less. These women are ineligible for regular bank loans since they have no collateral and no formal credit history; it is not an option to pay the one hundred to two hundred percent interest charged by independent moneylenders.

Freedom from Hunger loans can be used for any revenue-producing activity. The organization's eight thousand-member Bolivia microcredit program, Credit with Education, has been underway since 1990, and has been identified as a model for future USAID programs.

Cecilia Cossio, regional training coordinator, describes how history has set roles for the women. "Beautiful Inca women were for the king. The others were slaves who were classified by activity: childcare, laundry, weaving. Over time, little has changed: contemporary women are typically slaves to their families; women's work is not valued and they have little self-esteem. Although Bolivian women have earned income and managed family budgets for some time, ninety percent of our new members never made money, had a job, or created anything to sell.

"For these reasons, we don't just go recruiting when we set up a credit association. We first approach community leaders (almost all are men) and explain the benefits of the program: better food, better life, better income for the whole family and the community. The men tell their wives, who organize themselves and join us. This avoids trouble. Later, these men often call us amigas…. By increasing their awareness of women's worth and by helping women learn to relish their valuable role, we begin to help women increase self-esteem."

In some credit associations, for as long as two years, members are silent, afraid to speak to strangers. But Freedom from Hunger staff members return week after week. Consistent attention from educated people begins to catalyze women's feelings of self-worth, and attending weekly meetings makes women feel important.

The women's newly gained knowledge begins to pay off: nutritional education results in healthier children. Microbusiness training produces more realized income. Results build confidence. Self-respect grows. Women learn to trust what they think. The urge to express these thoughts overrides the cultural habit of keeping their heads down and mouths shut. And when they talk, they inspire new respect from their families.

WE DRIVE IN Freedom from Hunger's blue Toyota pickup through the countryside that is the breadbasket of Bolivia. Roads and houses are both made of mud, as if they were all of a piece. In town, cobblestones make the wheels clatter. Trees with bright red, pink, or yellow blossoms jolt against the azure sky.

The bridge to Tarata is temporarily impassable. Thursday is feria (market day), and an enterprising man has roped off the bridge so he can admit only those vehicles willing to pay admission. We pay.

The centerpiece of the town square is a Victorian bandstand surrounded by flowers. Bougainvillea crawls up the tall trees. A sign advertises that the Grand Festival of Jokes is coming up. Ferns that require only air to survive tangle on the electric wires. In the square near the market is a statue of a nursing Indian mother. Women carry giant calla lilies and gypsophila to the San Severino church for Corpus Christi tomorrow.

Telephone poles are candy-striped with blue, red, pink, gold, and green—the colors of the political parties whose candidates are vying to win the presidential election on Sunday. Most of the women we meet say that they will abstain from voting, even though villagers' votes are avidly courted. They are tired of politicians' endless promises. There is an inauspicious array of politicians on the ballot: an ex-general (whom journalists identify as an "assassin" who led the country during its era of military dictatorships); a coca producer ("narco king," per the reporters); a communist poet; a university president; the first Indian woman ever to run for president. (Women politicians are not new here. The first woman president of Bolivia served in 1980 and thirty percent of a party's candidates for the senate or congress must, by law, be women.)

The new president will need to attack many problems. Bolivia is the second poorest country on the continent after Guyana. Infant mortality and female illiteracy are high. Even women die fairly young, on average at age sixty-four. A typical family has five children. There are not enough jobs, so many men seek work in Argentina and Chile, leaving their families alone for two and three years

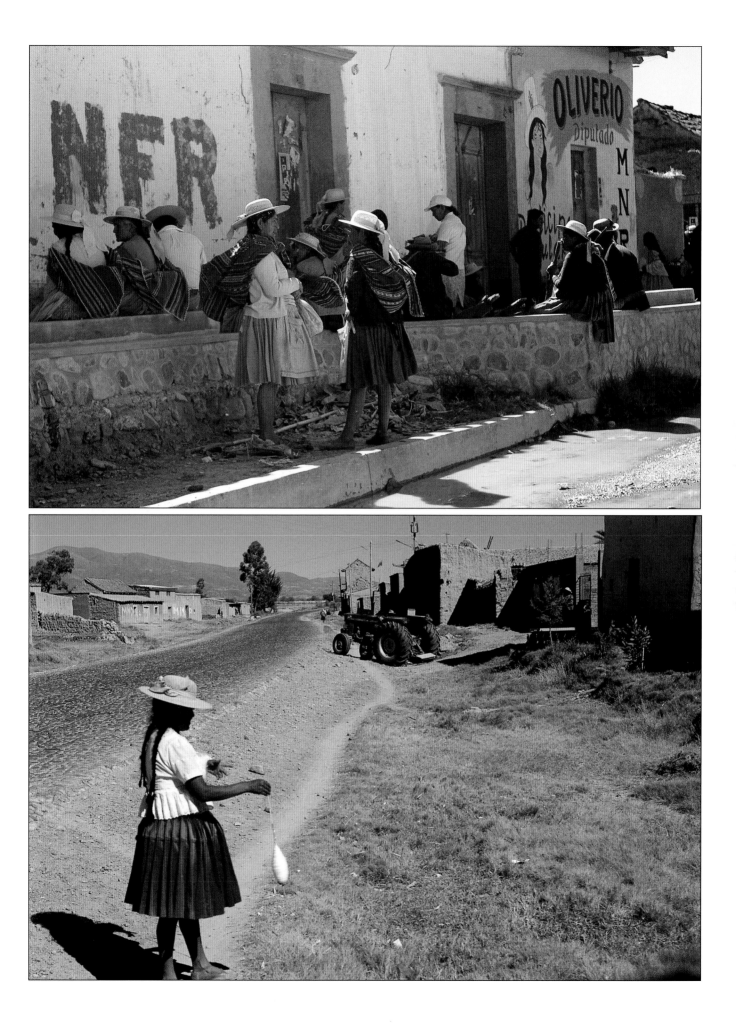

at a time. The litany of problems is long. All the candidates promise that everything will improve.

The Banco San Antonio de Tarata meets at Basilia Camacho's house, where scrawny chickens meander in and out of the doorway as the meeting gets underway. This is the eighth meeting in the current loan cycle. The group has borrowed and repaid five prior loans successfully, earning them each the right to borrow three hundred dollars instead of the lower start-up amount. Weekly, members repay twenty-six dollars, which includes the principal, three and a half percent interest each month, and the seven percent that members have voted to put into savings accounts. Loan funds came from American donors in the beginning, but interest fees ultimately will cover the cost of field agents (who provide banking and education services at the weekly meetings) and allow the credit association to become self-sustaining.

Maritza Usmayo, the Freedom from Hunger field agent, opens the meeting by calling roll: "Marcellina…Elena… Constantina…Angelina…Sophia…Alicia…." The members have decided that full attendance is essential; colleagues who are late or absent are fined.

Freedom from Hunger's microcredit program includes education as well as loans. Maritza's lesson today is about breast-feeding. Her informal class begins with an illustrated flip-chart presentation, then expands to a discussion of the women's personal experiences and questions, and ends as the women draw their own lessons and conclusions from what they have heard.

Half the Credit with Education curriculum focuses on health for very young children. Every day, across the world, thirty-five thousand children die of hunger or malnutrition and three quarters of them are under the age of five. These courses address the causes. During a single loan cycle there will be classes on nutrition for young children, diarrhea management and prevention, immunization, and family planning.

Business topics will include inventory management, product differentiation, adding value, and accounting concepts. Education segments are not theoretical—they have been designed to improve business practices.

When class is over, women come forth one by one to put their cash on the table and sign loan repayment records, either with pens or with their thumbprints. Having approved each other's business plans and loan requests, members encourage and support one another's repayment efforts. None of the members can get another loan until everyone in the group has repaid the previous one. Loans average $128, and repayment is virtually one hundred percent.

AFTER THE MEETING Basilia tells us she uses her loan money to buy rabbits (which she raises in an old car), raw materials to make brooms, and ingredients for *chicha*, the corn beer that she makes and sells—and insists we sample. Fiendishly, she fills our gourds full again and again. We pour a lot on the ground as offerings to Pachamama and are considerably relieved when two knitters demand our attention.

Margarita Torrico de Vargas and Trifonia Balderrama de Encinas, who use their loans to buy yarn, are knitting as Bolivian women do, walking around with a ball of yarn under one arm. They loop one strand around their necks to avoid tangles, and walk and talk and drink *chicha* as they knit. As they show us their work, we spy three tiny, bright, knitted dresses in Margarita's knitting basket. Can the dresses possibly be for the doll-shaped purses we came here to learn about?

Last December, when we were planning our research trip to Bolivia with Claire Thomas at Freedom from Hunger's headquarters in California, Claire told us that Quechua women used to knit brightly colored, doll-shaped purses, which they wore dangling from their belts. Since our project focuses on the lives of women earning money from crafts, we were intrigued by the idea of craftswomen's purses and planned this visit to Cochabamba.

When we flew from Lima, Peru, at sea level, to La Paz, at thirteen thousand feet, the ascent made us feel as if we weighed a thousand pounds and as if our brains had turned to mashed potatoes. Fortunately, Freedom from Hunger sent North American liaison Robert Ridgley to welcome us, because without his rescue we would still be standing in the jetway musing about life's imponderable mysteries—such as whether or not to go through customs. Robert suggested we proceed to the airport coffee shop, where he broke the news: "Our staff has not been able to find any doll purse makers." Robbed of the ability to see logical consequences and intoxicated by oxygen depletion, I said we would go to Cochabamba as planned. Actually, all I could remember about the city was that it had a lower altitude than La Paz.

Finally, thirty miles south of Cochabamba, it seems we might be looking at the makings of the fabled doll purses. Margarita is knitting double-faced dresses that are closed at the edges and tied with yarn bows at the neck. These little clothes-shaped pockets could certainly be used to carry money. "Come to my mother-in-law's house and you'll see more," Margarita smiles.

Opposite: Evangelina's family, which would love to knit and sell doll-shaped purses again, has made ten for us, each unique. Male dolls wear peaked hats; female dolls carry babies.

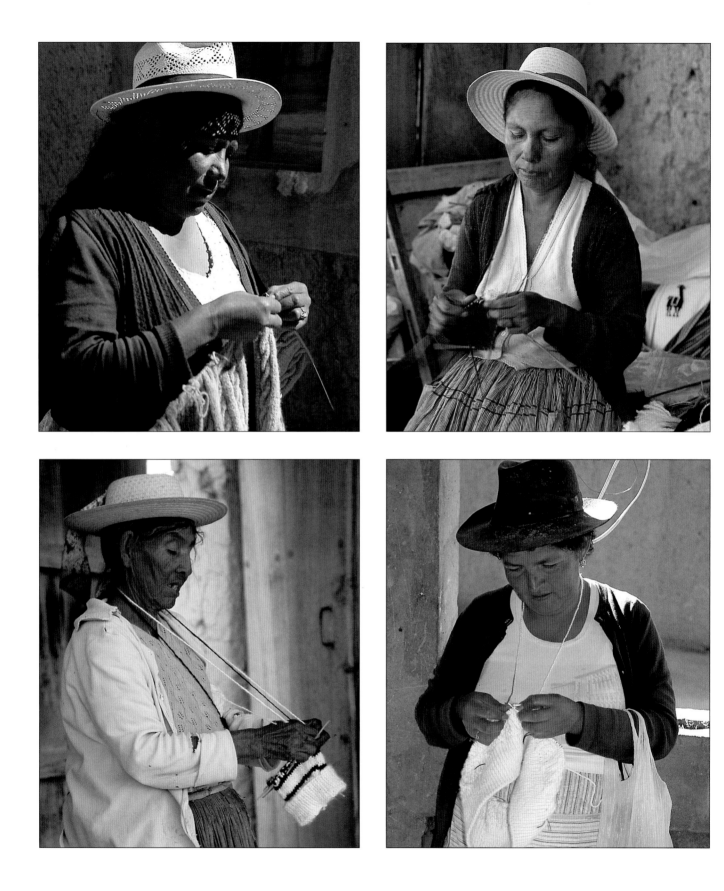

Above: Brimmed hats afford protection from the sun that nurtures grain in the breadbasket of Bolivia. Knitters work as they walk, carrying a ball of yarn under their arms and looping a strand around their necks to prevent tangles.

Opposite: Tarata is the only place we visited where a major plaza has a statue depicting a breast-feeding mother instead of the usual famous man.

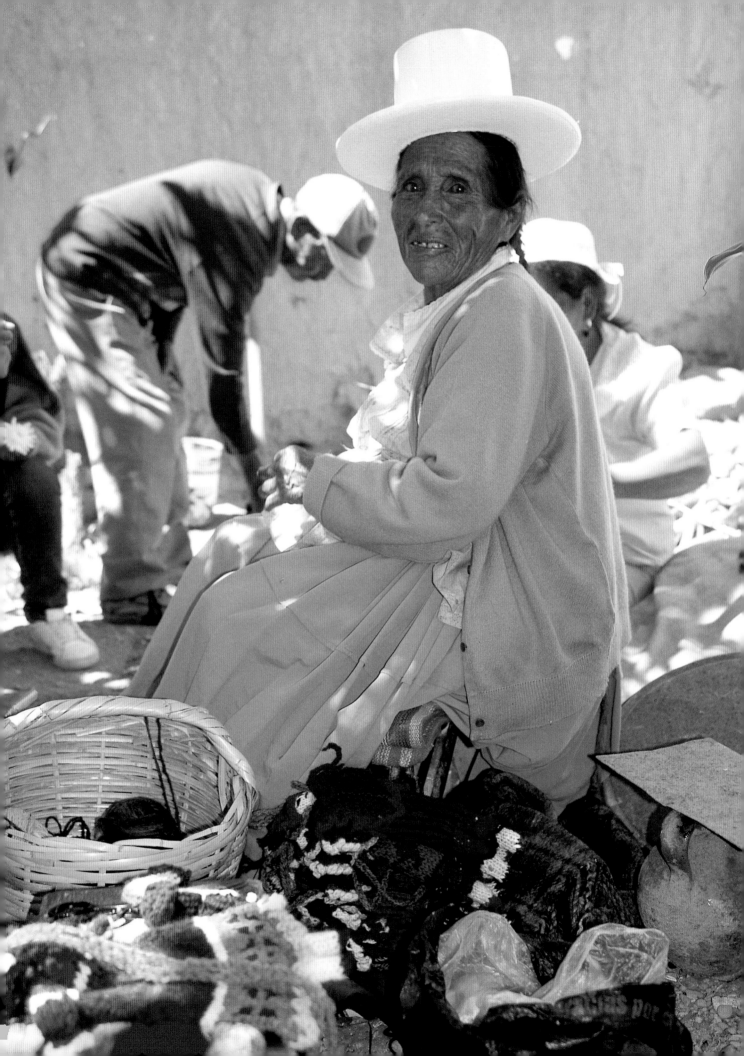

Her husband's mother, Evangelina Saavedra, seventy-eight, is not pleased when we explain our project. "Craftswomen?" she sniffs. "I taught everyone in my family to make the dolls! The men knit as well as the women." This is exceptional; knitting is usually a woman's activity in this area, but we assure her we will photograph the men, too. Evangelina tells us the family has not made the dolls in over twenty years because there is no market for them, but they long to make them again. We promise that, when we get home, we will inquire about marketing opportunities in North America.

When we return to Tarata the next day, we discover that the whole household has been up since four-thirty in the morning completing ten doll purses. Evangelina sits in the courtyard, surrounded by her family: her husband, most of her five sons and daughters with their wives and husbands, and most of her seventeen grandchildren. They are all knitting—fast. Finished purses are stacked high. Lipstick red, cadet blue, kelly green, chrome yellow, and shocking pink yarns are knitted into a profusion of designs and patterns. Each doll is unique. The male dolls wear striped socks, scalloped ponchos, and peaked hats. The female dolls carry knitted babies. We are enchanted.

Evangelina asks one dollar per doll. We buy all ten as samples. When we give her the cash, she kisses the fifty *boliviano* bill, puts it in her pocket, and tells us two stories.

The day before, she confesses, the family ran out of money. They had prayed for a solution. "Today is Corpus Christi, a holiday Bolivian children celebrate by eating fruit. Now the family has enough money to buy fruit for the children."

Second, she tells us that after we left yesterday she visited an herbalist who mixed a magic plateful of herbs, seeds, candies, and charms, which the family burned as an offering to Pachamama. "The flames took the shape of a full-blown rose," she says. "The rose symbolizes good luck. It means our dolls will sell again." And some of them just had.

ONE OF THE INTENDED CONSEQUENCES of Credit with Education is women's empowerment. "Two things provide the leverage for becoming effective: a little money and a little information. Plus the freedom to do with them what they will," Claire Thomas says of the women who participate. "We give them access to resources, but it is their hope, energy, and determination that make the resources work for them."

UNITED NATIONS STATISTICS tell us that in developing countries all over the world, women's income buys food and education for children. Here in Bolivia we hear a story that literally tops them all. Two years ago, Freedom from Hunger credit association members in the Altiplano, near Lake Titicaca, saved and pooled their money until they had enough to pay for a new roof for the local school. Today their children study there.

TODAY IS DÍA DE LA MADRE, Mother's Day, May 27. It is a solemn holiday. On this day in 1812, the Heroinas de la Coronilla, led by a blind woman, fought with sticks and stones to defend the city of Cochabamba from the Spanish. We see school children parading. Mothers will attend open houses in the schools this afternoon. In the historic plaza, vendors sell white-iced holiday doughnuts stacked in four-foot pyramids.

We visit the monument that honors the Heroinas, which sits high above the city where they did mortal battle. Wreaths with ribbons and messages surround the statue. The martyred Heroinas have become symbols of the courage and will of the women in Bolivia who, two hundred years later, are still intrepid and indomitable.

Opposite: Evangelina Saavedra, who wears her high-crowned holiday hat for Corpus Christi, taught her entire family to make doll-shaped purses.

I don't think they like us.

We wave to other pickup-truck passengers on the road, smile and nod to people in the village, murmur "buenos días" in the market—and get nothing back. Unless you count blank stares.

Is it resentment—or fear—or just shyness? We don't know what to make of it. Even when we go into banco *meetings, where we're properly introduced by mutual friends, we meet reticence. They're certainly a lively group when they celebrate by squirting each other with beer, but the* challa *is a brief gaiety plunked in the middle of a most reserved gathering. After the festivities, propriety reigns. Slowly we realize that what I feared was unfriendliness is simply a long-standing cultural trait: reserve.*

We sit down for some interview time with our hostess. Our questions elicit very short answers, or no answers, some vacant stares. Then we ask what we think is a simple getting-acquainted question: "How did you and your husband meet?" Our interpreter is shocked. "I would never ask her that. Much too private. Your questions are so personal! That's not done here."

We have tried so hard to be sensitive, but even so we're stepping on toes. Then we notice that Amanda, the Freedom from Hunger agent whom the women have known and trusted longest, has been sitting next to our hostess, gently stroking her arm to calm her in the face of our foreignness and our prying.

So this is shyness, and also defense of privacy. And it's something more than that. It also has to do with self-esteem, that quality in which the Freedom from Hunger people have seen a gradual but satisfying growth. As a result of that growth, even though our visit has temporarily frightened the women back into their shells, by the time we say good-bye to our quiet new friends in Tarata, we do have some conversation, some smiles, and even a few laughs.

. **Tarata, Bolivia**

This page: Cliza has a lively market from which Marina Ortiz stocks her home store. The buildings become billboards, ablaze with campaign messages at election time.

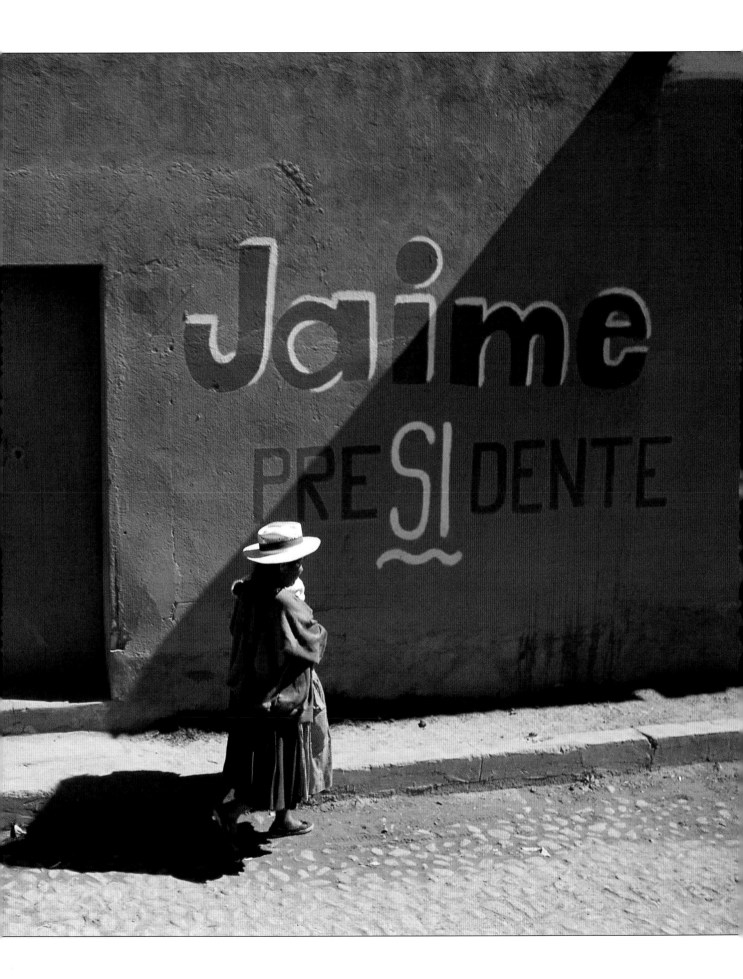

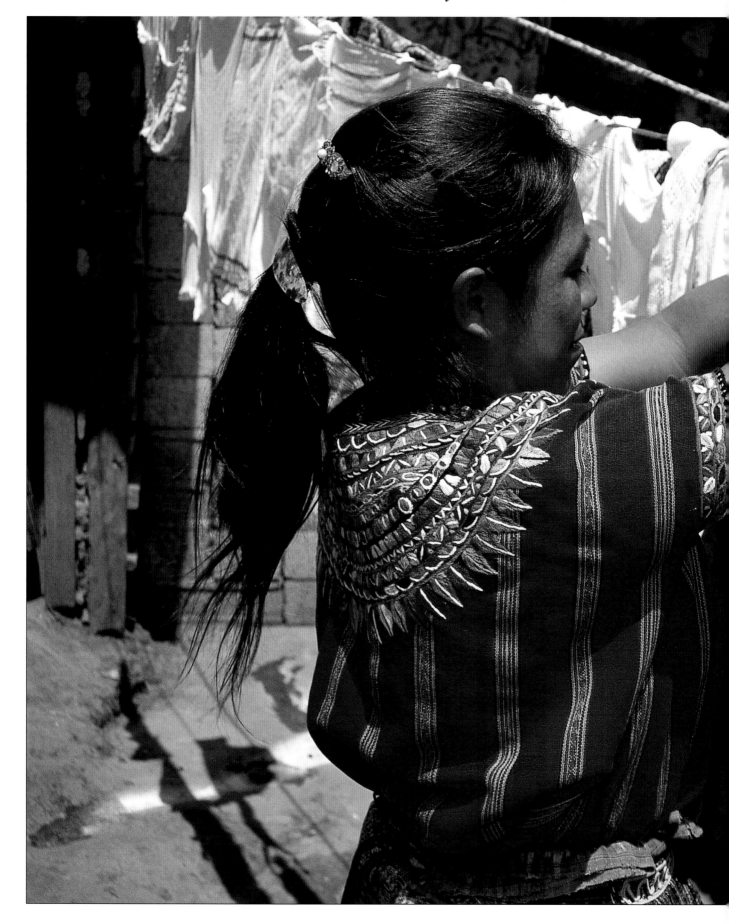

had been wearing the traditional apparel. Olivia, dressed in a contemporary outfit, had greeted us quickly, invited us to wait on a wooden bench, and returned wearing *traje*, an embroidered blouse and wrapped skirt. As she stood twisting yarn through her hair to create a bright coronet, she explained, "Like all the women, I wear *traje* every day—except when I sell in Guatemala City. One day when I was there, I was beaten and robbed. Now I don't wear *traje* there. It is safer not to look like a vulnerable Indian woman."

BANKS OF STEPS reminiscent of the ancient ruins at Tikal lead us to the Museo Ixchel del Traje Indigena, which is named for Ixchel, sometimes called Chac Chel, the Mayan goddess who created weaving. Her name translates to "Lady Rainbow," and she is associated with fertility and childbirth; Mayans speak of cloth as being "born" on the loom. The sacred Mayan text, the *Popol Vuh*, warns the Indians against forsaking the crafts that have been handed down through the generations: abandoning those crafts will betray the ancestors.

We tour the museum collections, which span one hundred twenty communities and two centuries. And of course, we visit the museum store, which is packed with work by the very weavers we are visiting.

AT THREE O'CLOCK, we are to meet two more superstar weavers, Albertina Patunayche and Irma Bajan, in the plaza of their village, Patzun.

Having left Guatemala City in frustratingly slow traffic, we are arriving two full hours late. We are more than just embarrassed—we are afraid we will never be able to locate Irma and Albertina. We don't have their home addresses, and we know they do not have telephones.

We squint through the dusty car windows, scanning the large plaza full of people, buses, and vendors. We survey the sidewalk that hugs the tan-colored, single-story buildings surrounding the square. Every woman and girl in Patzun wears a deep-red blouse with floral embroidery at the yoke and a skirt patterned with gray and white. Which of these identically dressed women are Albertina and Irma?

Finally, we decide to get out and ask. But as soon as our car pulls over, there is jubilant knocking on the back window, and Albertina and Irma are there laughing at us, hugging us, welcoming us.

The next morning we follow their directions through a labyrinth of one-story adobe walls, each house indistinguishable from the next for block after hilly block. Finally, we locate a trail that twines uphill and walk through plowed fields to reach Albertina's home near the top.

She is ready for us. The immaculate red surface of her porch is so glossy with wax that we ask if we should remove our dusty shoes, but she beckons us inside.

As we enter her living room, we quickly notice the table-top altar, still holding an Easter display: big bouquets of gypsophila spill from vases under a framed picture of Christ. The room is decorated with children's drawings and certificates that commemorate the completion of various grades at school. A small television set sits high on a shelf in the adjacent bedroom, which is only a few inches larger than the bed.

Five smaller buildings comprise the hillside complex, each a separate room connected to the others with broken wood fencing. There is a kitchen with a large brick wood-burning oven and enamelware on the shelves. There is also a shed full of dry ears of corn for tortillas, a storage shed, a chicken coop, and an outhouse. Although there is electricity, there is no running water. Water comes from a deep well in the center of the dusty yard, where there is also a metal sink for washing dishes and clothes and for other chores. A brown puppy plays nearby. Two white, pet birds perch on metal garbage cans. Tall, exotic, scarlet flowers blossom in a garden patch.

Many activities take place on the shady porch with the shiny floor. Albertina's fifty-eight-year-old mother, Hilaria, is already working there, warping yarn. While we talk, Albertina embroiders, then weaves.

Albertina worries that Guatemala's weaving tradition may ultimately be lost. "Some women don't know how to weave; they buy used *huipiles* from other villages instead of making their own in Patzun style. A few women even buy Western clothes. Some mothers want to teach their daughters to weave, but the girls must do homework instead. Men used to wear the woven shirts and pants their wives made, but not now.

"One reason weaving is not so popular is that few tourists come to buy. We used to have a thriving market in Patzun but the Pan-American Highway didn't come this direction, and banditos on the old road scare people away. So weavers must compete for business. We never work together any more; everyone wants to keep their skill to themselves."

Albertina began to weave when she was seven, learning on a child-size backstrap loom. She graduated to a grown-up loom when she was ten. "I felt very happy at that point because then I could earn some money." Her first sale netted thirty-two cents, which was enough to buy ribbons to braid into her hair.

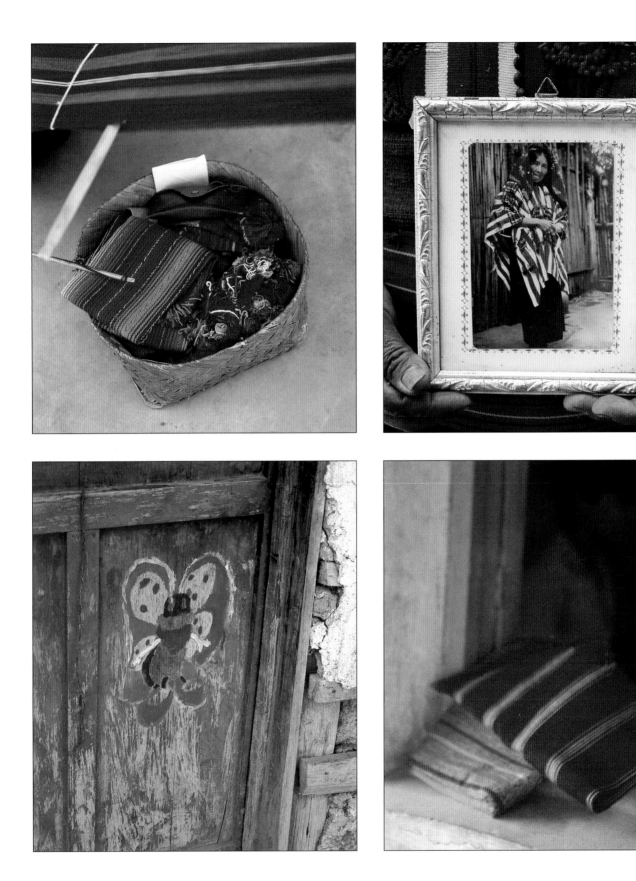

Above, clockwise from top left:
The basket under Olivia Asij's backstrap loom contains yarns and tools for weaving and brocading. At day's end, it will also hold her work-in-progress and the collapsed loom. • Olivia proves that her mother's wedding *huipil* was as fancy as the style preferred by young women today. • Albertina's bright textiles helped qualify her to work with neutral-hued *cuyuscate* for the Ixchel Museum's Pro-Teje Project. • Albertina's son, Freddy Haroldo, twelve, shares his mother's artistic talent, as evidenced by his graffiti; his dream of learning computer graphics is probably unaffordable.

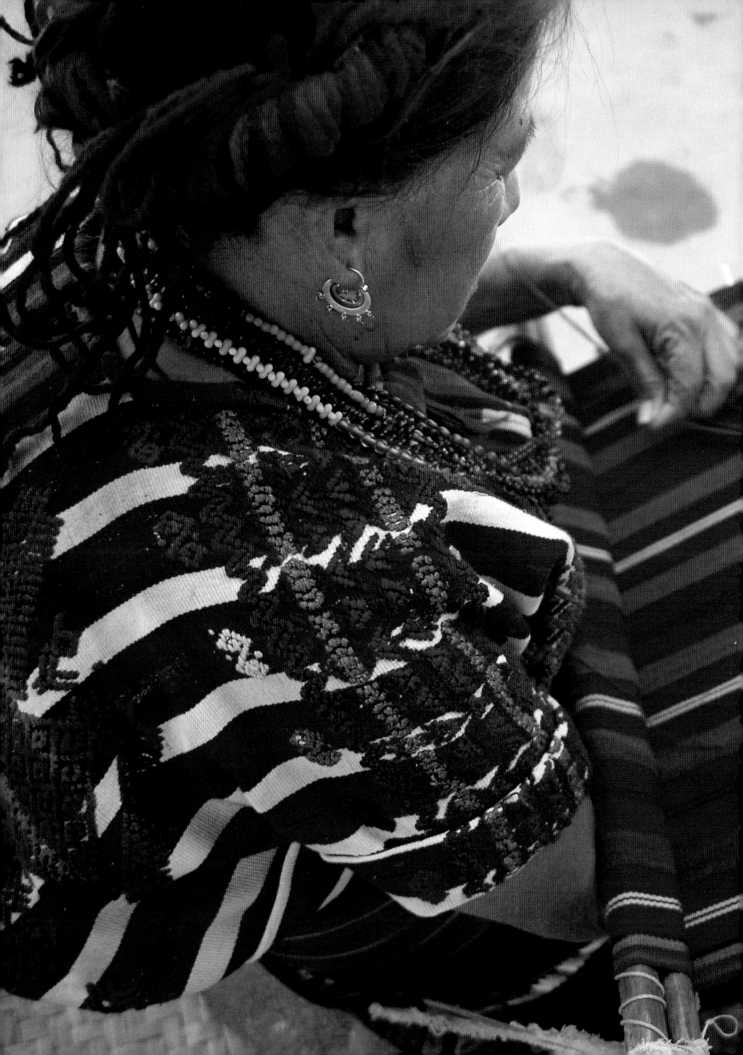

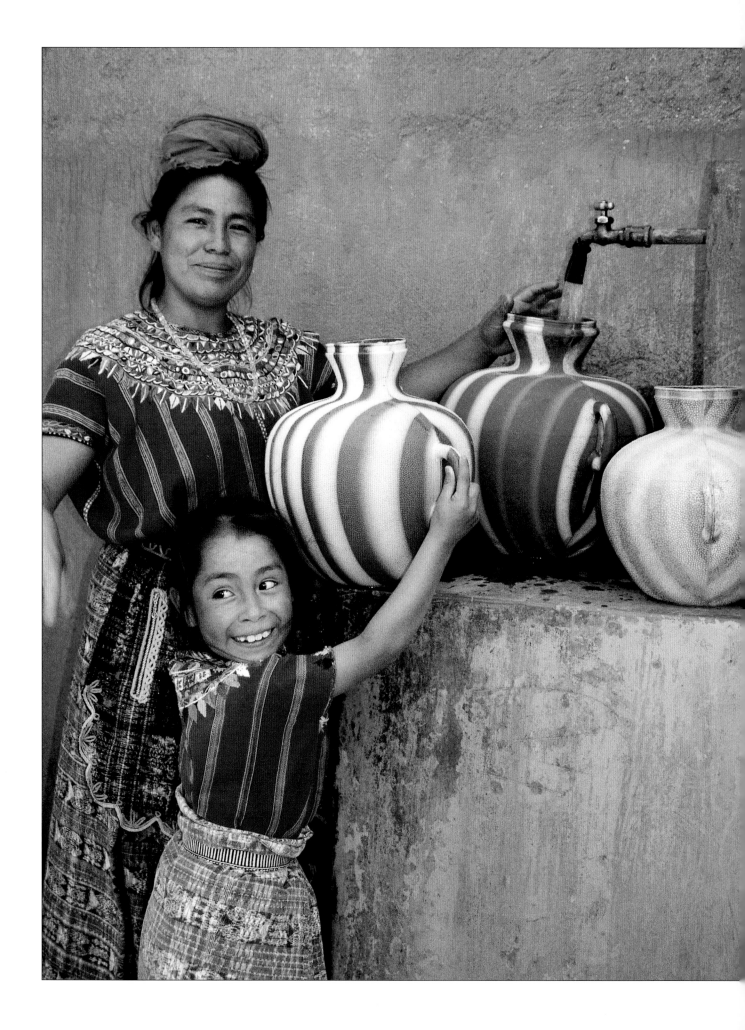

Education is important to this family, in a country where fifty-five percent of the population is illiterate. Albertina's father joins us and describes going to night school as an adult and learning ("slightly") how to read and write. Her mother says she could never catch on. Albertina finished the second year of high school, where her favorite subjects were mathematics and language. She reports proudly that her four children are all in primary school.

"School expenses are thirteen dollars a month. I can barely give the children money for anything except school," she acknowledges sadly. When Albertina can't afford books, supplies, and uniforms, her parents contribute.

Albertina is a single mother. We assume that her husband was killed in the civil war, like many women's husbands, but this is not the case. "I met my husband walking down the street, the way everyone meets. I did not finish high school because we got married. I am Catholic; my husband was Protestant. I didn't like to go to his church, so we started having problems. He started drinking. He died from it when he was thirty, seven years ago." She speaks slowly, struggling under the weight of whatever guilt she feels for this sad ending.

Her daughters, now seven and nine, can already weave. "For fun they pretend they have orders. They cut leaves into strips and weave the pieces together." Albertina wishes the girls could become teachers, but she cannot afford the required education.

Her son, Manuel Roberto, seventeen, works half days as a baker's apprentice. He will finish primary school, then work full time at the bakery, where he has worked since he was eleven. As we talk, Manuel Roberto arrives home bearing a basket of fresh warm buns for lunch.

Albertina's other son, Freddy Haroldo, is almost thirteen. He is a talented artist—we can tell from the embroidery project he did for an art class at school and the amusing cartoon figures he has painted on the shed doors. He likes computers, but there are none at his school. Albertina shakes her head, "I would like so much to see him working in an office in Guatemala City when he is older, but technical schooling would be too expensive."

Today we brought bag lunches so our hunger would not burden this family. Albertina won't hear of our sitting on the ground to have a picnic. Instead, she leads a singing, enthusiastic parade uphill, with each family member helping to carry the table and chairs that usually furnish the kitchen. It seems to be this generosity and joyful sense of family that keep Albertina from losing heart at the difficulties of her life.

IRMA LIVES HALFWAY DOWN Albertina's hill. Her daughters have names that sound like music: Irma Leticia, Gladys Maribel, and Brenda Lorena. Her fourth child is due in October. "God and my husband will decide how many I will have altogether," she admits. "I am still only twenty-five. My mother had nine babies."

The five people in her household now live in her one-room, windowless adobe house. There is no door to close, but the immaculate room contains a wooden cabinet that holds everyone's possessions, and there are two beds placed at a ninety-degree angle in the corner, covered with matching blue woven bedspreads.

Irma's husband, Remigio, does agricultural work and earns three dollars a day. Her own woven place mats contribute three dollars a month, but Irma hopes that when her girls grow up they will sell weaving and contribute, too. She is teaching them on the same child-size backstrap loom that she used when her mother taught her. Although she would like her daughters to continue school, she is pragmatic: "If the girls can't go far in school, they can weave and get along all right."

Irma rises at four in the morning, and her day is full. We accompany this energetic, sunny young woman and two of her daughters to buy eggs at the market, visit the girls' teacher, fetch water from the town spigot and carry it home on their heads in striped plastic water urns, then hang laundry.

It is almost time to cook. Irma asks with a wide smile, "Do you want to see my kitchen?" We follow her diagonally uphill and stop at the windowless kitchen building across from the corn shed. There is not much light inside, but it is not difficult to see why Irma invited us—to appreciate her prized new possessions: an electric blender and a spotless white gas stove.

Previous pages: Some days, Olivia weaves with *cuyuscate*, the indigenous cotton that grows in pale shades of green and brown, but today her palette is not neutral.

Opposite: Irma's daughters go to school now but she is teaching them to weave so that, if education becomes unaffordable later on, they will be able to get along.

It is cold here at four-thirty in the morning. Cold and dark. And a little scary. Centuries of seismic and volcanic calamities have left a legacy of broken walls and crumbled buildings in this old colonial city, ruins that look charming in the sunshine, dressed in geraniums and bright new awnings. But now, in the eerie darkness before cockcrow, the effect is ominous—all jagged shadows and hiding places.

We are up and about at this unlikely hour because it's Good Friday, and wonderful things are going to happen. There will be no chocolate bunnies for Easter weekend here, but there will be parades. And before the Good Friday procession begins at nine, the parade route is to be decorated with "floral carpets." It's a big job, so the work begins well before the crack of dawn. We want to see it.

We wander the empty streets fruitlessly for a while, then our flashlight finds a group of people hunkered down on the pavement around a collection of baskets and plastic pails, some piled with flowers, petals, leaves, or pine needles. Other pails are full of brightly dyed sawdust in jewel colors. This little crew of neighborhood artists is doling out the "paints" with which their art will be created.

In the next block, two young couples are working together in the dark, on a long rectangular base carpet of colored sawdust. On the pavement sits a stack of stencils with flower, cross, and crown cutouts and a basket of border greenery.

Within minutes the activity level has quadrupled, and by the time the first glimmer of gray light shows in the sky, the meandering length of the procession route is fully populated with twos and fours of Antigua's citizens, industriously bent over their labors of religious love. With the growing morning light the baskets of flowers and petals bloom with color. All sorts of designs are taking shape on the six- to twenty-foot street paintings: birds, animals, crucifixes, blossoms and trees, and words of devotion. I am moved by one carpet that bears a stenciled plaque reflecting the recent resolution of a long and bloody political situation: "Señor, gracias por traernos la paz." Lord, thank you for bringing us peace.

Four or five rolls of film later, as sunlight streams into the street where we stand, a dramatically side-lit volcano rises in the sky beyond the end of town. It looks as if this flowery roadway of color and pattern runs right through Antigua and up the side of the mountain.

Crowds are gathering on the sidewalks, and children appear in the iron-grilled windows of the houses along the way, seated among the potted petunias on the deep windowsills to watch expectantly down the street.

Things are speeding up now; there's a sense of urgency. Finally the carpet makers put the finishing touches on their works and gather their pails and baskets to scramble out of the way, just seconds ahead of the procession. Farther up the parade route the workers have a few more minutes, but here on this block the main event has arrived.

We have a final moment to take in the beauty and color, to appreciate the creativity and effort that have transformed the cobble paving into a wonder of disposable art. And then it is gone. A thousand marching feet are trampling the floral carpets into oblivion. When the tuba players and drummers, the Roman soldiers and purple-robed Israelites, the dozens of men bearing statues of the crucified Christ and dozens of women carrying the Virgin—when finally they have all passed, continuing up the street onto fresh fields of floral design, all that is left behind is a scramble of sawdust and mangled flowers.

The carpet makers return to the street, this time with push brooms and dustpans.

. Antigua, Guatemala

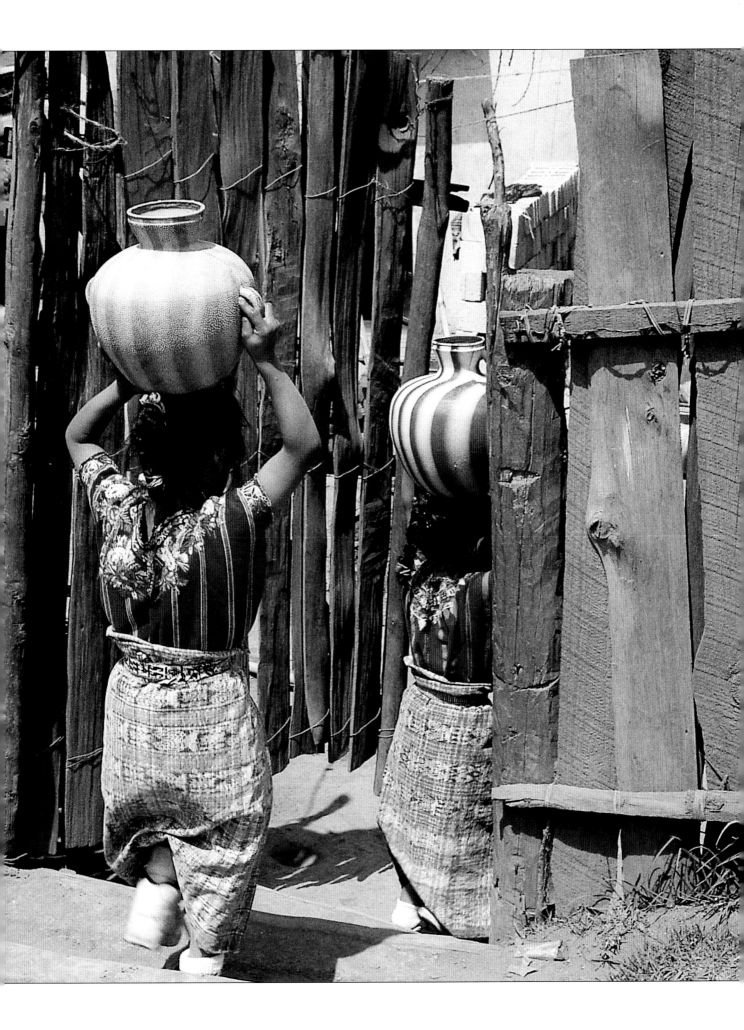

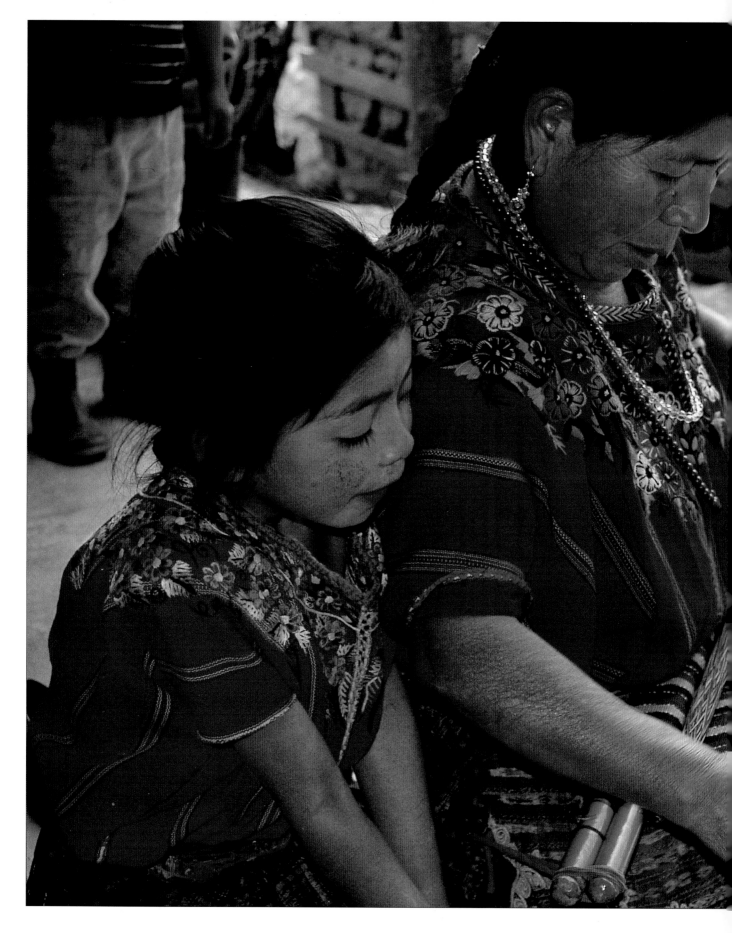

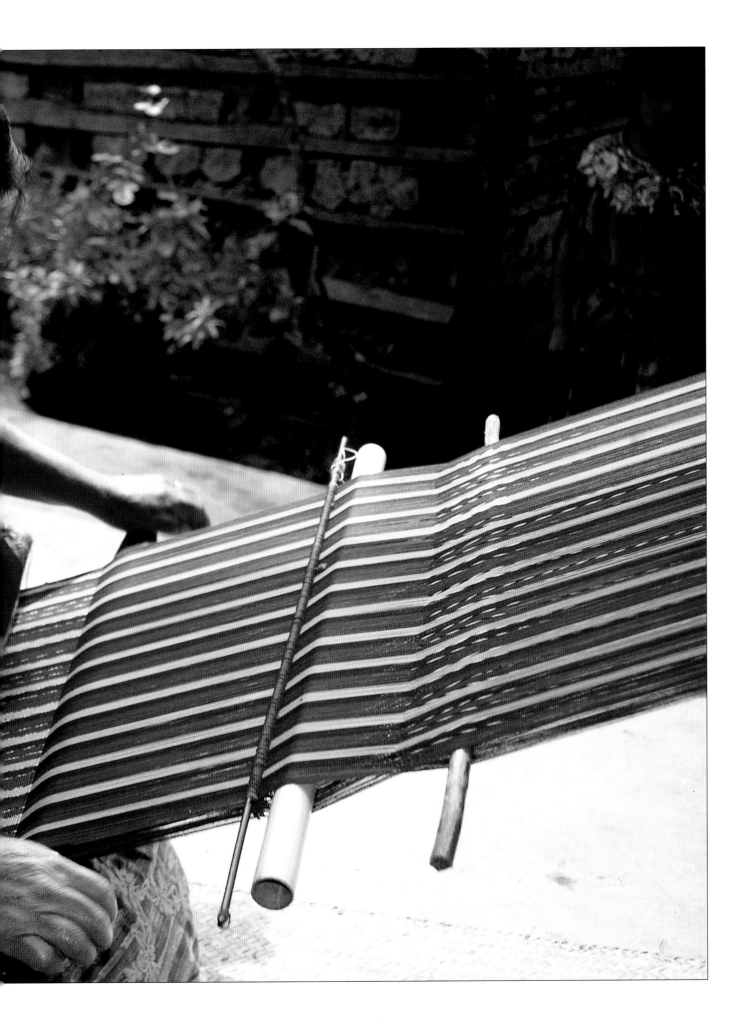

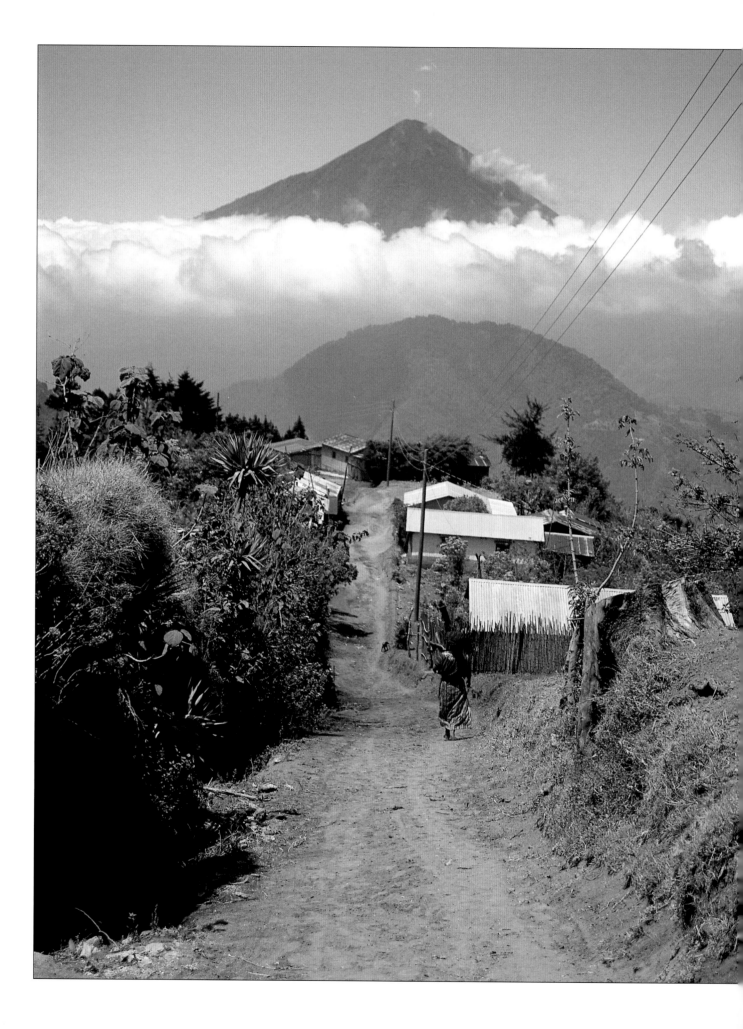

THE GATEHOUSE AT THE MILITARY BASE in Sololá is shaped like a soldier's boot: twenty feet tall, a guard window in the heel, rifle portals above the laces. Gravestones on the hillside above Chichicastenango are painted flower garden colors: buttercup yellow, lilac, rose, forget-me-not blue. In late December of 1996, only four months before our arrival, a truce was signed that ended the thirty-six years of civil war that Guatemalans call "the Violence."

We are on our way to interview weavers who live in the highlands. Like many others in the Chimaltenango region, these women lost husbands, fathers, brothers, and uncles to the Violence. For years, their weaving has been the sole support for their families.

PINE, JUNIPER, AND LAUREL line the mountain road. Rounding the next sharp turn, our Land Rover skids to a stop. Boulders block the way. Vey Smithers bounds from the car, talks with the road workers, and calls to us, "Come on, we have to move the rocks." We help her lug the huge boulders to the side, liberating the Land Rover to move forward.

Vey, now forty-seven, came to Guatemala from the United States in 1973, loved the country, and stayed. Land was affordable enough that she bought a small piece of property in Chuinimachicaj, which means "big sky." The town perches at eight thousand feet overlooking Lake Atitlán.

In 1982, fighting between government soldiers and guerillas erupted in the village. Over the next year, as the community became more dangerous, the women and children sought safety in more peaceful places. Later, when Chuinimachicaj quieted, they returned, and Vey's neighbors asked her to buy the clothes they were wearing so they could feed their children. Their *huipiles* (woven blouses with embroidered yokes) had become old and tattered. Vey bought them but warned, "This is not a good idea. Next month, your children will be out of food again, and I will be out of money."

Vey volunteered to help the women think of a way to use their weaving skills to make products people would buy, use, and buy again, instead of the *huipiles* that tourists only buy occasionally. She now runs an elegant boutique called Colibri in Antigua, Guatemala. "I wanted the store to be their market," she tells us. "I price for fast turnover so the women will have a steady income." Backstrap weaving from four hundred fifty women in fifteen villages is available at Colibri: beautiful woven cotton domestic goods such as tablecloths, place mats, runners, small towels, and napkins.

Vey created patterns based on the women's traditional weaving skills. To standardize quality, she provides the weavers with skeins of colorfast yarn in subtle hues that appeal to Colibri's sophisticated customers.

Some of the weavers have remarried, but about three-quarters are still widows. The fact that they have a reliable stream of revenue has changed their lives. Vey is taking us to meet some of the women.

THE VILLAGE OF PACHAY LAS LOMAS peers over the hazy mountains and sprawls downhill from the Catholic church. Houses cluster below, then scatter into the woods. The only road leads to the mill where the women grind their corn every day. In the opposite direction are the school and the *pila*, the open-air pool where the women wash their laundry.

There has been a mix-up about our arrival. Ambrosia, the leader of the weavers, is at the market in San Martín Jilopepeque. Two women Vey does not know get out their backstrap looms to demonstrate for us. They worry that they cannot feed us lunch and that there are no chairs to sit on. We perch on Ambrosia's porch floor.

Slowly, members of the group gather: Lucia, Julia, Clemente, and Guadeloupe, who took a break from weaving when her baby was born. We talk, smile, listen, share our oranges and cookies. Now women venture from all directions to join us. There must be thirty grandmothers, mothers, children, and babies. Discomfort gives way to curiosity. Many sit and nurse their infants; all seem eager to talk. "We are glad you came," they tell us. "Where do you live?" they ask. "Did you arrive by car or airplane?" "Will you take a group picture?" They ask if there are markets where women sell weaving in the United States. We describe Navajo women's rugs, and they ask whether Navajo women are more or less talented then they are. And finally, "Do you have any more cookies?"

The women tell us the stories of their first sales: what they sold, how old they were, who bought, how much they were paid, what they did with the money. Vey translates from Spanish to English; the women who speak only Cakchiquel appoint intermediary interpreters to translate to Spanish so Vey can take the next step. I worry that the multiple translations may distort what they say, as in the birthday party whisper game, but one thing is clear: these women want to talk.

EUSEVIA GUERRA IS THIRTY-THREE NOW. When her father was killed, she left school to help her mother, who taught her to weave when she was twelve. By fifteen she was good at it, and three years later she sold her first *huipil* in Chimaltenango for fifty dollars. "It took six months to

Previous pages: Benita Yaqui teaches her granddaughter to weave using the same *kema* (shuttle) her mother-in-law used long ago to teach her.

Opposite: Benita's village is Chuinimachicaj, which means "big sky" in the local Indian language. The women's burgundy *huipiles* indicate that their village is near Patzun.

41

make that *huipil.* Today, that much work should bring a hundred and fifty dollars."

She has been earning twenty-four dollars a month by making one set of eight napkins; she uses the money to buy sugar, salt, soap, and children's clothes. Now that she weaves only table linen, she buys the *huipiles* she and her three daughters wear. Here, only women still wear traditional clothing every day. Most men in the Guatemalan highlands, sport jeans and T-shirts. During the Violence each village's distinctive style, color, and design acted as an advertisement that told enemies where the men lived, so many men stopped wearing traditional clothes.

Eusevia and her husband own four *cuerdas*, about two acres, where her husband plants corn; they contract with coyotes, companies that collect vegetables to sell for export. Eusevia does not know how much her weaving contributes to the household compared to the vegetables, but the amount will increase as she makes more tablecloths—she has just completed her first.

Her days begin at four in the morning. She makes coffee, then tortillas ("If my family doesn't have tortillas, they don't have enough strength to work with a machete or an axe...."). After breakfast she washes the dishes, straightens the house, then begins to weave. At eleven o'clock the boys come home from school for lunch before going to help their father in the fields. In the afternoon, she goes to the mill to have her corn ground, then does the laundry. After dinner and dishes, the family goes to bed as soon as it gets dark since there is no electricity here.

I ask what makes her happy. "Having weaving to do. What would we do without work? If you don't have money, you can't eat. The wind knocked the corn down last year, so we even had to buy corn. I have six children and don't want more because they would cost too much."

Asked what her dreams are for her daughters, she says, "I hope they will finish the sixth grade, then weave like I do. There is no work here except for weaving."

WE ASK THE OTHER WOMEN the same question: what makes them happy? "When we get together for a wedding or birthday, we forget our problems and are happy," one says. "When I go to church and pray, the silence and the peace make me happy," another adds. "I'm happy because I'm learning to read," a second grader offers. "I'm reading a book from the library." A widow who still has three children at home describes her role: "I am happy when I have work. I am like the trunk of the family tree and my children are the branches. I don't know how

to read or write but I want my children to go to school. If I have work, I can pay for that."

A mother volunteers, "I'm happy having work, too, so I can buy things: sugar, corn, clothing, notebooks, pencils, pens, books. Books cost three dollars now, but after children go beyond the first and second grade, books cost so much that people with many children cannot educate them all. Two of mine, a boy and a girl, are going to finish school," she announces. Pride, determination, and certainty are braided in her voice.

Vey later explains that often families have to choose which children to send to school, and it has usually been boys who are given the privilege. But that is changing. On highways we pass government billboards that read, "An educated girl is the mother of development."

Do the women realize that educated children often leave home to find jobs? They do, and are resigned to live with that eventuality as long as their children have better lives. "The heartbreak," Vey comments later, "is that some educated people have to sit on sidewalks in Guatemala City selling Chiclets."

"I BOUGHT MY LAND in Chuinimachicaj from an old lady who moved to the coast," Vey remembers, "and moved in next to Doña Benita Yaqui and her husband, Bartolo. An earthquake had just hit the area, hard, but because the houses were built of sticks and mud, people weren't killed when the houses collapsed." Benita learned weaving later than most. At twenty, she married Bartolo, and his mother, the town midwife, taught her to weave. Benita still uses the fifty-year-old *kema* (shuttle) her mother-in-law left to her. When Benita is happy, she sings church songs while she weaves. But for her and for many women in this village, there have been times of heartbreaking sadness.

"The Violence began here in 1980, and lasted five years," Benita recalls. "My son Alejandro disappeared in 1982. All the women and children in the village soon fled to safety, and when we returned two years later, I found Alejandro's body. The army had camped in our woods, captured, killed, and buried him. In 1985, my husband disappeared from the streets. He was arrested for no reason that anyone knows, and was never seen again."

It was Benita who approached Vey, her neighbor and friend of seven years, asking her to buy *huipiles* when she and the other women dared to return to Chuinimachicaj in 1984. And it was Benita who helped Vey establish the first weavers' group. Fourteen widowed weavers elected Benita their leader. But being the leader was simply a

Opposite: Weavers in the Chimaltenango area, like this mother with her children, are among 450 women whose work is available at Colibri in Antigua.

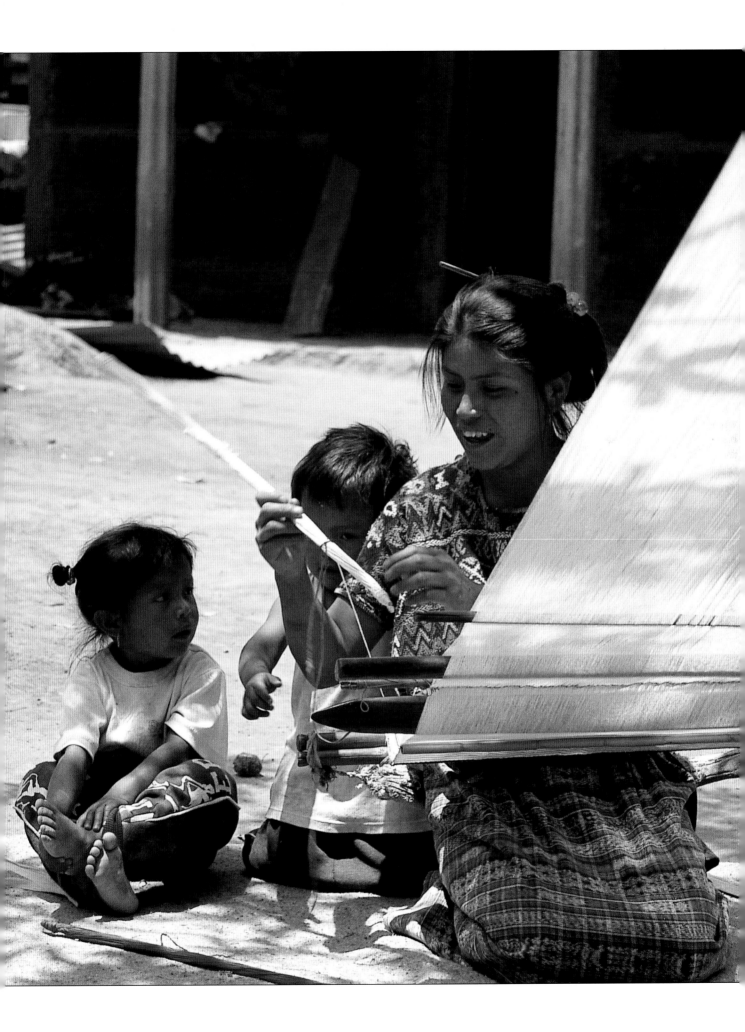

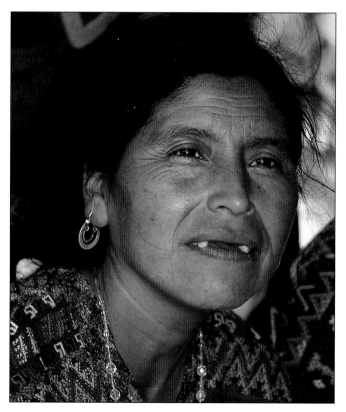

Above, clockwise from top left: Benita, now fifty-five, raised her seven children alone. Uneducated herself, she is proud that all her grandchildren have finished the sixth grade. • Francisca is a weaver and spiritual healer who is sought by people from Guatemala, Spain, and Mexico to help them find their destinies. • This weaver in Pachay Los Lomas has no front teeth, like many here who have inadequate nutrition and suck sugarcane. • Matea, Francisca's mother, continues to weave at eighty-three, even though her eyes are not as good as they used to be.

Opposite: Women in Chuinimachicaj, like indigenous women throughout Latin America, carry their babies in brightly woven slings.

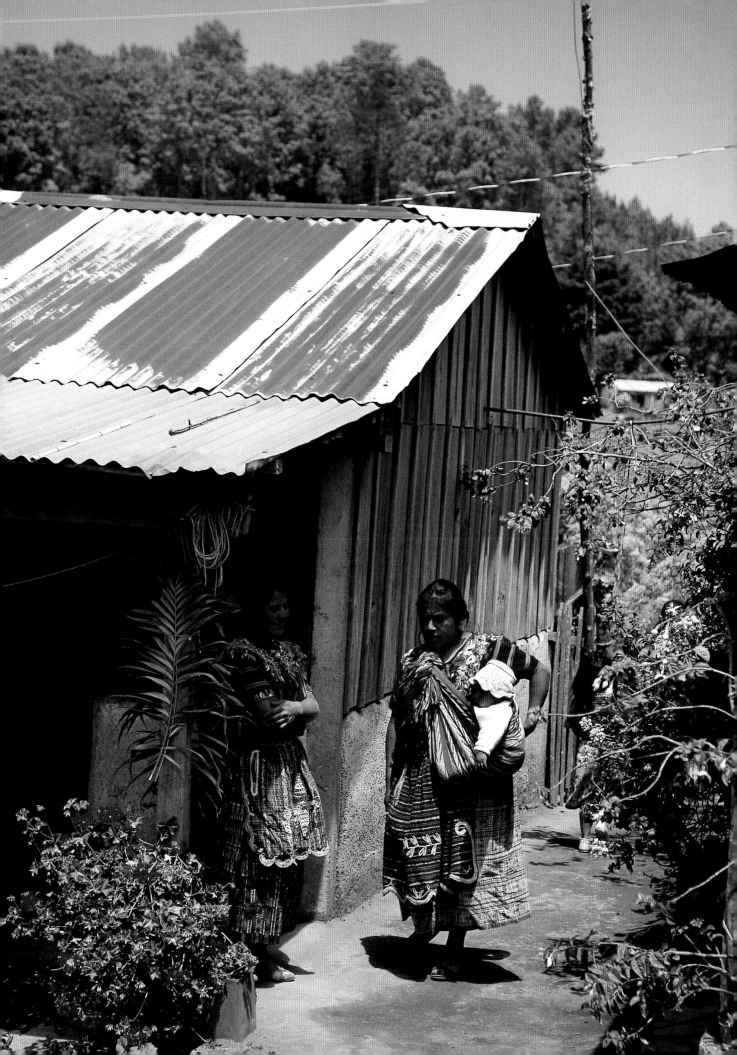

necessity; the accomplishment that made Benita proudest was being able to earn money. "The weaving has been a big help in the village's recovery. It has helped me. I haven't had anything else," Benita tells us. "In the beginning, we were all sad. It helped us to know we were part of a group. We each worked in our own house, but felt we belonged to something."

Doña Benita, now fifty-five, raised her seven children alone and has many grandchildren, whom she views as blessings. Uneducated herself, she tells us that all her grandchildren, including the girls, have finished the sixth grade. "I have twenty-four grandchildren—and a good rooster," she says, satisfied. As we leave, she gives the rooster to Vey as a thank-you present.

IN XAJAXAC, a Cakchiquel word that means "new hope," we visit three generations of women in one family, all weavers: Francisca Guarcax, her mother Matea, and her niece Flora.

Francisca's husband was killed in the Violence. Matea lost her husband, a son, and three brothers—all of the men in her family. Flora was orphaned.

Matea, now eighty-three, learned to weave from her mother. When she was young, *huipiles* were brown-and-white homespun, natural cotton. "No bright colors. No decorations. Not like now," she says. Her granddaughter, Flora, wears the new fashion: there is glitter in the *randa* (connecting strip) of her *ikat* skirt.

Matea did not go to school. Her father was a healer and was well respected in the village. Matea had been married for nine years and had four young children when her husband was killed. He had sold vegetables, so it had not been necessary for her to work, but after his death she had no choice but to weave for money. With the money she earned, she managed to support her family, and now has thirty-five grandchildren.

Flora, twenty-two, finished the sixth grade but feels she does not speak Spanish well enough to study further. Vey points out that she is a talented weaver whose work is even and beautiful. Flora learned weaving when she was twelve years old and has been part of the weaving group for six years. She weaves cocktail napkins as she talks with us, and the remarkable striped pattern she is creating mirrors the stripes of her traditional *huipil*.

Francisca, thirty-eight, has direct, clear eyes that seem to attend to the world consciously with both energy and calm. She has long led her community's weaving group and is a spiritual healer sought by people from all over Guatemala as well as Spain and Mexico.

"I have returned to the Mayan religion. My family is both Mayan and Catholic, so they understand—we have never lost our Mayan beliefs. My grandfather had the destiny of being a Mayan healer. People who are born on my birthday in the Mayan *Imosh* (calendar) are to be healers. My fourth son—my son Albertin, who is fourteen—was also born on this day.

"My work is to tell people where they are in their life and work, to help them find the right direction. Everyone is born with a destiny—but some people have spiritual problems. They do things counter to their fate and nothing works out right for them. I feel my future is with the Mayan religion. I have dedicated myself to healing. To tell the truth, I do not weave anymore."

This is news. Vey's surprise includes worry for the leaderless weavers, joy at her friend's decision, and fascination with Francisca's path. Francisca offers Vey reassurance about business. Although she will no longer weave herself, she says her daughters, Maria and Soila, will continue, and she will lead the weavers as she always has.

When Francisca continues, she explains, "I am called *ajqij*, which means priestess. We have no written books. I use incense and candles in ceremonies and call on all the nature spirits: rain, sky, and wind."

Does she feel a special affinity to Ixchel, the Mayan goddess of weaving? The question brings her to a stop. She seems uncomfortable and refuses to answer. "This is very sacred. I cannot talk about it."

But she adds, "When we are ready to deliver our work, we all go out and buy incense to make a ceremony so that our weaving will sell." Vey had told us that this group's weaving fly out the door the minute they bring them into Colibri—they sell like hotcakes.

Why is weaving so important here, we ask. Francisca gives a thoughtful answer that reaches beyond facts. She does not mention that land here has been subdivided for so many generations that one plot is not large enough to feed a family, or that two percent of the population owns eighty percent of the land. What she says is, "Weaving is important because there is a sense of friendship and unity among the group."

"There is an economic component…" Vey suggests.

"Yes, but really, the important thing is the sense of togetherness we have from working."

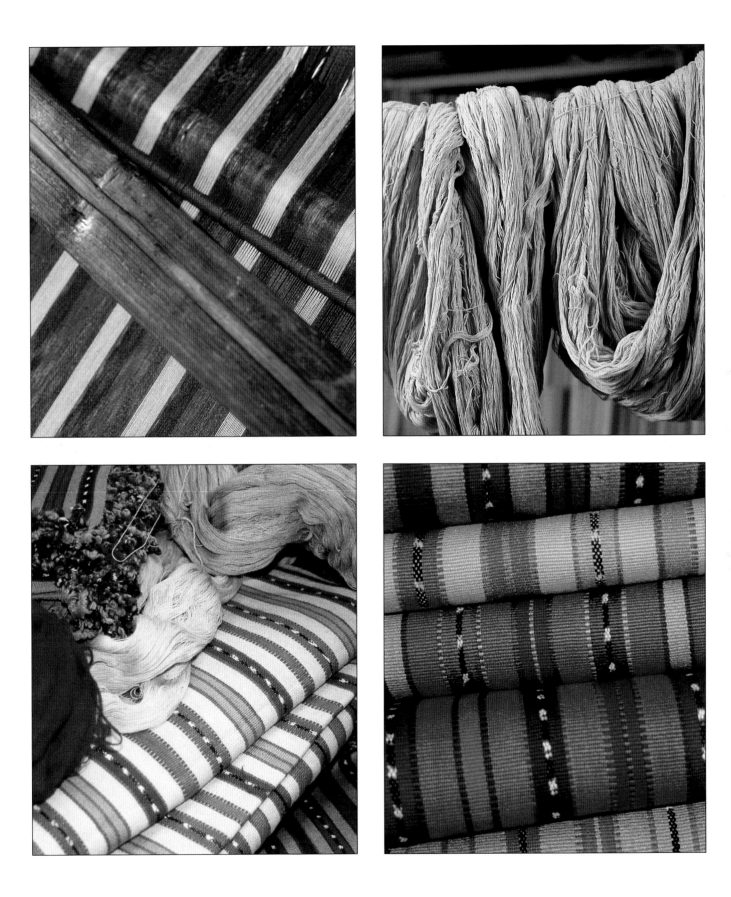

Above: The weavers whose work is sold at Colibri adapt traditional patterns to tablecloths, napkins, place mats, runners, and hand towels. Colibri provides them with skeins of color-fast yarn in subtle hues that will appeal to contemporary consumers—but the women weave with backstrap looms and shuttles like the ones their mothers and grandmothers used.

What a delicious existence! To wake up in our big, comfortable beds to the busy music of a thousand birds accompanied by the gentle splashing of our courtyard fountains—while "our staff" is busy laying the patio table and preparing the world's sweetest orange juice and the world's freshest eggs with yolks the same shade as the juice. Bliss!

This is borrowed bliss. This elegant colonial-style house in Antigua was loaned to us by a generous woman who's lucky enough to have two. She advised that staying in Antigua would position us conveniently for daily forays into the mountain villages where we might not find anyplace to stay.

But what a shock when, still lying here thinking about getting up, we look back over the previous day and are confronted with the contrast between our days and nights. We have been spending our days in the dust and the grit of lives that are light years removed from this serene environment.

Living in comfort in the face of others' poverty can be a guilt-maker. But it is a great satisfaction to have met some women in Guatemala who have found ways to use their advantages to make a difference. Vey Smithers is an inspiration, bouncing over the impossible mountain roads to deliver materials, payment, and encouragement to a little army of weaving war widows—while operating a most sophisticated boutique business where the weaving meets its market. And the women volunteers of the Ixchel Museum in Guatemala City are dedicated to preserving and promoting something beautiful of Mayan culture, while affording a livelihood to a hardworking contingent of Mayan mothers and grandmothers.

What amazing women we've found around the world… the talented craftswomen who take family welfare into their own hands, and the caring women who support their efforts.

. Antigua, Guatemala

This page: Chuinimachicaj's wattle-and-daub houses are built with sticks, mud, and corrugated metal.

Following pages: Throughout the Guatemalan highlands weavers use warping boards to prepare the vertical threads for their looms.

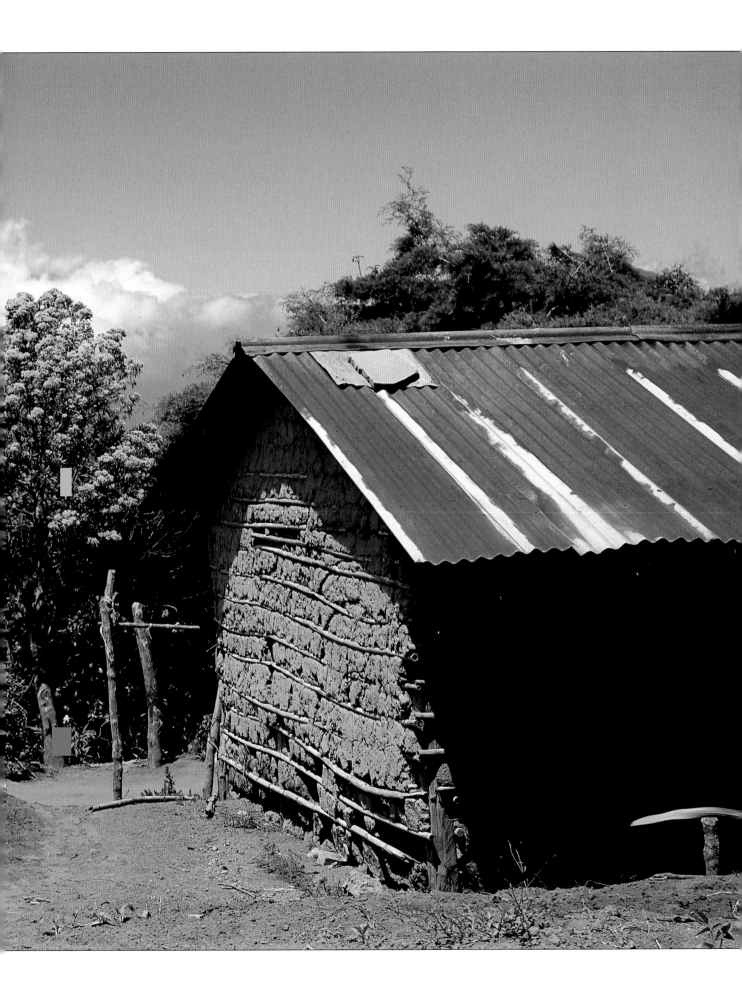

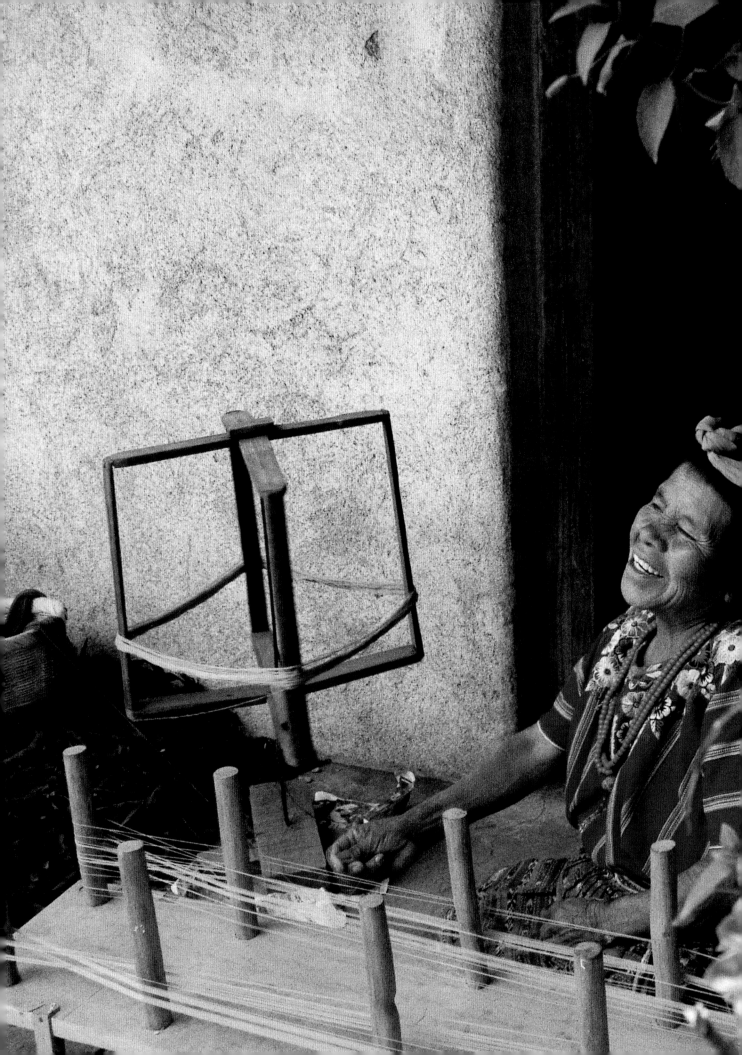

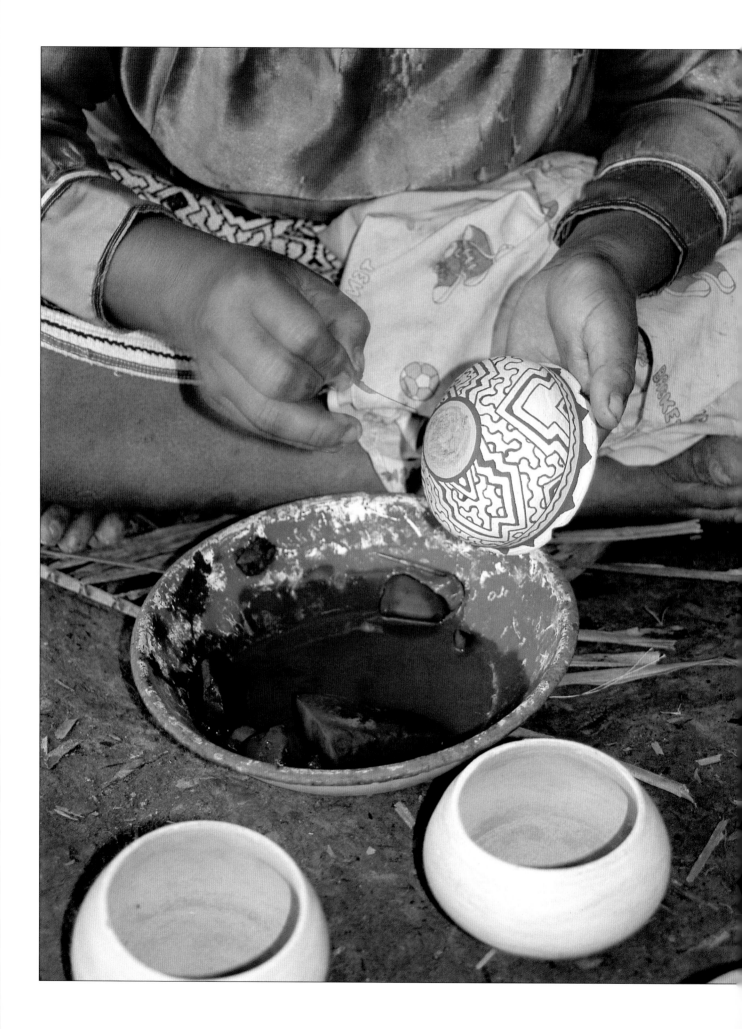

THE SETTING SUN HAS TURNED the jungle harbor an apricot hue, illuminating the water and washing the sky with a breathtaking, otherworldly orange. Fishermen, running late, collect their nets. Children take running jumps off the ubiquitous skinny, long boats tied up to the floating dock.

We are trying to arrange for just such a boat to take us to San Francisco, a village on Lake Yarinacocha in the Amazon River basin a few miles north of Pucallpa, Peru. "Five hundred dollars will get you to San Francisco!" offers an entrepreneurial boatman. "San Francisco what, California?" We laugh and keep walking. The man who gets our business takes us the next morning for fifteen dollars.

Ten violent years of terrorist activity by leftist Shining Path guerillas have kept tourists away. Although this area is peaceful now, the famous Shipibo women potters have had too few customers for a long time. The Maroti Shobo cooperative store in Puerto Callao, once haunted by savvy collectors, is dusty and almost empty. Clusters of Shipibo women hawk their pots on the city streets of Pucallpa—pots like those in museums all over the world.

Our boat trip takes us past banana and papaya plantations, past lacy, pink flowering trees that stretch high above the jungle roof, past huts that hug the shore. Olga Mori and Celia Yui, Shipibo women who work for the Organización de Mujeres Indígenas de la Amazonia Peruana (OMIAP), are our guides and interpreters.

Like all Shipibo women, Olga and Celia each wear a jewel-toned satin blouse, a thick belt made out of many strands of white beads, and a sarong-style skirt embroidered with the linear geometric patterns that compose all Shipibo designs. This is what they always wear. OMIAP members have a soccer league, and they wear this fancy garb even when they compete!

Olga and Celia tell us that OMIAP, which is governed by a board of seven indigenous women, was founded in 1993. It has organized ninety-six Mothers Clubs with a total of four hundred members in seven Shipibo communities. A United Nations grant from Denmark in 1997 helped OMIAP market Shipibo crafts. The organization also delivers medicines to the villages and trains members to raise chickens for food and income. On Sundays, OMIAP maintains regular communications with the villages via a public-access radio network.

Our long boat veers toward a muddy shore, and we traverse a low marsh, then start uphill toward the huts of San Francisco, where about twelve hundred Shipibo live. Ahead, we hear conch-shell trumpets announcing our arrival to the residents. An official welcoming committee

meets us at the crest of the hill: the mayor, his administrative assistant, and the town secretary. The mayor leads us to the Women's Pavilion, yelling through a bullhorn: "Come! Bring your things! They are here!" Women join us carrying tables, benches, chairs, and half-finished clay pots wrapped in muslin.

Collecting companions as we go, we parade past the thatch-roofed platform houses that line the wide, dusty path—a path that is lit at night with anomalous high arc lights like those used in cities. We pass a shaded communal well where children are drawing water in buckets, splashing it on each other. Fences are festooned with drying laundry: the mothers' bright blouses and embroidered wrap skirts, the children's Western-style play clothes and school uniforms.

The men, who wear jeans and T-shirts, wield machetes, slashing the high weeds around the single-story brick elementary school so snakes have nowhere to hide. We hear students inside chanting in Shipibo, perhaps memorizing multiplication tables. The Women's Pavilion is next door to the school, and several men are rethatching it, seeming to defy gravity as they balance on beams high above our heads.

About forty craftswomen convene. Some build a fire, carry in water, and start it boiling in large vats that will hold chicken-foot-and-fish-head soup. Several women have black hands, stained from dying their hair the night before in anticipation of our arrival. Shipibo women consider glossy black hair to be beautiful, and wanted to disguise the brown, brittle hair that results from inadequate nutrition.

These women, who are known for their pottery, make many other crafts as well, and although they usually work at home, today they will demonstrate all the Shipibo women's arts for us at the pavilion. They unpack their bundles and get to work.

Some women and their young daughters spin cotton thread for beadwork. Others string necklaces, combining beads, seeds, piranha jaws, fish fins, and crocodile teeth. Many beaders work with their infants asleep in their laps. Other women demonstrate textile arts, weaving on back-strap looms that are lashed to the pavilion pillars. Still others are embroidering or painting cotton fabric with clay slip, the runny neutral-color paint that is made of mud from Lake Yarinacocha.

And many women are creating the pots we came to see. Mothers teach their daughters to make pottery according to a method used for many generations: knead lake mud

Previous pages: Shipibo women's pottery is in fine museums everywhere, but tourist demand stopped when Shining Path was active in this part of Peru's Amazon basin.

Opposite: Craftswomen paint intricate geometric lines on their pots using fine brushes made, traditionally, of their own hair.

55

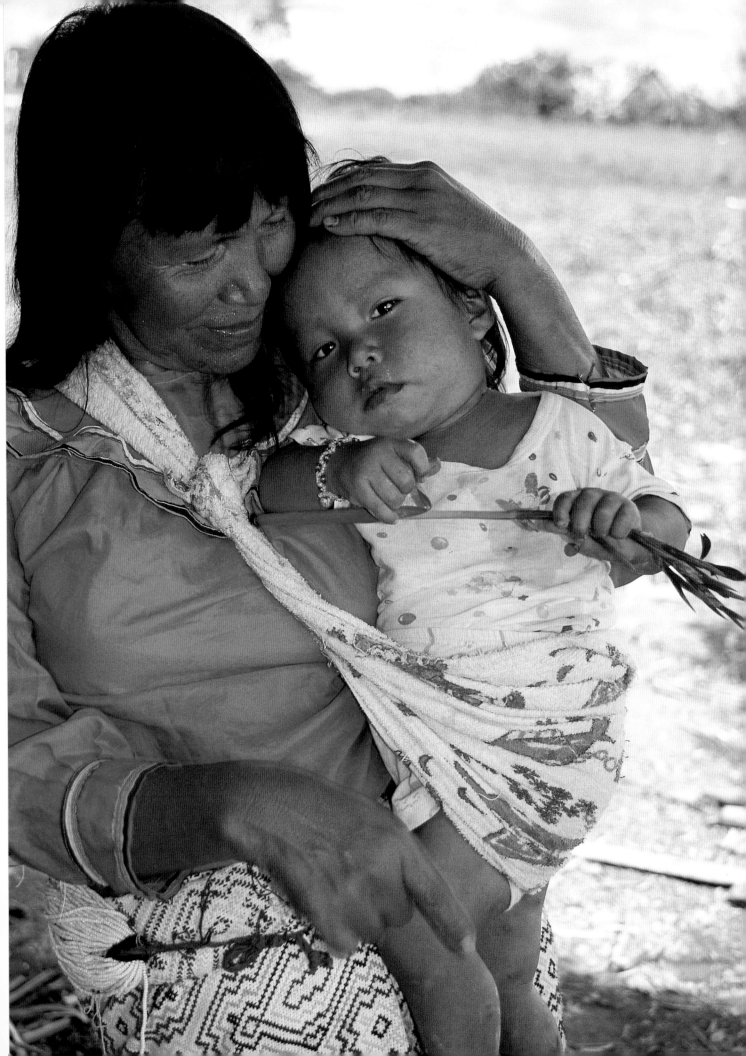

men exhale smoke in lines to demonstrate the patterns of health?"

"My smoke makes the same linear patterns in the air that the women paint and embroider. Each medicine man has a pattern, just as each woman does. We are the keepers of the visions."

"Then why don't men render the designs on pottery?" we challenge suspiciously.

"Men leave the painting to women because they don't want to take away their inspiration," Mateo says.

We are not sure whether he is patronizing or honoring women, so we ask him. "Men respect the women," he responds, "the women care for the medicinal plants and the children. You have to respect that. Everything else depends on that."

KEYLA ROJAS LIVES in Yarinacocha now, but her family was originally from Paullung, twelve hours north of Pucallpa; they came to the city so her mother could be treated for tuberculosis. Keyla is an expert on Shipibo design. Her first job was as head of quality control at the Shipibo cooperative store, Maroti Shobo. Now she sells handicrafts made by her mother, aunt, and two sisters, Nilda and Loriana. "I love to tell the story of how Shipibo art is made, and I love to talk with people. Not many women like to sell as much as I do."

Perhaps Keyla will reassure us after all that the traditions of the Shipibo linear designs have not been lost to the women. We ask Keyla if the designs have spiritual meaning.

"No. They are art."

"We read that Shipibo women don't make the designs when they are menstruating."

"Not true."

"A book said people here believed that there was such power in the Shipibo geometric designs that they used to hang their patterned clothes from the rafters to scare off burglars."

Keyla bursts out laughing. "No!"

We give up and ask, "What should a smart buyer look for?"

She comments, "Painted fabric should have no blotches. In embroidery, the smaller the design and stitches, the better. Lines should be straight, not drunk lines. The lines should be more or less the same length. And beautiful colors in the embroidery."

We are curious about Keyla's life. She is full of energy, charm, and laughter as she tells the story of her wedding. "Mother ordered me to marry my husband. I was not in love with him. I was fourteen, and I didn't know the boy. They woke me up and said, 'Now you have to marry this guy.'" (I ask Loyda, her mother, why this marriage seemed like such a good idea. She says simply, "He was a good man and a good worker.")

"Keyla, did you know what to expect from marriage; did you know about sex?" "No and no."

"We read that a Shipibo marriage ceremony occurs when the bride's mother gets the groom's mosquito net and takes it to her house. Did your mother do that?"

"Yes."

"Then what?"

"I got used to him," Keyla smiles.

When Keyla shows us her house, we notice red lace bikini panties hanging on a hook. She grabs them and stuffs them in her pocket, giggling.

Eleven family members live together here; there were a dozen until a month ago, when Keyla's three-year-old granddaughter got a cold and did not respond to medication.

The fifteen-year-old thatch-roofed kitchen is all that remains of the original house that Keyla and her husband bought ten years ago for four dollars. Last spring, Keyla took a loan and added five small bedrooms built of brick and cement block with corrugated metal roofs. All the land surrounding the house is hers, she says, including the mango tree and the privy with the burlap curtain in the backyard.

We talk about gender roles in a matriarchy. If Keyla's husband earns money, he gives it to her to manage. Asked if there is much physical abuse of women, she replies, "Yes. Men abuse women. Women abuse each other. And women abuse men, too."

"Are men and women equal in the Shipibo culture?"

"Yes. In the cities and the villages, equal in abilities as well as contributions."

Her sons, Orlando, Luis, and Franclin, agree; her mother, aunt, two sisters, and four nieces agree. It must be so.

THE DAY WE ARE TO LEAVE the Amazon basin, it is pouring and our plane is delayed. Itinerant vendors try to seduce us into buying dried piranhas as last-minute souvenirs.

Suddenly, Rosa Cumapa materializes. She has traveled from San Francisco by boat despite the rainstorm to ask if we know how she can get financial aid to cover a dollar and a half per day per child for college room, board, and books. Rosa's priority, her children's schooling, is of far more consequence than even the torrential rain.

Opposite: Older children attend school next door to the Women's Pavilion, but infants and toddlers accompany their mothers while their fathers fish, build huts, and clear the fields.

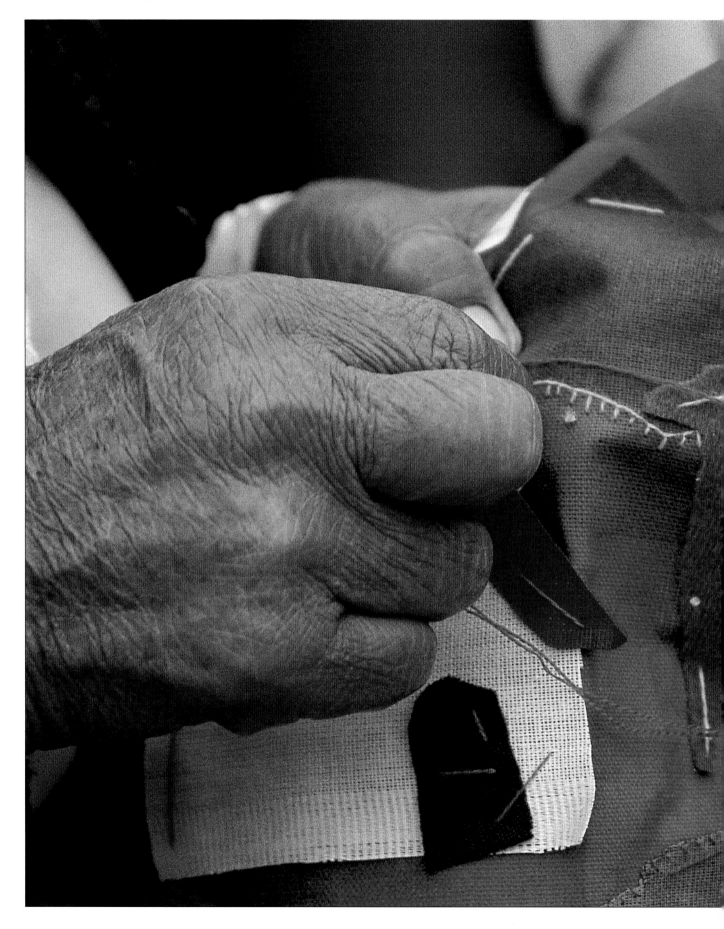

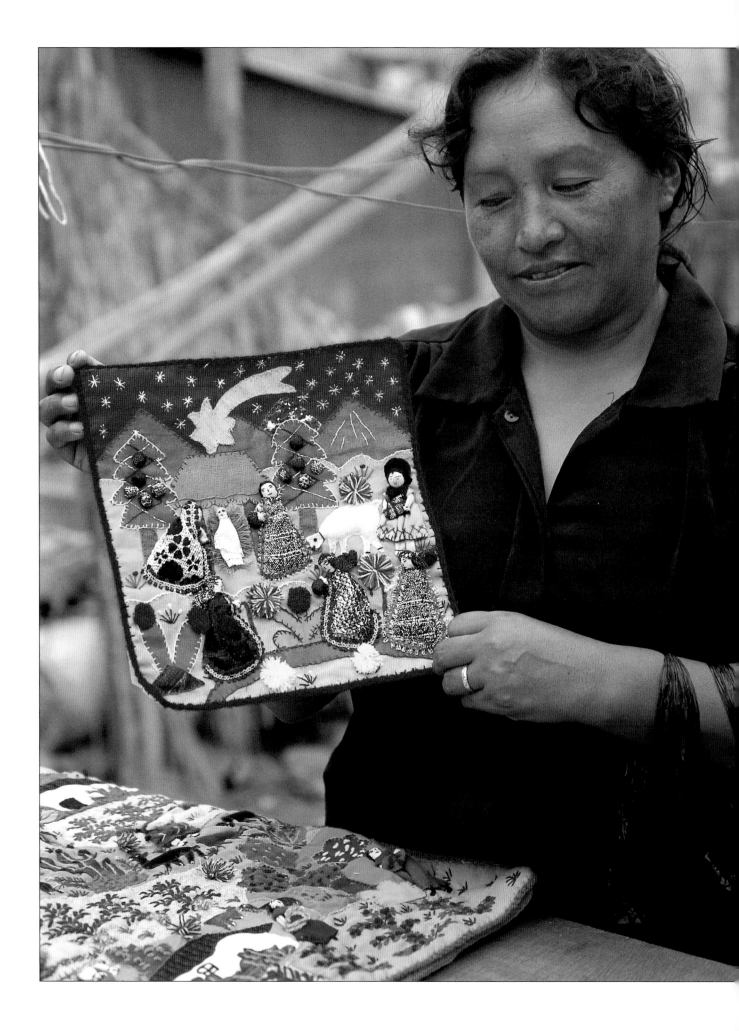

A SET OF SIX new cooking pans is stacked on the top of the refrigerator in Angela's bedroom, still wrapped in crackling-new brown paper from the store. She is paying for them on an installment plan, and will inaugurate them when a new gas stove replaces her counter-top burners. Nowhere in our travels did we meet another woman artisan who had the resources to buy anything to use later.

Angela's home is in Pamplona, one of the shantytown communities that ring Peru's capital, Lima, and house half the city's population. There, shacks like Angela's spring up from salvaged parts: old doors, used windows, panels of matting, corrugated metal, and crating. Roofs are not the first priority: it never rains in Lima. Thanks to Peruvian president Alberto Fujimori's connections, Japanese tanker trucks deliver water to the shantytown; otherwise water is unavailable.

About a million people live in Pamplona and Villa El Salvador, sections of the "Belt of Poverty." Ultimately, the squatters are given title to the land they occupy, which helps them obtain bank credit. Pueblo Jovenes, south of the city, was settled in the 1960s and demonstrates the determination with which the poor prevail: those residents now own their land; their houses have adobe walls and some, even second stories.

Crowded, dusty, indigent neighborhoods surround metropolitan areas in places as distant as Istanbul and Ahmadabad. Rural refugees flood to the cities in hope of finding jobs. The cities' infrastructures cannot support them: jobs, housing, and plumbing are inadequate. But in many cities, the shantytowns become hotbeds of artisanal activity as the struggling newcomers rely on known skills to survive.

THE WOMAN WHO IS SAVING her pots is Angela Pareona Riviera, thirty-one, president and founder of a Mothers Club that was originally funded by the government. Despite the noisy urban setting of her house in Pamplona, she and her group sew *arpilleras*, three-dimensional scenes of pastoral Peruvian country life. In a week, the sixty industrious members could easily decorate six hundred sweaters with *arpilleras*, but they can only sell two hundred in the domestic and export markets.

Angela, like many other women who live in the Pamplona and Villa El Salvador area, learned to make *arpilleras* "from a perfectionist," a Chilean woman named Rosbita who taught sewing at the German-run Humboldt School. In fact, *arpilleras* originated in Chile, where women political prisoners who were held during the Pinochet period used them to camouflage notes sent to helpers and collaborators outside. Even the most suspicious guards did not think to check the appliquéd pictures for messages, since sewing was seen as inconsequential "women's work."

Today's Peruvian *arpilleras* also carry messages in little fabric pockets, but the notes describe the scenes portrayed in the pictures. It was Rosbita's idea that the shantytown women should create fabric pictures of the village life their families had left behind.

When Angela's mother, Anna, was seven, she, her parents, and nine brothers and sisters left a village in central Peru hoping to relocate near schools and clinics in Lima. Angela, one of Anna's six daughters, is among the second generation of family members to live in the city. "The older generation here speaks either Aymara or Quechua (the pre-Inca and Inca languages), depending on where they are from," Angela tells us.

Today, Anna baby-sits Angela's three children while Angela supervises sewing in the workroom near the front of her house. She gives the women who belong to her Mothers Club sewing materials, acrylic or cotton cardigans to decorate, and sample sweaters on which she has basted figures. Because she knows that the export market has been saturated with *chompas* (sweaters), she changes the patterns and colors annually to rekindle demand.

Angela's education, Spanish fluency, energy, and savvy make her a natural leader. She is also a natural at business. Angela married her husband when she was sixteen, but for two years before that she managed the money he earned. She was honored that he trusted her; she learned to budget. He made enough money as a mechanic that she, whose family was very poor, believed that after the wedding the two of them would live in a big house. "I had lots of hopes and illusions; I was in love, and very emotional," she admits. But faced with reality, she became very practical.

Grimacing, Angela's five-year-old namesake stands in the courtyard, scrubs her face with soap, rinses with splashes of cold water from a hose, and rubs with a rough towel. The little girl squirms into her uniform, a dress of pale yellow cotton with a white collar. Threads dangle from one frayed cuff, but her uniform is starched and ironed. She is clean and ready for school, which she attends from noon to five. Her mother has always managed to provide the hundred dollars required each fall to buy school uniforms and shoes for two daughters.

Like working mothers everywhere, Angela pieces her life together like a puzzle. She gets up at six, fetches water, cleans the house, goes to the bakery a half-block away to buy bread, wakes the children, and fixes eggs for breakfast

Previous pages: *Arpilleras* are three-dimensional fabric collages. Whether wall hangings, sweaters, pot holders, or cards, each typically shows life in the Peruvian countryside that is known for llamas and mountains.

Opposite: *Arpillera* makers in the "Belt of Poverty" that surrounds Peru's capital, Lima, create imaginative holiday nativity scenes that sometimes include Christmas trees and Peruvian mountains.

Above: *Arpillera* makers in groups run by Central Interregional de Artesanos del Peru meet weekly in homes to work and study sewing, as well as reading and writing, so they can sign their own contracts. The various materials used to build walls indicate a homeowner's economic progress.

Learning is important to these women, who ask to be photographed in the room where they have sewing tutorials on Mondays. Juliana, who is the coordinator for all four of the groups, is also teaching them to read and write so they can eventually sign their own contracts.

Although her husband finished secondary school, Juana only finished the third grade and wishes she could read and write correctly. She hopes education will help her kids avoid the kind of life she has had. We observe that she has adjusted from farm to city life and learned to make products, money, and friends, which seem to us impressive accomplishments. That may be true; but counting accomplishments does not make life better.

Before we leave, a woman takes us aside and says, "Please. You must take me home with you so I won't have to live in this horrible place."

THE AVECITAS (Little Birds), the second group of displaced women we visit, is different from the first in every way. The president, fifty-year-old Victoria Gonzalez, lives in a brick house with flowers growing along a paved walk from the street. There are five or six books in a wall niche in the cool main room where five women have gathered to sew. Each has come from a different village with its own customs and culture, but the women are close. Three have been friends for thirty-one years. All their husbands work, though inconsistently, as a mason, a steel salesman, a civil servant, a radio technician, and a car painter.

These women are known to be the best *arpillera* makers of the four CIAP groups. They are experienced and comparatively educated. Their stitchery is fine; their *arpilleras* are complex compositions that use perspective, subtle colors, and sophisticated design ideas such as three-dimensional river grasses whose reflections are embroidered on the water's surface. But good design and workmanship do not improve revenue. Each woman will net only about a dollar and a half a day if she can sell a wall hanging to a wholesaler for fifteen dollars. We are taken aback at this information; the usual retail price in the United States for an *arpillera* wall hanging is sixty dollars.

Graciela Magan is not as worried about net profit as about the fact that the women's income is inconsistent. "We get one order now, another one in a couple of months." CIAP's goal is to get enough orders to sustain the women full-time so they can survive on their revenue if necessary.

One reason the women's cash flow is uneven is that the *arpillera* market is reaching saturation, so CIAP has initiated a new product development contest. The Avecitas are already planning to meet the first Monday in May to begin samples of their ideas. They hope to win the one-hundred-dollar prize that will be awarded in July. We are privileged to preview some of their entries: *arpillera*-decorated pot holders and note cards.

THESE WOMEN ARE NOT WELL-OFF, but they have the luxury of thinking of more than survival. For example, they know that their *arpilleras* are a historical record. Victoria shows us wall hangings they made twenty years ago, which are rougher, more political, and stylistically livelier, with naive, brighter colors. "This shows the men rioting. We were already here in Lima, remembering the political situation in our villages before we left," she explains.

Rita Serapión has gone back to high school herself, now that her daughters are through their professional schools (one is a nurse, the other an elementary school teacher), and she will graduate this year. Originally from Iquitos in the Amazon jungle, Rita recently helped document the lives of the Lima women who sew *arpilleras* in the book *Creative Women of Pamplona*, which, like the *arpilleras* themselves, chronicles the craftswomen's lives. Rita is one of the few craftswomen who speaks analytically, abstractly, and articulately about her relationship to her art. "The more we work, the more creativity we find in ourselves," she muses. "In the beginning, I never thought the *arpilleras* would help me in my life. But this is an art that has no ending. We are always trying to renew our ideas. We are very proud that our pieces are appreciated and sold. The fact that they are exported is a big compensation: it animates us. We all have a little art in our minds and in our hands; we will leave something as a legacy for society. It will stay behind us, in another place, in another time."

Opposite: When this woman's *arpillera* group began in 1989, its members—displaced women who fled Shining Path violence in Ayacucho—were illiterate, spoke only Quechua, and had been traumatized by losing family members.

Above, clockwise from top left: Juana Huaytalla, president of an *arpillera* group, arrived in Lima with no work, skills, friends, money, or place to live. • Angela Pareona Riviera's daughter attends afternoon classes (students go to school in three separate shifts). • Angela dreams of a "real" kitchen; houses in her neighborhood don't have roofs, much less real kitchens. • Angela's niece (shown here) walks to school with her daughter while Angela, president of an *arpillera* group that decorates *chompas* (sweaters), works with the other women.

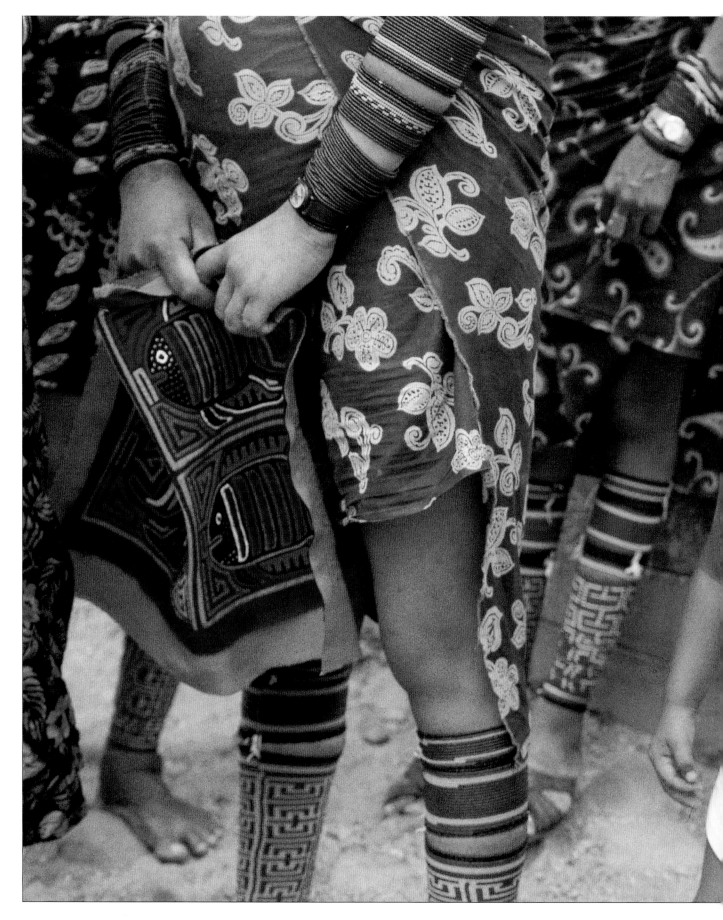

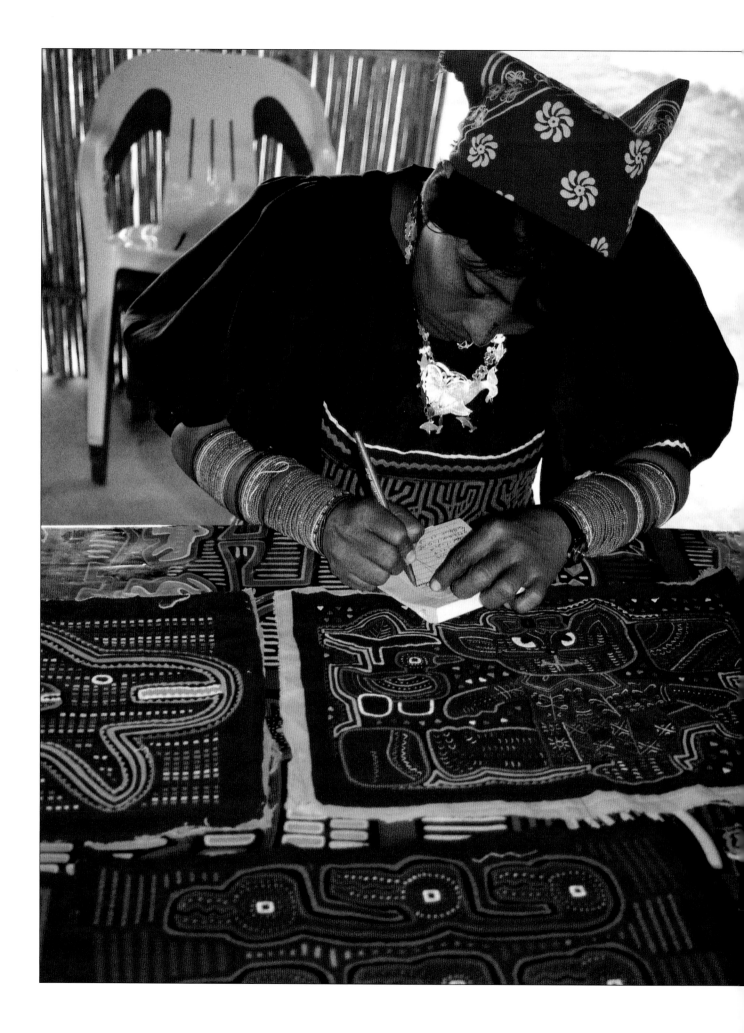

OUR SIX-SEATER PLANE heads east from urban Panama City at four in the morning and clears the Darién jungle by dawn. We reflect on a potpourri of facts we have read about the Kuna Indians. They believe they are "Golden People" who come from the Great Mother. They are egalitarian, interested in beauty, balance, and using nature's gifts well. Columbus reported seeing them in 1502. They are supposed to be the shortest people on earth after the pygmies.

Among the few indigenous American ethnic groups who have never been conquered, they maintain an autonomous, traditional way of life on their ancestral lands, which, until twenty years ago, visitors were not allowed to enter and Kuna women were forbidden to leave. In the Kuna cosmos, everything in the world—natural, cultural, or spiritual—is allocated by gender. Virtually every Kuna woman sews *molas* and talented *mola* makers win great prestige for their families and communities. *Molas*—intricate layered and appliquéd pictures of Kuna Indian material culture, rituals, and social and political life—are sewn with skill, charm, and wit, then used as blouse panels, part of these women's gaily-colored outfits, which are unique on earth.

As we fly over the Caribbean San Blas archipelago, each island is a haven of palm trees in a sea turned peach by the rising sun. Abruptly, the plane lands on an old airstrip built on the mainland by the United States military. We trundle our bags and photographic equipment a hundred feet to the water's edge where a boatman with a rough deep mahogany canoe waits to take us to Uagitupo, Dolphin Island.

THE NEXT DAY, we are put on trial on nearby Aligandi Island to determine whether we deserve permission to interview and photograph *mola* makers. The *congreso*, a sixty-by-forty-foot thatch-roofed hut, is the center of village affairs. There, citizens participate in all-day meetings for as long as they have time and interest. Benches form a theater-in-the-round, encircling the *sahilas* (deputy chiefs), who recline in suspended hammocks while governing. Usually these men smoke cigarettes during debates and wear trilby hats with dented crowns, the insignia of their office.

The rhythmic monologues that *sahilas* deliver during meetings are the men's art—just as *molas* are women's. We are not appropriately appreciative of the men's oratory, however; we are daunted by the fact that they are not inclined to grant us permission to do our work.

The *sahilas* are tired, they say, of foreigners who write books without crediting their Kuna informants, and who publish inaccurate information about Kuna culture. "Many people write lies. We are an independent people who govern our own territory. We are educated, and have doctors, lawyers, and people who have gone to Europe to study; Kunas place a premium on education and often travel elsewhere to obtain it. When their schooling is complete, they always return to their original island. Our history is profound. Information should come from our *sahilas*, not from superficial, lay sources."

To no apparent avail we explain through our interpreter that we are as interested in truth as the Kuna are. After about an hour, it looks as if we will be banished from the territory without seeing, interviewing, or photographing even one *mola* maker. Then, without transition or explanation, the senior *sahila*, Julio Benitez Coleman, smiles: "You have listened to us long enough." He then escorts us personally around Aligandi Island, leading us through labyrinthine footpaths between the thatched huts.

OUR FIRST STOP is a free public school that is part of the National Culture Institute. A new term is just beginning and students have come to learn indigenous crafts such as pottery, hammock making, basket weaving, and of course, *mola* making.

Tirsia Fernandez, forty-nine, teaches young girls to sew *molas* the way she herself learned when she was eight. Ten little girls are working diligently on their first *molas*, which may take a month to complete. Their mothers use reverse appliqué techniques, stacking colored fabric, then cutting slashes in the top layer to outline the pattern and pulling the lower colors to the top; they add even more colors on top using traditional appliqué techniques. But the little girls are starting with just two layers of fabric. They have cut the pattern in the top piece and are sewing with big stitches that will be ripped out and redone until they are correct.

While they concentrate, Tirsia is creating a sophisticated *mola*, which we ask her to describe. She explains that while Kuna men are responsible for public oratory, Kuna women are responsible for lamenting death. Her *mola* shows that tradition. "The parents are in the hammock with their dead baby. The woman standing by them is showing them how to grieve. It is Kuna tradition that women weep and recite the accomplishments of the deceased. But with a baby, we must teach each other how to mourn. The right way is to express your sadness by weeping, and narrate the baby's life to date, then talk about what the baby's accomplishments might have been if he had grown up."

We ask if many babies die on the San Blas Islands. "Many babies used to die, but not now. Now nutrition is better and we have a good hospital."

Previous pages: Kuna Indian women's outfits are unique: beaded leg and arm cuffs, patterned sarong skirts, red print headscarves, and blouses with *mola* (appliquéd picture) panels, which are sometimes offered separately for sale.

Opposite: Yasmina Eloina De La Ossa Tejada, a savvy entrepreneur and talented craftswoman, sells *molas* that she and the other women in her family create.

IN THE AFTERNOON, we travel by canoe back past uninhabited white sand islets floating in teal water to Dolphin Island to talk with the beautiful Yasmina Eloina De La Ossa Tejada, thirty-one. Her love story reminds us of Romeo and Juliet. When Yasmina's family sent her to Nargana Island, one hour north, to attend the first two years of high school, she fell deeply in love with her teacher's son, Eric. Later, after Yasmina had finished two years of sewing school in Panama City, Yasmina and Eric were married. Since Kuna society is matrilocal—husbands move in with their wives' families—the couple returned to Yasmina's parents' home to start their lives together.

Not so fast, said fate. Yasmina's parents held traditional Kuna beliefs about what husbands should be like, and Eric didn't qualify by those standards. He was not from their island. He had neither land nor coconuts, the assets required to support a family. He was a policeman, not a farmer who could help Yasmina's father. To her parents, Eric was not an acceptable son-in-law.

Yet Yasmina and Eric adored each other and managed to live together for three years. They "never had an argument," and had two children, Eric and Erica, both named by their romantic mother.

Yasmina's parents became increasingly insistent that they separate. Her brother-in-law, Geronimo De La Ossa, reports, "Her father has the old mentality. He criticized Yasmina for marrying this man. Finally, her husband said, 'I love you, you are my wife, but I must leave.'" Eric is now a policeman in Panama City. The couple yearns for a way to be reunited. Although Eric contributes financially to his family, Yasmina is now the single mother of their two children, ages four and seven. She sews and sells *molas*, and works part time at the Dolphin Island Lodge, which is run by Geronimo. The resort is one of very few places visitors can stay in the 138-mile-long, 378-island chain. Yasmina is the resort's hostess, and does everything from serving meals to guiding guests around the islands she knows so well.

After lunch one day, Yasmina spreads out *molas* to tempt guests to buy the work that she and the other women in her family have created. The patterns are based on daily life and show fish, boats, and lobsters; recent history, including the 1969 aqueduct opening and political campaigns; and aspects of popular culture including Ninja Turtles and package label designs. *Molas* that retail in the United States for sixty dollars are offered here for fifteen to thirty-five dollars, good prices for both buyer and seller.

Kuna women manage family money whether they earn it or not, Yasmina tells us. "The men sell coconuts, then buy cigarettes and whatever they need and give the rest of their money to their wives. In old times, the women used to put coins in a box around their neck. When they went dancing, the coins jangled."

As we talk about business with Yasmina, it becomes apparent that she is unusual among the women we have interviewed: a savvy entrepreneur whose expertise, enterprising nature, and focus have made her a financial success in her community.

When she was a nineteen-year-old sewing student in Panama City, Yasmina launched her first venture. "I had never seen *molas* on skirts; I made that idea up out of my own head. They were the first things I ever sold. I charged ten dollars for a black skirt with a round, colorful *mola* that took a week to make. My friends' mothers bought them."

Now that she is an adult, her financial skills have matured. "If I sell two or three *mola* blouses, my income is ninety dollars a month," she says. She tells us that she invests what she earns in jewelry, which she can easily pawn when she needs funds. Today, Yasmina wears a beautiful necklace with dangling gold dolphins.

But jewelry is not all she owns. "I bought my grandmother's land," Yasmina tells us, "because I didn't want more arguments in our family. My father had renounced the property, and because I have five sisters and two brothers, there could easily have been fights about inheritance. Since I wanted the land, I offered my grandmother a hundred and fifty dollars and she accepted. Later, I arranged to buy ten of my grandfather's coconut trees for five dollars each. They are valuable. The traders who come here from Cartagena, Colombia, pay twelve cents for one coconut. Local people pay twenty-five cents for half a coconut leaf, and they need hundreds of leaves to make a roof that lasts fifteen years. When you buy coconut trees, you get the land under them automatically. I built a house and lived on that land for three years."

Over time, Yasmina invested four hundred dollars in five plots of land that have now been appraised at ten to fifteen thousand dollars. No other woman on the island has come close to owning such a large amount of property. "The others don't save, " Yasmina observes. "They purchase *molas* to wear instead of sewing them. That's squandering money." Later, she shows us a fenced plot she has loaned to the elementary school this year so the eight- and nine-year-olds can learn science by growing tomatoes, oranges, and lemons as if they had a little farm.

Yasmina sells the same *molas* she makes and wears on her own blouses, so there is a qualitative difference between her sophisticated designs and fine workmanship

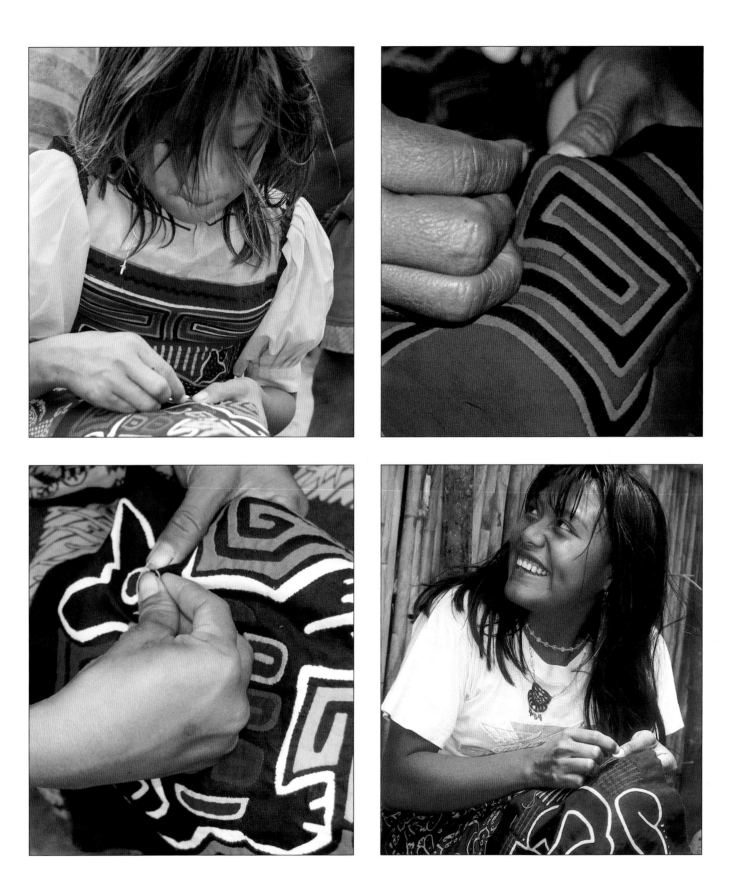

Above: Using reverse and regular appliqué techniques, *mola* makers stack colored cloth, slash the pattern through the layers, pull the lower colors to the top, then stitch additional pieces on the surface.

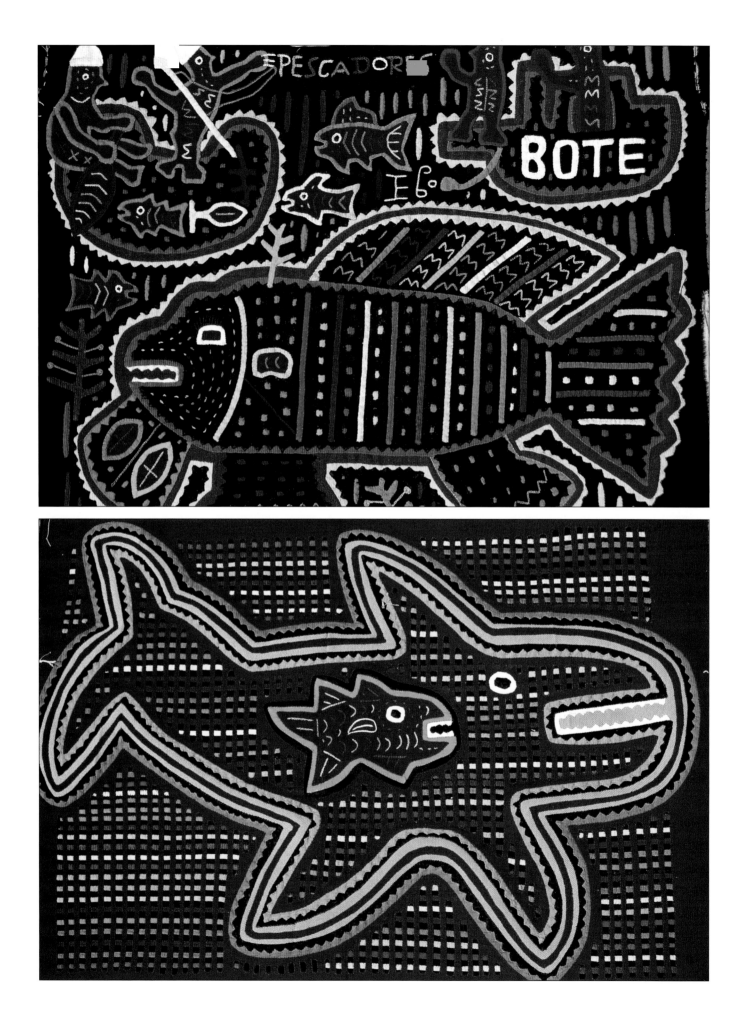

and those of the women who make *molas* expressly for sale to tourists. Most tourist *molas* have coarse (or worse, machine) stitching and artless motifs.

As we interview Yasmina, she sews with painstakingly small, even stitches, using many layers of colored fabric in her appliqué. We ask why we see no knots in her work. Without waiting for our English to be translated, Yasmina responds in Spanish, "We just cut the thread and fold it between the fabric layers." Noticing our surprise that she understood our question, she admits, "I understand a little English."

She understands many other things too, including strategy. When we play cards after dinner, she beats the socks off us.

ROSA MARTINEZ (Geronimo's half sister on his father's side) is recycling her *winis*, the beaded cuffs that Kuna women wear on their arms and legs and change every two months. She sits by a black caldron where lobster is cooking for dinner. Her familiar, a green macaw who follows her like a puppy, keeps her company.

Rosa uses rubbery tree sap to attach the old string to a new one, then slides the beads from one string to the other. "It takes an entire ball of string to cover two legs and two arms with beads," she says, but allows that "If women don't have enough time to put on their own *winis*, they pay four dollars to have someone else apply them."

YASMINA, too, is changing her *winis* today. We sit with her all afternoon while she wraps a long bead strand around and around one leg until a Greek key–like design appears and repeats from ankle to knee. It will take her eight more hours after dinner to restring and rewrap the bead patterns on her other leg and both arms.

While Yasmina restrings beads, we confirm whether the things we read about Kunas are right or if, as the *sahilas* implied, they are all lies. Did Yasmina have a haircutting ceremony? "Yes, when I was eight or nine. After that ceremony, Kuna girls never wear long hair again. We believe that the head-first trip down the birth canal makes an infant's hair unclean; if you don't have a haircutting ceremony for purification before you are grown, you cannot enter God's kingdom when you die. If their parents can afford it, all girls have this ceremony sometime after the age of two, but always before puberty. It used to be that everyone in a village attended. People contributed ten fish, firewood, plantains, everything that was required to feed the village for a ceremony that lasted three days and nights. But now some villages have fifteen hundred inhabitants, so community haircutting rituals are no longer affordable."

Yasmina is deftly wrapping the bead strand round and round her ankle. I tell her that we have read that *mola* makers sometimes soak leaves in water and put them on their eyes to help them visualize new designs.

"Yes. Sappi Karta is a sacred tree whose leaves are patterned with concentric circles by a fungal parasite. They look as if someone has drawn on them. The elders use the leaves as botanical medicine and put them on the eyes to provide inspiration for *molas*. The *puba* (soul) of the leaves helps women make beautiful *molas*. When children go to school, they sometimes receive that same medicine to help them gain knowledge. My son has had Sappi Karta, but since he just started school, we have not yet seen an effect."

THE NEXT MORNING, we go with Yasmina to see her children at home, across the channel on Achutupo, on Dog Island. A crowd of children flies toward Yasmina as soon as our canoe is made fast. She grabs her son and daughter in great hugs, and the other children on the welcoming committee spin ahead of us doing cartwheels and handstands in the sand.

Yasmina's one-room hut is part of her parent's compound, a cluster of relatives' huts and yards connected with bamboo fencing. Adjacency makes it easy for Yasmina's mother to take care of Eric and Erica while Yasmina works on the neighboring island.

Yasmina typically rises early to make meals, wash, and sew, then goes to the *congreso* in the afternoon—but today is unusual. This morning, women relatives drop in to participate in the Kuna equivalent of an Avon Party. To make a cosmetic paint, Yasmina crushes charcoal with a machete and mixes it with the juice of a nut she has picked from a tree. Each woman uses a fine stick to apply the dark liquid, making a filigree pattern that runs the full length of her nose. As soon as Yasmina finishes her own design, she paints her daughter's nose—and then both of ours. Unbeknownst to us, the black lines are semipermanent; five days later, customs officials will observe us with curiosity as we enter our country with Yasmina's designs spiraling down our noses.

BACK AT DOLPHIN ISLAND LODGE that afternoon, Yasmina's older sister, Mariela, shows us her newest *mola* designs while she tells us how she met her husband, Geronimo.

"It's different today. As you know, Yasmina followed her heart, but when it was my turn, our father looked for a husband who had a farm so he could support me. He negotiated and bargained. Geronimo's parents, seeing that my father was honest and had resources, accepted him.

Opposite: *Molas* show material culture, rituals, and political events. No two designs are identical, even when subjects are similar. Boats and fish, essential to daily life, appear often.

"At that time, I was thirteen and Geronimo was twenty-five. I was old enough to be married because I had had my puberty ceremony, but I protested that I was too young. It didn't help. My father wanted me to marry him. I was innocent; I didn't know what sex was. There was no sex education in school in those days, and it was completely forbidden—against God's law—to teach young girls about sex. My grandmother told me how to make love. My mother told me that Geronimo was an old man, and then I was even more afraid." With all those reservations, we wonder what her wedding was like.

"The ceremony is the same today. As soon as the families agree to the marriage, they pick ten men who, on the wedding day, grab the groom by the leg, the hair, whatever, and bring him to the girl's house. They put the groom in the hammock. One of the guys gets a stick of firewood and puts it under the hammock while another goes off to look for the girl, who is sitting next to the kitchen. The guy picks her up and puts her on top of the fiancé in the hammock. The ten men start swinging them and singing a song: 'She will always be in the kitchen cooking smoked fish and plantain and will always serve food for her husband.' The girl jumps out of the hammock. Then the ten men and the bride bathe themselves. The next night, the bride and her father bring the groom to the bride's house. The groom must prove himself to his new father-in-law by cutting one hundred pieces of firewood with an ax and catching enough fish for the whole family. If he can do this, there is a party for everyone who participated in the wedding. There is no honeymoon, but after that, the bride and groom get to spend time together alone."

Geronimo grins, "Now we've been married thirty-five years, have five children, and everyone realizes that I have been perfect." Mariela just smiles.

HERE, TRADITIONAL AND CONTEMPORARY LIFE make a piquant counterpoint. For hundreds of years, the Kuna have participated in world commerce. They are a sophisticated, cosmopolitan people who integrate foreign influences when it serves them, who combine old and new comfortably, yet who vigilantly protect their cultural heritage.

On Mamitupo Island one of the teachers uses a twelve-volt battery to jury-rig a television set so students can watch educational programming. The lonely, anomalous antenna reaches high over the soft roofs of the village.

On Aligandi Island the public library showcases a chess tournament prize. A modern hospital is well staffed and immaculate. Both buildings are near the *congreso* hut, where governing is done from hammocks.

On Achutupo Island Yasmina has mounted a basketball hoop on the bamboo fence that surrounds her hut so her son can practice. Old and new coexist in layers and patterns as complex as *molas*.

Opposite, top: Yasmina named Erica for Eric, her adored husband whom her parents rejected; he came from another island and was not a coconut farmer.

Opposite, bottom: One in eighty-five Kuna babies is albino, believed to be an angel with the power to prevent eclipses of the sun.

Uagitupo looks like all the other gem-like islands as we approach by motorized dugout: palm trees swaying in the breezes over clustered huts of thatch are heart-stoppingly beautiful. But Geronimo's Dolphin Island Lodge, his little tropical outdoor inn, is not just any Kuna village. Its huts sit on concrete pads, nice for keeping the sand out of one's belongings; there is a shower in our hut for refreshingly frigid bathing (no hot water); there are real flushing toilets; and beds. The Kunas sleep in hammocks. We too have hammocks on our porch, where we can sneak a delicious nap in the breeze before dinner.

The lodge is tiny, with just four guest huts, an open-sided dining hall facing the beach, and a cookhouse, where the resident blue macaw lingers on the step, panhandling snacks from the camp cook. Outside in the clean-swept central yard rise a half-dozen splendid palms, and between them are stretched more hammocks. They are woven stripes of vibrant colors, each one with a different dominant hue, stretched in bright diagonals from tree to tree.

We get to know our fellow guests during a leisurely postprandial chat around the long table, then wander out for further relaxation in those palm-grove hammocks to find that they have been rearranged into a different Hockney-esque abstract (the yellow one here and the red one there). When we get up in the morning, the composition is different yet again.

And then I catch him at it! It is that one young fellow who works here, the albino. It seems to be his job to take down all the hammocks whenever it looks like rain, then put them up again. And whether accidentally or by design, he does it differently each time, to stunning artistic effect.

An albino is very noticeable in an Indian community, and our notice of this boy has been almost painful. The sun is very, very hot and strong here, and he has no natural protection. During our stay, he ferries us from island to island, and never wears a hat, or sunglasses, or even a shirt! We yearn to leap up and smear sunblock all over him. He never touches the stuff, just accepts the fried shoulders and blistered lips.

We aren't the only ones concerned for him. One of the other Dolphin Island guests is a Frenchwoman, Dr. Pascale Jeambrun, a lovely person who is a doctor and specialist in albinism. She has been here before and has returned to continue her research on the subject, because in this unlikely little corner of the world, as in a few others—the Hopi and Zuni communities of the American Southwest, for instance—the incidence of albinism is extraordinary. One in every eighty-five Kuna babies is born albino.

This does not worry the Kunas. When a baby is born albino here, born into a brown-skinned world but glowingly white as if lit from within, the Kunas believe they have produced an angel, and they rejoice. Pascale calls those pale little babies "les enfants de la lune."

Albinos have special mythic powers and responsibilities here. For instance, when the terrible flying dog attacks the sun and attempts to take a bite out of it, producing what we would call an eclipse, only an albino has the power to shoot it down and thus save the sun. There is a favorite traditional mola design: an albino with bow and arrow taking careful aim at the mythical flying dog.

T. San Blas Islands, Panama

FOUR WOMEN WHO GREW UP HERE in Zalipie, a farming village on the Vistula River in southeastern Poland, begin to sing:

Zalipie flowers! I grew up among you;
You used to be my colored world
Upon the white wall with a low roof.
I often return to you in my memories....
To painted cottages upon the Vistula.
Like mother's love through childhood years.

We are in the office at the House of Painters. While Zofia, Stasia, Renata, and Wanda sing about childhood, Renata's four year old, Gregorz, rolls a leaf into the manual typewriter and pretends to write a letter. He has spent most of his young life playing in this building where his mother, aunt, and grandmother paint products to sell.

Zalipie's women painters cover their houses inside and out with floral designs. They paint flowers on stoves, coffeepots, plates, aprons, tablecloths, cabinets, windows, fences, chicken coops, barns, privies, tarpaulins, and doghouses. They paint wreaths on the ceiling, garlands on the beams, floral swags under holy pictures. They have even painted blossoms on the town fire truck.

Thanks to a grant from the regional government in Tarnów, the women artists opened the House of Painters in 1977. It is the cultural center of Zalipie, with painted bouquets crowding its glass doors, its windows, and its corridors. Its theater holds musical competitions, dance recitals, and puppet shows; there is a library full of books about Polish culture; and there are classrooms where children learn floral painting.

THE TRADITION OF FLORAL PAINTING began here in the 1800s when village women brightened the walls of their tworoom cottages. Originally, their brushes were birch sticks shredded at one end. They used lime to paint white dots on walls that were dark with soot because their ovens, used for cooking and heating, had no chimneys. Over time, the women began to use color to convert the white dots to daisies, peonies, cosmos, roses, lupines, and bachelor buttons like those in their fields and gardens.

By the twentieth century the advent of chimneys and whitewash provided the painters with a clean palette for their creativity. They had learned to bundle cow or horse hair to make finer brushes, and flowers remained their visual vocabulary. Grandmothers taught the floral art to daughters and granddaughters. Felicja Curylo, who died at seventy in 1974, popularized the Zalipie flower art. After her death, the Ethnographic Museum in Tarnów made her home a museum. Felicja's granddaughter, Wanda Racia, herself a painter, grew up across the street and is now the

museum curator. When visitors arrive, Wanda crosses the road, opens the gate, and unlocks the door.

Felicja Curylo's family, like all peasant cottage dwellers, designates one room for secular and the other for sacred activities. The latter room includes a little gallery of religious pictures: Jesus and Mary, plus saints such as Rosalie, who protects families from illness, and Florian, who protects homes from fire. The other room includes a profusion of painted flowers on walls, stairs, and ceilings; crocheted floral bedspreads and embroidered floral pillows; floral valences cut from paper; floral wallpapers; and flowerseed collages of the Polish national emblem, the eagle.

ALTHOUGH FLORAL PAINTING is also done in six neighboring villages, Zalipie's painting has become more innovative, individual, and nuanced because of juried springtime competitions that have encouraged experimentation and improvement for the past fifty years. Each winter the painters create new art to enter in the contest. They begin sketching in secret, eager to surprise their rivals and win one of the twenty category prizes. Although they compete enthusiastically, the painters respect and like each other. Of the eight hundred Zalipie residents, there are seventy painters—more than ever before. They are a close community of creative friends and relatives.

RECENTLY LIBERATED from communism, the village women are beginning to sell what they create at prices they set themselves, hoping to supplement their families' farming incomes. During the months between harvest and planting seasons, the women gather by the stove at the House of Painters to paint flowers on vases, garlic keepers, piggy banks, door chimes, and souvenirs.

We ask how life in Zalipie has been affected by capitalism and are told, "Not much has changed. Things are more expensive. There are a few more products in the store."

We visit the store and meet Jan, who painted houses in Chicago for four years, then returned to Zalipie and built a modern, two-story house with a market in its garage. His wife has painted a blossom border on the walls above the shelves of liquor, canned goods, and boxed foods. Jan wears a baseball cap left over from a Lipton Tea promotion to grocers. The slogan on his hat says, in English, "Cooking Up Profits," which seems at once admirably aggressive and hopelessly anomalous.

THE HOUSE OF PAINTERS tries to help the women artists profit, too. The organization buys raw materials—pigments, brushes, items the women can decorate—then buys all the work the artists produce. Artists each receive the same money for finished products of like size. This vestige of

Previous pages: One of seventy floral artists in Zalipie, Zofia Owca models the traditional festival costume she embroidered while she paints flowers by her front door.

Opposite: Maria Sierak's skill shows in her valences and curtains. Having won many painting competitions, she took first prize in the "new style" category at age seventy-five.

91

the communist compensation system assumes that everyone's work is equally valuable. Only privately do the painters confess that they know they are variously talented.

Wanda Chlastawa has managed the House of Painters for seventeen years. She studied culture and tourism for two years in college, and now organizes special events such as the September Harvest Festival, which will take place in a few weeks. She coordinates classes in dance, music, and art, purchases equipment and supplies, and markets the artists' products.

It is not as easy as one might think. There is a display showroom in the House of Painters where tourists could buy, "but only about five tourists come here on a good day," Wanda confides.

It is an understatement to say that Zalipie is not a tourist destination. It took us four hours to find our way from Tarnów, which is thirty miles away. Zalipie hides in a labyrinth of country roads and has no hotel, no restaurant, and, in fact, no commercial district. Fields and miles separate the painted cottages and there are no guides to help visitors find them.

Zalipie painters participated in the International Trade Fairs in Munich and Vienna in 1995 and 1996. They show their wares in the pre-Christmas exhibition in Pilzno. They also accept group commissions, as they have done for years; the women are very proud of the painted hall their mothers contributed to Cracow's Ethnographic Museum.

Those same women also painted the interior of the Catholic parish church in Zalipie, where each high arch is outlined with a braid of painted forget-me-nots. Felicja Curylo herself painted the flowers of the baptismal font, and talented women embroiderers in Felicja's group stitched flower designs for the priest's vestments.

Now, a shy nun invites us into the sacristy to see the holiday ecclesiastical attire. Glossy pink-and-white chrysanthemums form a stark cross on a field of black velvet. Crimson poinsettias duplicate the symbol on a field of kelly-green satin. A Madonna and Child are embroidered on midnight blue, surrounded by blossoms. The variety of embroidery patterns seems endless, each more lavish and beautiful than the one before.

ZOFIA OWCA, fifty-five, has been painting for thirty-four years and embroiders equally well. Her work is technically and artistically impressive. She had to work every day for a whole month to complete her traditional floral waistcoat. Although costumes like this are worn for festivals and special occasions, Zofia has just worn hers to tape

a Cracow television show during which she painted flowers on the studio wall to promote the crafts of Zalipie. We watch the tape in a neighboring village on the only VCR around.

On the show, Zofia wears her embroidered vest laced with ribbons, a painted apron, a floral-print challis skirt, and a ruffled white blouse. She looks as if she lives in 1850. She has been scheduled to appear on the television show as the representative of tradition, along with the Paper Bags, a shirtless, pony-tailed rock group that represents contemporary Polish culture. Every once in a while as she paints, Zofia glances surreptitiously and very skeptically over her shoulder at the gyrating youth. We can't help laughing out loud. Zofia and the Paper Bags personify the generation gap.

We meet Zofia in her kitchen to enjoy coffee and heart-shaped chocolate-dipped shortbread cookies. We are eager to see this room, which is the envy of Zalipie. When we arrived in town, we asked which painter we should interview. The artists were confounded that we might interview only one when so many were equally talented. Then they agreed unequivocally that Zofia was the best candidate because her kitchen is most photogenic. Zofia's walls and tablecloth are painted with flowers; there are flowers growing in the window boxes; there are crepe-paper flowers in vases; even the cooking pots and pans are painted with blooms.

Zofia milks the cows, gives the barn cats a saucerful, and presents the kittens to her four-year-old grandson, Tomasz, to play with. She throws a pumpkin to the ground in the yard. It splits open on impact and becomes a meal for her geese. Then she puts finishing touches on a blue floral painting near her front door.

After a lunch of soup, we join her husband and neighbors working in the potato fields across the road. Poppies, miniature daisies, and other wildflowers tangle together at the edge of the road. After a week of rain, digging the potatoes has become an urgent priority. The neighbors collaborate, working in each other's fields until the harvest is over. A neighbor woman delivers the workers' midday meal: cheese, plums, tea, and sausages to roast with fresh potatoes on a fire built on the spot.

Zofia and her husband, Franciszek, have been married thirty-five years. He lived near Felicja Curylo's house when he and Zofia were growing up. As soon as Zofia arrives, he jumps up, teasing her about being interviewed for a book, and leads her in a little jig. Like the other husbands, he appreciates that his wife is an artisan. But when there are potatoes to dig, art waits.

Above: Although women in the 1800s painted blossoms on the sooty walls of their cottages to brighten the dark interiors, women today paint bouquets on home accessories and souvenirs and then sell them at the House of Painters in Zalipie. The two vases were painted by Stasia Curylo.

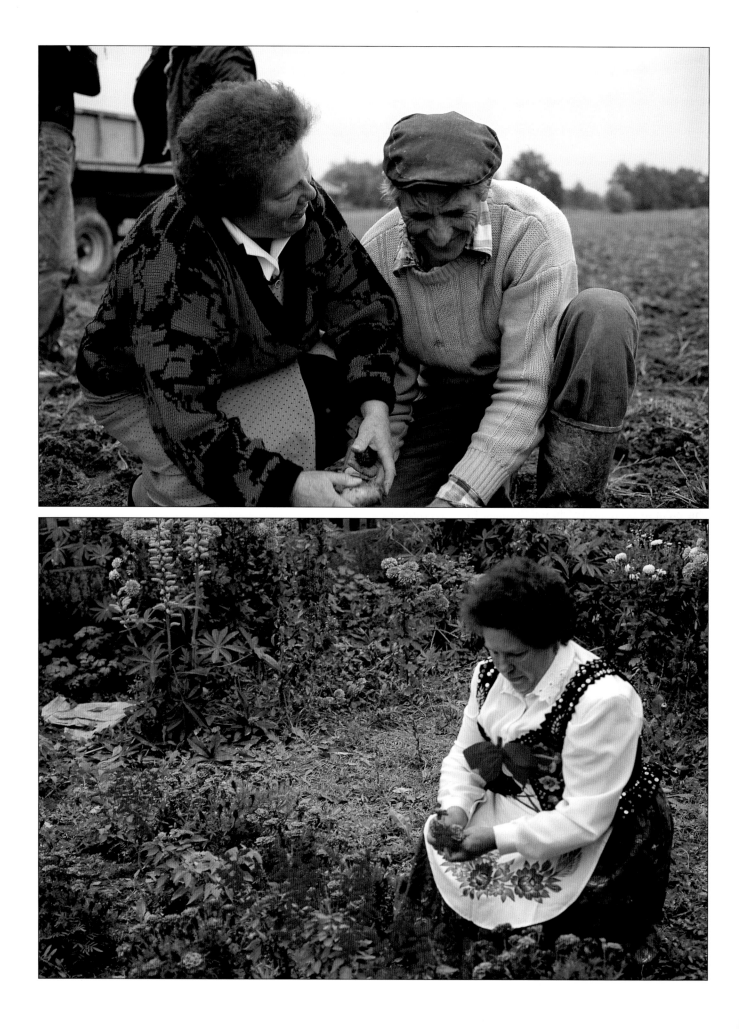

Zofia's thirty-one-year-old daughter, Renata Kowal, has painted for twenty years, but she is not painting now because chemicals in the paint give her terrible headaches. Zofia encourages her, "One day you will paint again. Some company will surely develop paints that will not affect you." Meanwhile, Renata's self-esteem is intact, because she does not define herself by her work but rather by her feminine roles: "I am a daughter. I am a mother. I am a grandmother. That is life."

ALL OVER THE WORLD, compensation comes in many forms, including spiritual income and monetary income. Zalipie's women painters mostly receive spiritual income. The most industrious artist, Stanislowa (Stasia) Curylo, contributes less than twenty percent of her household budget.

Stasia signs all her work, as do her colleagues. A small vase she has made is for sale at the House of Painters for six dollars. She paints an average of four hours a day and earns about sixty cents an hour, twenty percent of which goes to taxes.

Now thirty-six, she has competed in eighteen of the thirty-three Zalipie competitions and has won many of them. Stasia has long used her talent to earn money, although there are many obstacles in the path to profits. At nineteen, she painted greeting cards for Cepelia, the government-owned folk art retailer, but the chain's prices were too low to pay for the full hour required to create every card. Later, she painted skirts, but textile paints are expensive and made the skirts too pricy to sell in volume.

Stasia hopes her children will go on to university, although most Poles attend school only until they are nineteen. Her ten-year-old, Michal, might like to be a lawyer. "Or a farmer like father," the boy pipes in, "or a flower painter." A male painter? We ask Stasia how she feels about that. "Long ago, one man did painting; Michal is not the first. And he has company. He is one of three boys in the children's class at the House of Painters."

IN 1993 FOUR PAINTERS, including Zofia and Stasia, were commissioned by Cracow's old town restaurant, Kawiarnia U. Zapiianek, to recreate the floral murals their mothers had painted two decades earlier. From mothers to daughters to granddaughters—and sons—this tradition has passed on not only a skill, but also a joyful spirit born of creativity. And although the women wish they made more money, they feel gratified. "We paint for affection and memories," Zofia admits. Stasia agrees: "This is an art of the heart."

Opposite, top: Zofia and her husband, Franciszek, are potato farmers, as are most Zalipie residents. When they work with their neighbors to harvest the crop, time for art is scarce.

Opposite, bottom: Zalipie artists, inspired by flowers in their fields and gardens, paint poppies, daisies, cosmos, foxgloves, roses, and marigolds, like the ones Zofia picks here.

My friend and collaborator, Paola, is such a scaredy-cat. She thinks I should be a lot more conscientious about all those traveler concerns—water, strangers, money belts, food, documents, dengue fever, robbery, rape, and murder. I say she's conscientious enough for any three people, and give her a hard time about it.

As darkness falls on the House of Painters, the night we've arrived in Zalipie, Paola and I, along with Barbara (our interpreter from the Peace Corps), are shown to the guestroom. The women are very proud that their community craft center can offer accommodation. We immediately dub it "the infirmary," it's so like all the summer-camp infirmaries of our childhoods: clean, white, and bare-bones simple, with four little cots all in a row.

Paola has made certain that the door to our room is locked, even though our hostesses have locked the building, leaving us with the whole place to ourselves. The building at night is very big and dark and empty—not to mention cold. (We've arrived a week before the scheduled date for turning on the Zalipie heating system. A schedule is a schedule, never mind the near-freezing temperature.) And the bathroom is about a quarter-mile down dark, winding hallways. But we're fine. And Paola is comfortable because our door is locked.

Suddenly I'm awake. Something's rattling. It's the door. What could make the door rattle? It's the latch! Somebody is actually rattling the latch of our door, inside our big, dark, locked building. Can't be—must be—can't be. My insides are all aquiver, and it's fearless Toby who is whisper-shrieking, "Paola! Wake up! Somebody's trying to get in here!"

Now she's awake, too scared to bother with "I told you so!" We whisper back and forth with no useful ideas, then begin trying to rouse Barbara, who can only wake up enough to give us a muffled, "Don't be silly."

She who talks a bold story must take bold action. So I get myself, quaking, over to the door and deliver a very firm and scary, "Who's out there? Get away. Now!"

Nothing for a second—and then the door rattles again, while I'm still standing right there! What nerve. So I bang on the door.

A tiny wee furry something wiggles under the door and darts across the floor.

"Oh, good grief, it's only a teensy field mouse. He's been rattling the door trying to squeeze under it." I sigh with relief, along with Paola—and then Barbara goes ballistic. "A mouse? Oh, no! Not a mouse. Ohmygod!"

Well, well! Three scaredy-cats…of slightly different stripes.

T. **Zalipie, Poland**

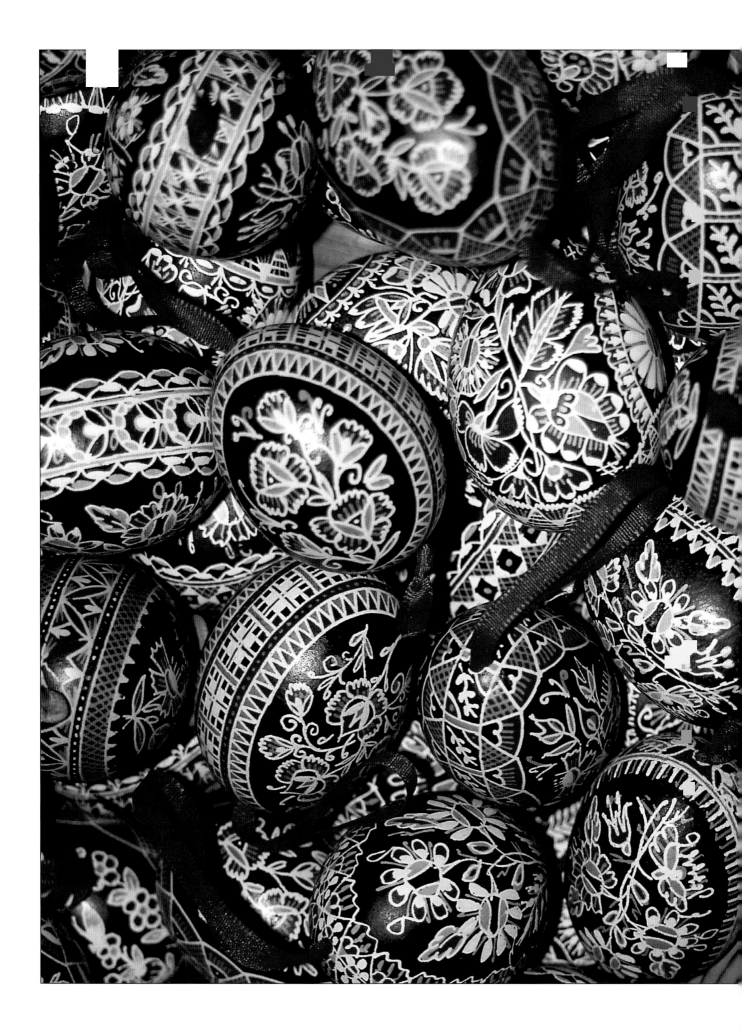

DURING THE COMMUNIST OCCUPATION of Czechoslovakia, fine arts were virtually snuffed out. But women's crafts like painted Easter eggs were regarded as nonthreatening, apolitical. The communist government even sent Ludmila Kocisova on cultural exchanges to Poland and Russia to demonstrate her art. Today, Ludmila is still one of the best egg painters in the country. Her work can be found in the permanent collections at the Ethnographic Institute in Brno.

The Communists left power in 1989. These days, a playwright is president of the Czech Republic. Jugglers, mimes, musicians, and artists vie for attention in Prague's Old Town Square, and churches open their doors for public concerts on summer nights. Tourists from all over the world flood the lively capital city. And almost everyone goes home with at least one Easter egg, painted on the fragile shell with bright, intricate designs, which costs about a dollar and a half.

"Vnorovy, with its three thousand people, is the only place in the world where, in each house, at least one woman paints Easter eggs. That has been true for over a hundred years," Michal Pavlas says as we drive through rolling fields of sunflowers, poppies, wheat, and corn toward Moravia, four hours southeast of the capital city. Michal, twenty-eight, is a buyer for Ceska Lidova Remesla, galleries in Prague devoted to traditional Czech crafts. Ludmila paints only for the Ethnographic Institute and these shops.

"Each village has its own style of *kraslice* (Easter eggs), Michal explains to us. "The women of Vnorovy created the batik technique for coloring eggs. Theirs are always white, yellow, red, and black combined in geometric and floral patterns.

"In ancient cults, the egg was a symbol of life," he continues. "People believed that eggs ensured a successful harvest and fertility. Decorating the eggs was meant to strengthen their magical power."

Ludmila Kocisova and Josef, her husband of forty-seven years, meet us at the door of their two-story home, where window boxes spill over with nasturtiums. Across the street is a field of plum trees that we soon discover provide the fruit for plum wine.

We take off our shoes at the door, as is the custom, and climb the steps to the living room. Ludmila asks if we would like a snack. She has prepared an entire platter of open-faced sandwiches—papery slices of ham layered in ruffles on fresh bread—as well as crunchy, just-pickled cucumbers and newly made plum wine.

We have been told that this is a conservative, formal society, so we are carefully subdued. We sometimes break the ice by showing our own family pictures. Ludmila gets her box of photographs to reciprocate. She spreads snapshots of Josef, their three sons, and their six grandchildren, as well as pictures of herself with people in costume at folk festivals in Warsaw and Moscow.

"In Moscow, I was allowed to see Lenin. Everyone wanted to see him, and police guarded his tomb. I thought it was a little crazy, but I looked. It seemed to me as if the shirt he was wearing was actually made in this country. To tell the truth, I didn't think he looked very healthy," she commented, eyes twinkling.

"I didn't want to be unethical—we weren't supposed to see how people lived—but I looked through the bushes along the road. They live in very small houses in Russia; they are very, very poor."

Ludmila began painting eggs when she was five. "I sold my first egg when I was seven or eight, about when I learned to write. I wrote the name of our national anthem on that egg and painted a picture of a small house. The design was not at all traditional. My sister took my egg to the market, and it was the first one that sold. An English woman bought it and so it went all the way home with her.

"My mother taught me how to make traditional designs and how to create my own. You know, no egg design is purely traditional; every single one is different, like snowflakes."

Talking about her mother leads Ludmila to fetch her mother's tools, which she still uses—and that leads to a demonstration. She melts a mixture of beeswax and candle wax in a spoon suspended above a candle. Her special pen is made from a thin metal sheet rolled into a cylinder to hold wax for painting.

"You begin painting in the middle of the egg, and duplicate the pattern as it progresses toward the ends. If you really want to see how beautiful painted eggs are, you must look down on them from one end.

"When you're done with the first wax designs, you dip the white egg in yellow dye; then you paint wax designs on top of the yellow and dip the egg in red; then you paint on top of the red and dip the egg in India ink. Only when you remove all these layers of wax do you see the whole design for the first time. It is a great painter's skill to imagine the whole design and create a wonderful egg. You must be very careful; every line in the whole design must be perfect." Ludmila warms the eggshell over the flame,

then rubs the now-black egg gently with a soft cloth to remove the wax and reveal a lacy, intricate pattern of circles and squares. As she had hoped, it is perfect.

Because Michal has come to pick up products for the store, it is time to do business. Ludmila approaches the wooden cabinet that runs the full length of her living room. For the first time, I notice that there are hundreds of painted eggs stored in egg cartons under the furniture. Michal and Ludmila sit on the floor and inspect the work. Ludmila will earn about sixty cents each for the elaborate egg designs and about fifty for the simpler ones.

Although Josef retired when he turned sixty, as most men do here, and although most women retire at fifty-five, Ludmila is still working at sixty-seven. "My work is also my hobby; I cannot imagine life without eggs. But the profit from them is not enough to live on, so I also make corn husk figures," she says. "And I teach egg painting to help keep the tradition alive. My students are old women who have retired, and young women who are pregnant. In those situations it is difficult to have enough money to live." Michal estimates that the average income for rural people is about forty-five dollars a month.

Ludmila appreciates the eggs' design history as much as their rituals. She picks up two eggs she has just finished. "This design is from the year 1895; this one, 1888. I wanted to bring forgotten traditional designs to life. It was difficult—I had to wait two years before the institute researchers had time to help me. But now the designs are alive again and all is well."

Josef and Ludmila laughingly enact the traditional flirting that occurs at Easter time. "On the Monday after Easter, boys try to catch the girls they like by giving them a gentle tap with a willow switch decorated with ribbons. The next day, the girls do the same with the boys. The idea is that the power and health of the willow will make you strong. Each time the switch connects, another ribbon is tied to it, and the one who taps another gets a beautiful painted Easter egg."

Ludmila, who was reserved when we arrived, is now lively, relaxed, and full of stories, and clearly does not want us to leave. "I was so nervous last night that I didn't sleep at all, worrying about your visit," she volunteers. "When I was painting the eggs, I was afraid the lines would look wobbly in your pictures. But now I can't stop talking!" When we leave, I thank Ludmila and give her a good-bye hug—no longer improper, this is the affection of fast friends.

Above, clockwise from top left: Ludmila teaches the *kraslice* art to pregnant and retired women who would otherwise have no revenue; heating wax in a spoon over a candle, she draws lines with wax then dips the egg in yellow dye. • Czech Easter egg designs are unique to each town; these are made in Vnorovy, where Ludmila lives. • She repeats the process with red and black dyes, then heats the egg over the flame to remove the wax and see the design. • Easter eggs from different towns display different patterns.

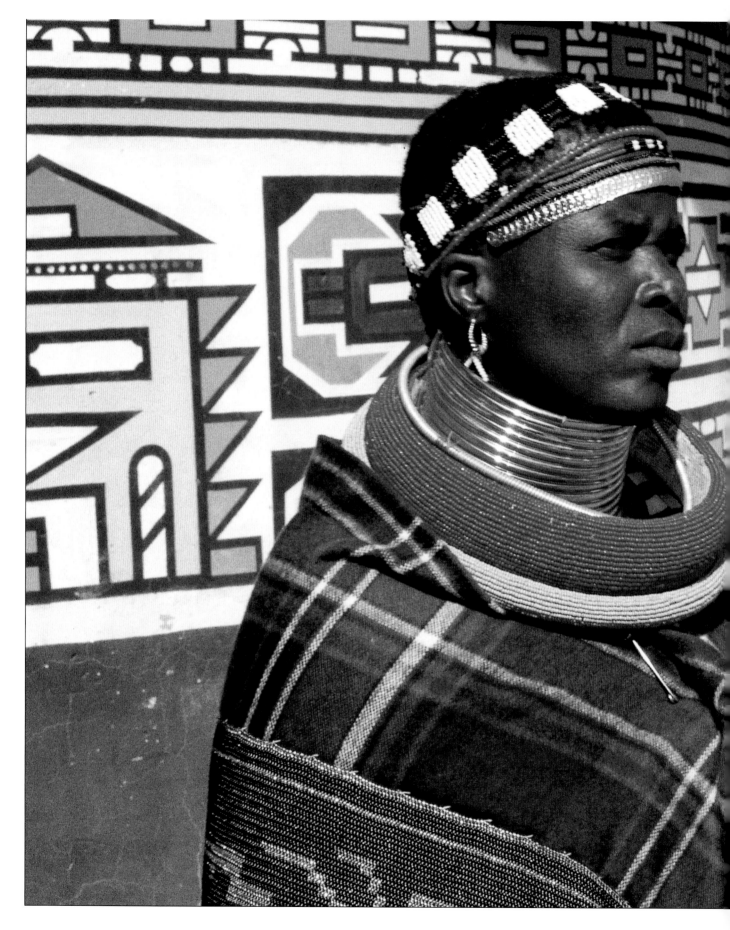

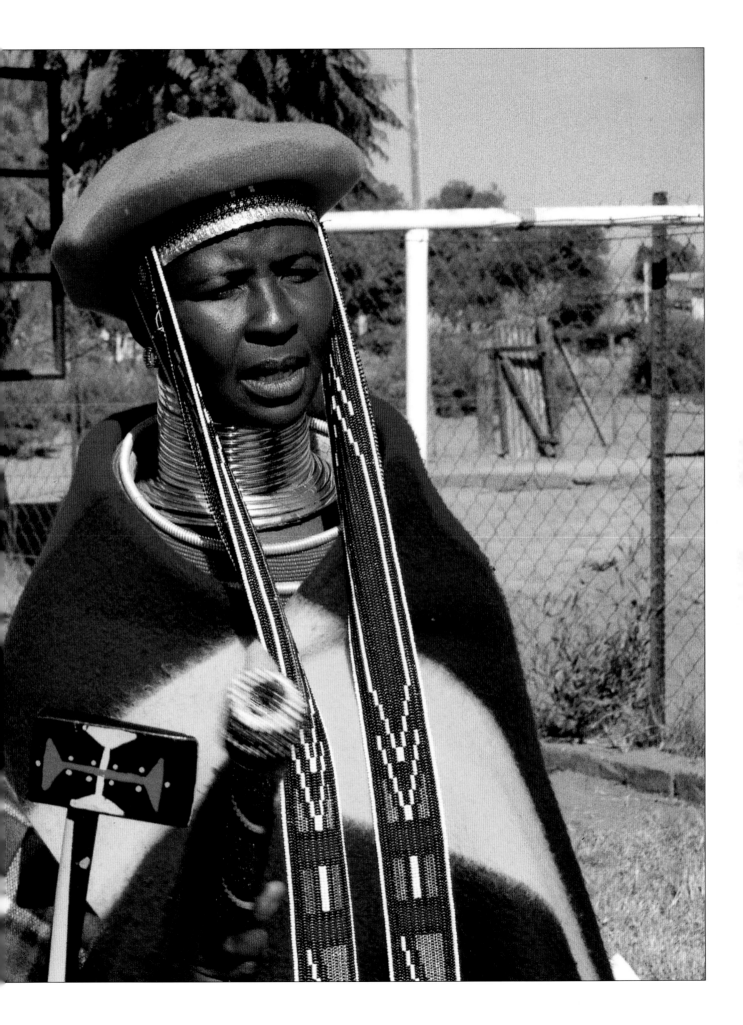

THE ROAD TO WELTEVREDE, which is three hours northeast of Johannesburg, cuts across prairies that look like Wyoming in November—bleached wheat fields, hills that open onto flat mesas, rock outcroppings—or California, with manzanita, live oaks, and rolling hills. Some towns have California names (Palm Springs, Menlo Park) and American stores (Kentucky Fried Chicken, Woolworths). But most of this region could only be South Africa. Vendors sell bagged oranges at roadside stands and children sell roasted corn at stop signs. A funeral cortege walks through the treeless stubble to say good-bye amid the gravestones. One-room cement-block or corrugated-metal houses cluster on the flat, rust-colored earth.

Dinah Mahlangu, who leads a women's craft group in this KwaNdebele homeland, rides with us and talks about the region's history. Dutch and German settlers, whose descendants are referred to as Afrikaners, long held power here. Having tried three times to bring the Ndebele people under their control, in 1882 Afrikaners dynamited their food storage caves to starve them, killed their leaders, razed their crops, confiscated their land, and assigned them to five years of indentured labor—five years that, in fact, lasted over a century. Ndebele women reacted against the Afrikaners' efforts to decimate ethnic identity by resurrecting the distinctive beaded apparel that their foremothers began creating in the sixteenth century, when the Portuguese brought Czechoslovakian and Venetian beads to southern Africa to trade for slaves and ivory.

"I CANNOT APPROACH the King's palace without covering my shoulders with a blanket or I will be charged one calf—and I don't have a calf," Dinah confesses as she stops to borrow a blanket near the impressive gate at Weltevrede.

We tour the royal *kraal* (compound). The king's mother and his five wives live in *rondavels* (thatched roof huts) that are covered with designs. The women of the kingdom have painted bold, colorful geometric patterns on every wall of the palace complex, designs that derive from patterns in Ndebele women's traditional beadwork.

Beadwork has influenced much more than just murals on palace walls; it is centrally important to Ndebele history, rituals, cultural and political identity, and commerce. A sequenced, beaded wardrobe marks the important events in a Ndebele woman's life. A single-strand necklace is given at birth. An apron is worn until puberty when a girl's mother makes a stiff front-apron for her initiation into womanhood. A back-skirt is worn after initiation to announce a woman's availability for marriage. A ceremonial apron, train, cape, and veil, or a blanket, comprise her bridal costume. A five-panel apron is worn after her first child is born, and two long strips that hang from a head-band are worn when her sons are initiated and she has reached maturity.

Today, Ndebele people do not wear beaded clothing every day, and although traditional items are sold occasionally, the Bead Women's Club members specialize in dolls, jewelry, bead-handled brooms, mats, and trivets. Their products are marketed locally and internationally by Rural Crafts in Johannesburg, which is part of the National Crafts Association, a coalition whose low-income members are part of micro- to medium-sized self-help craft businesses.

IN THE VILLAGE OF WATERVAL, wide, dusty roads are lined with two-room cement-block houses. There is a granary, a grocery, and a pool hall. The town barber, whose apron says "Black Like Me," is cutting a young woman's hair on his shop porch; three women wait, wearing wool skirts and sweaters.

Thirty women are sitting on the ground in the yard behind the Rural Crafts office, relaxing and gossiping and beading. They wear tennis shoes and cotton dresses. The married women wear their everyday blue plaid blankets and headscarves. We learn the local way to shake hands: clasp the hand, milk the thumb, and clasp the hand again, a method that reminds us of the hip handshakes of our own country. Later, we discover that Ndebele children shake differently; they reach right past our hands and grab our wrists.

Many of the women are beading doll aprons, blankets, and headdresses. Dolls play many roles in this culture. A Ndebele girl may wear a miniature doll pendant on a necklace to enhance her future fertility, or keep it hidden as a talisman to ensure that she will find a good husband. As she prepares to marry, she may take care of a new doll. This doll's name will become the name of her first child. If a couple is not able to conceive, sometimes initiation rites are repeated and the woman carries a doll as a surrogate child. Today, dolls also provide income for Ndebele bead women.

A PLATOON OF EIGHTEEN- to twenty-one-year-old men run together down the dirt roads of Waterval, chanting, carrying staffs, and wearing loincloths and ceremonial blankets with wide stripes of crimson, green, royal blue, and yellow. They also wear tennis shoes. After three months, they have healed from their circumcisions, and their return from the bush is cause for great celebration.

"Each initiate's house is marked with a white flag," Dinah points out. "The group travels to the home of one initiate every day. His parents kill a cow and make a feast. They sleep there overnight, then go to the next house. They do

Previous pages: To rekindle ethnic identity after Afrikaner efforts to decimate their group in 1882, Ndebele women resurrected the distinctive beadwork tradition their foremothers created.

Opposite: Dinah Mahlangu enjoys the "power, strength, and light" of opening a bank account for the Waterval Bead Women's Club. The money will be used to buy materials so they can make products to sell.

not divide up until they are finished. This is the last day. The next initiation will not happen for three years."

The initiates halt in a large *kraal*, where they are joined by the elders who have been their spiritual guides during the initiation and by Mr. David Mahlangu, king of the Ndebele tribe's Waterval branch.

By now, the young men have cast off their bright blankets and wear only loincloths and their mothers' beadwork. Elaborate multistrand necklaces overlap ropes of beads that cross both chest and back. Thick, colored bracelets of beads cover their arms and legs, and they hold bead-covered scepters. They begin to sing, harmonizing and improvising with energetic, infectious chants. The older men direct the singing, brandishing shields and wearing breastplates of animal skin and fur.

July is winter here but pale pink blossoms cover the trees. The sky is sapphire, the day is exultant. The boys—now men—receive new names. They will never use their childhood names again.

Their mothers are in ritual mourning for children who have become men. Tomorrow the mothers will travel from house to house singing to the initiates' families, wearing "long tears," narrow beaded panels that cascade fifteen feet from beaded headbands, symbolizing both their sadness and their pride in their sons.

We help the mothers dress for a rehearsal, watching with fascination as they sit winding ace bandages the full length of their legs, then wrapping them with cardboard, pulling on the thick, beaded leg bracelets, and stuffing foam rubber near their ankles to prevent chafing. A gymnastic maneuver is required to stand: the seated women twist to put their palms on the ground behind them, then turn over and walk stiff-legged until their legs are beneath them and they can stand.

They move like robots, but they are dignified and glorious, wrapped in traditional Ndebele ceremonial blankets and carrying beaded scepters. Their music combines chanting and singing, whistling and laughing, ululation and jubilation.

IN ADDITION TO SPEAKING NDEBELE, the bead women speak English and/or Afrikaans. Even their names reveal linguistic variety. Timmy, whose Ndebele name is Deliwa Ndala, is getting married in five months. Her son, fourteen, is Gavin (Phiwa in Ndebele) and her two-year-old daughter is Sharon (Lindo).

Does her fiancé, Andrew, know her children's father? "Yes, Phiwa's father, my ex-lover, is in another Ndebele area.

Andrew is Lindo's father. He likes these two children more than he likes me! He wants to do everything for them and is already keeping money for a school fund. We have to buy two uniforms plus matching shoes for each child; they must wear different colors on different days of the week. Phiwa's uniforms cost $125 for two outfits."

Timmy does dressmaking, but most of her money comes from beaded necklaces, bracelets, and rings. Her income ranges from twenty-two to fifty-seven dollars a month.

We ask her to describe Ndebele weddings. "Typically the husband's family will visit the bride's home, present a blanket, and agree to pay sixteen cows as *lobola* (bride price). The first *lobola* payment is made then, and the second is paid after the first child is born, when the bride has proved her worth.

"Like all brides, I will wear two striped blankets with beads around the edges for my wedding. I will put a towel on top of my head. A big one, any color. I like red and yellow. And I will wear tennis shoes—red ones with little bead decorations. The wedding will take place in my father's house. Afterward, we will move in with Andrew's family for maybe five years until we can afford to buy our own place."

Traditionally, *dzilla* (brass neck rings), were placed on a woman by her new husband on their wedding day to show that she was now married. The women wore them until their husbands died, then removed them for one year. We are alarmed to learn this because the rings have been known to cause bone collapse and death when they are removed. To our relief, our friends show us that contemporary plastic *dzilla* lace closed with ribbons.

BEAD WORKER MARTHA MASILELA'S initiation party was held in 1991. She spent the requisite month in seclusion in a special enclosure in her house, wearing a blanket, sleeping and eating, and learning from her mother the secrets and roles of womanhood, including beadwork and wall mural painting. Today, she wears the clothing she wore to her post-seclusion party. Wide bands of beaded bracelets cover her legs and waist. Her stiff, beaded apron symbolizes her ascent from childhood to womanhood. She is bare breasted.

"In 1995," she confides, "I was born again. A child of God. I heard The Word. He touched me and I took Him as my friend and king. I wear this attire to honor our tradition, but inside my heart, I am always praising Him."

Martha, who wants a career in public relations, reconciles the Ndebele women's traditional and contemporary lives,

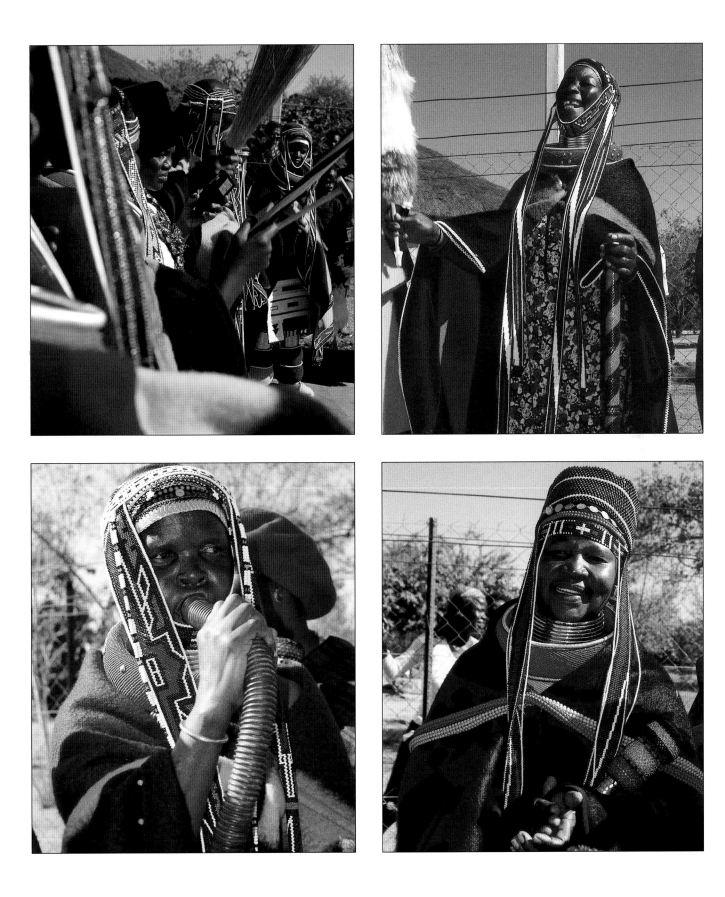

Above: Brandishing scepters, whisks, and feather plumes, clapping, ululating, even making music with a drier hose, the bead women rehearse the music that will welcome their sons.

Following pages: When their grown sons return from initiation, Ndebele mothers wear beaded "long tears" to express both pride and sadness at their sons' maturity.

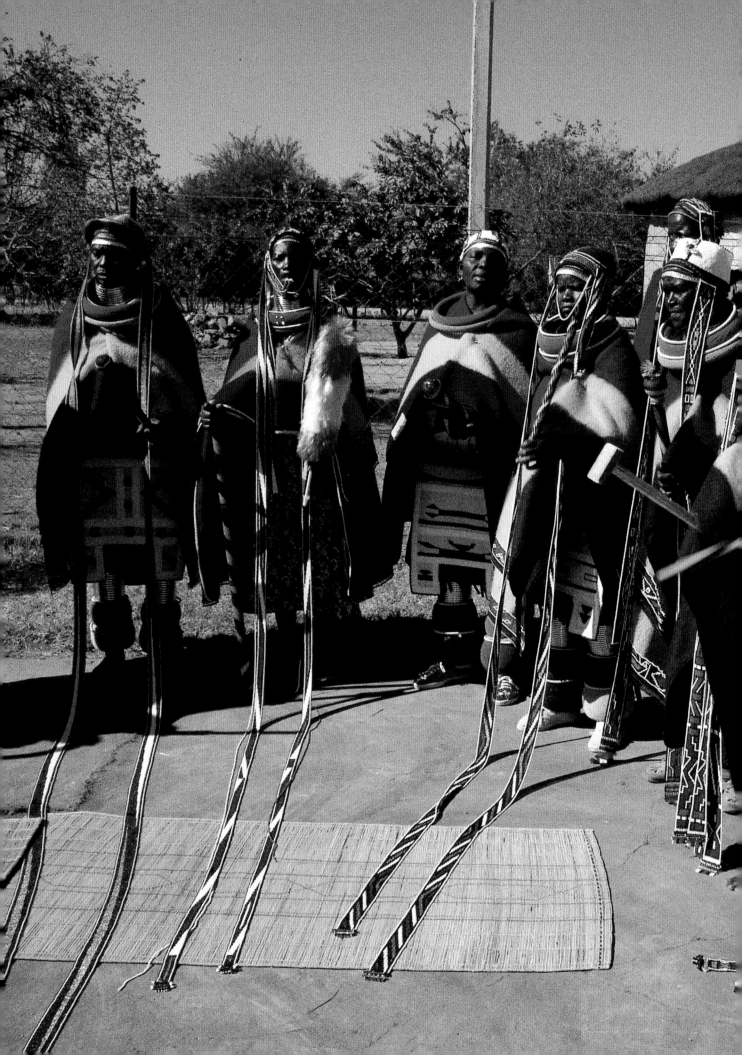

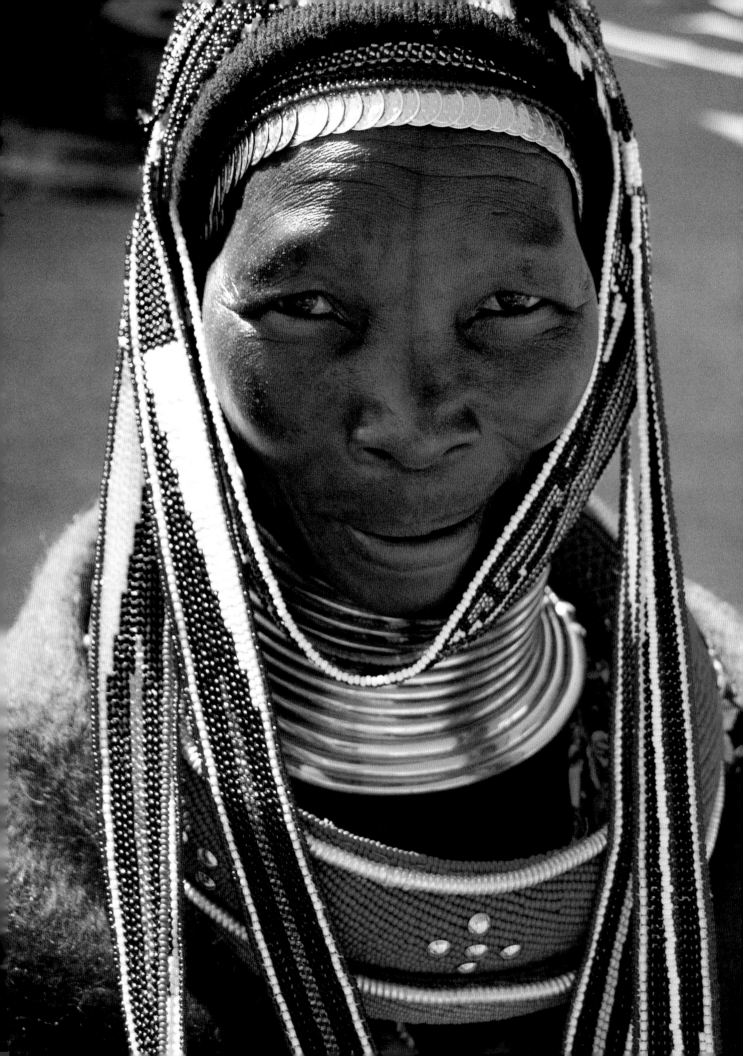

saying, " We can't cast our culture away. That is why I wear these clothes. Culture is important."

TWO OF THE BEAD WOMEN, Letty Mthimunye and Anna Msiza, are *sangomas*, healers who are experts in ecstatic possession and divining. They throw bones to learn the future, diagnose sickness, and prescribe a cure. Their knowledge is gleaned through communications with ancestors while they are in dream or trance states. They describe the torment of the uncontrollable shaking that has given them privileged access to the world of the dead.

Unlike the bare-breasted initiates, Letty and Anna wear bras for pictures. They demonstrate dancing with their elephant whisk wands. Their insect-larva ankle bracelets clank percussively. Their full skirts are dotted with red and white beads that symbolize the traditions of herbal medicine and divination. They wear "necklaces of power," made of beads; horns; magic calabashes that contain herbal and animal essences from snakes, elephants, rhinos, and crocodiles; and wood, which represents female energy.

When I admire Letty's handsome head of braids, each ending in a cowry shell, she removes her hair and, laughing at my surprise, insists that I try her wig.

DINAH MAHLANGU, thirty-seven, has three children: David, twenty; Billy, thirteen; and a ten-year-old girl named Goodness. She is a single mother—her husband was killed in a car accident in 1993.

Dinah completed Standard Ten, the equivalent of high school, and hopes her children will, too. "I especially wish them to have their will. To have the kind of job or business they want. The choice will be theirs."

More choices are now available, thanks in part to the activism of Ndebele women. For example, in 1986 President P.W. Botha tried to force the Ndebele to live with their rivals, the Pedi, on a reservation. This change was never instituted, but Ndebele women took up the fight. They demanded meetings with the white police, but instead got the riot squad with tear gas and attack dogs. Many women were injured. Still, in 1988 they took the issue of women's suffrage to the Pretoria Supreme Court—and won, just in time to elect the first Ndebele local government.

"Men and women are equal by the rules; they are paid equally, but they are not equal in action. Men believe that women are their slaves. Husbands abuse wives. They forbid them to do things. Some abuse their daughters sexually, which wives will not discuss for fear of being divorced. Most people here are not yet educated. Men feel they can do anything and women feel that without a man, they can't

do anything. Most of the women in our area are resigned to suffering," Dinah says.

"In 1994's election, I worked as a voting officer, checking identification. In my area, seven hundred and fifty people voted. Everybody hoped that many things would be different after the election.

"We do have a lot of change. We can create jobs for ourselves, working at anything. There were many jobs we were not allowed to do before; it didn't matter if you had talent. To get food for the children, most people were forced to go to the town to work for somebody else. People here used to have to ride the bus four hours to work in Pretoria, leaving at three in the morning and returning at midnight.

"Now we can organize ourselves, have our own projects, and contact people from the outside like you women from America, which gives us power, light, and strength."

Dinah is a diminutive woman with gigantic ideas. When we first met, we discussed our practice of compensating the women we interview so they do not lose money by talking instead of working. I asked her what would be fair pay for a Ndebele woman. She fell silent. Finally, she asked us not to pay individuals, but to open a bank account that could be used by all the bead women to buy raw materials.

We take Dinah and two other bead women to the bank to register so they can co-sign future withdrawals. We notice that, although apartheid has ended, we are the only two whites around. Our race doesn't seem to matter, though. We are introduced as friends. We listen to the local gossip. We play with the babies and admire women's hats. Hours later when the process is done, the bead women are ecstatic. Having no money for raw materials had been crippling. Dinah is already planning how to increase the bank account balance. "We will sit down with our members and discuss how the account is to be used. We will not be working to eat money like peanuts, but to push our account higher."

MONTHS LATER, Dinah writes to us that the women now have a second bank account, this one funded by the membership fees of craftspeople in twenty-two villages whom they visited and organized. The groups' accounts total $2,600, enough so that many can borrow to buy the raw materials they need to create products—an opportunity that results from "power, light, and strength."

Opposite: Before 1994, Waterval women were domestics in Pretoria. After the watershed election, they created jobs to use their talents and enable them to feed and educate their children.

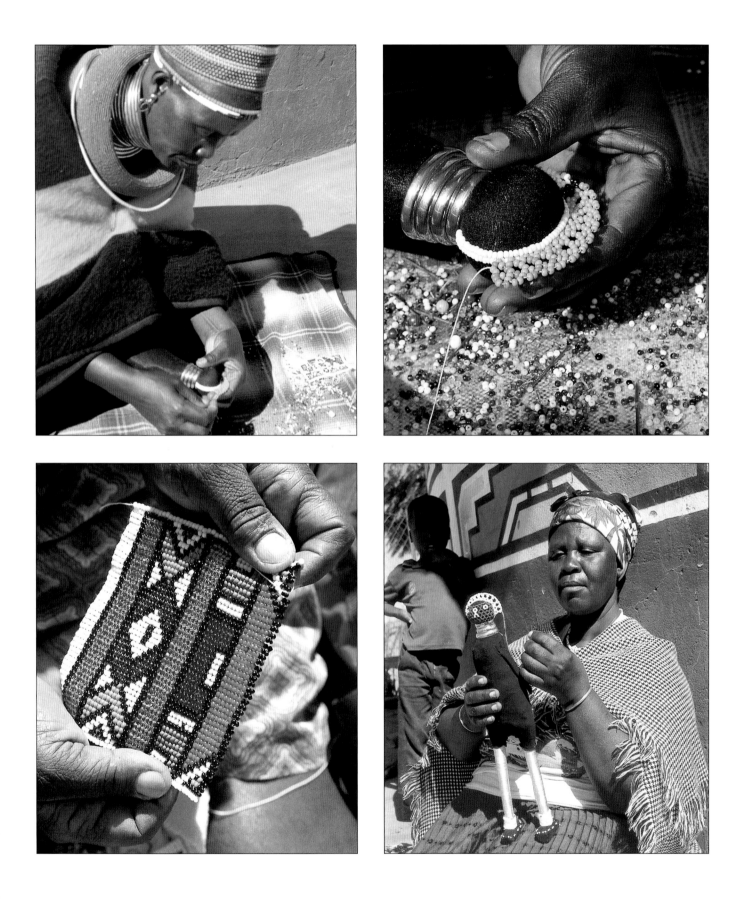

Above: Inspired by a new bank account that provides funds for raw materials, Waterval's Ndebele women bead dolls and jewelry, and decide to organize twenty-two villages into a regional handicraft group.

Opposite: Ndebele initiates return to Waterval after three months in the bush, wearing the beadwork their mothers created for them to celebrate their rites of passage.

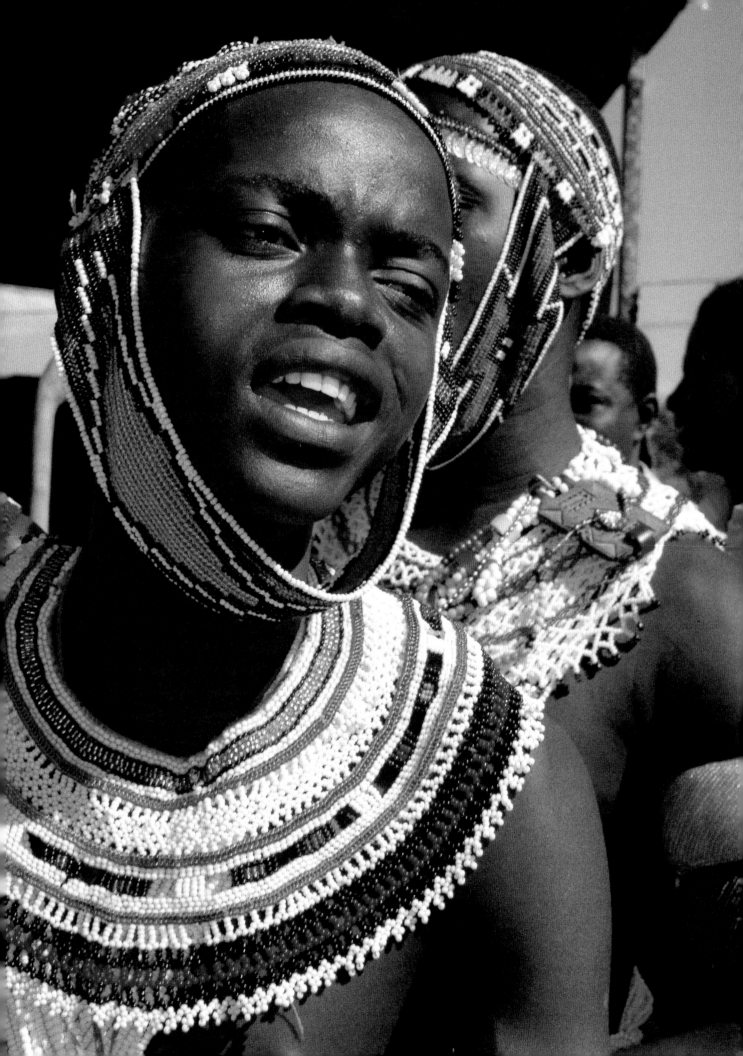

I stop taking pictures for a minute, and just listen
to the sounds of the place: insects droning, children
chasing each other in the next baked-earth yard, and
the low, soft burble of the women laughing and chat-
ting, enjoying one another's company as they work.
The language of the Ndebele is beautifully mellow
with deep, round syllables accented by a sprinkling
of the clicks and squeaks of the Zulu language from
which it derives.

Then there is another sound—a chirp, a whistle; it is
Betty, with a plastic referee's whistle held in her teeth,
swaying and shuffling across the courtyard to the
tempo of her whistle chirrups. One at a time, other
women set their work aside, stand, and join her in
a slow, graceful, sideways conga line of a dance. The
singing starts sotto voce, with deep, sweet harmonies
as a dozen of the beaders join the performance. I am
told they dance only occasionally for their own
amusement, but always at festive gatherings, and
in this case, for us, because we are guests.

A basso note is added. Johannah is blowing into what
appears to be a drier vent hose while holding the other
end up over her head, creating a rhythmic tuba pulse
as she takes her place in the curving line of dancers.

I can't resist. I have to start moving to the beat, doing
my best to imitate their steps—and friendly hands
move me right into the middle of the line. There is a
brutal African sun overhead, and not a bit of breeze,
but the dance is slow, the exertion minimal. And then
a woman who is not dancing brings me her headdress
and places it on me, with its bright loops of bead
strings swinging under my chin. Another woman is
inspired to put her beaded scepter in my hand, and
somebody snaps a wide plastic neckpiece in place.
Finally a dancer sacrifices her multicolored wool
blanket to be draped around my shoulders. We sing
(I contribute the occasional "yeah-yeah-yeah").
And we dance.

I am quite a picture, wearing my glorious Ndebele
ceremonial regalia over my khakis and T-shirt, my
blondish curls drooping, and my dripping face the
color of a waning South African sunset.

Waterval, South Africa

This page: Dancing here, Johannah Anna
Mahlangu learned doll making at fifteen. Today,
she can finish three dolls a day and earns more
money than her husband does as a house painter.

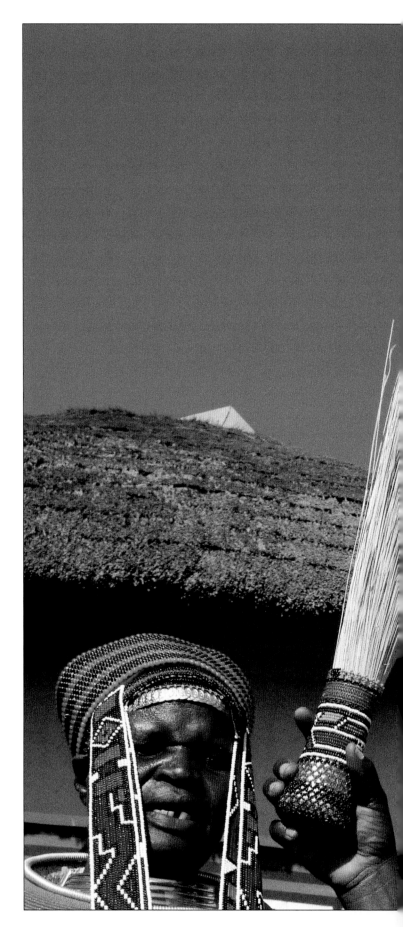

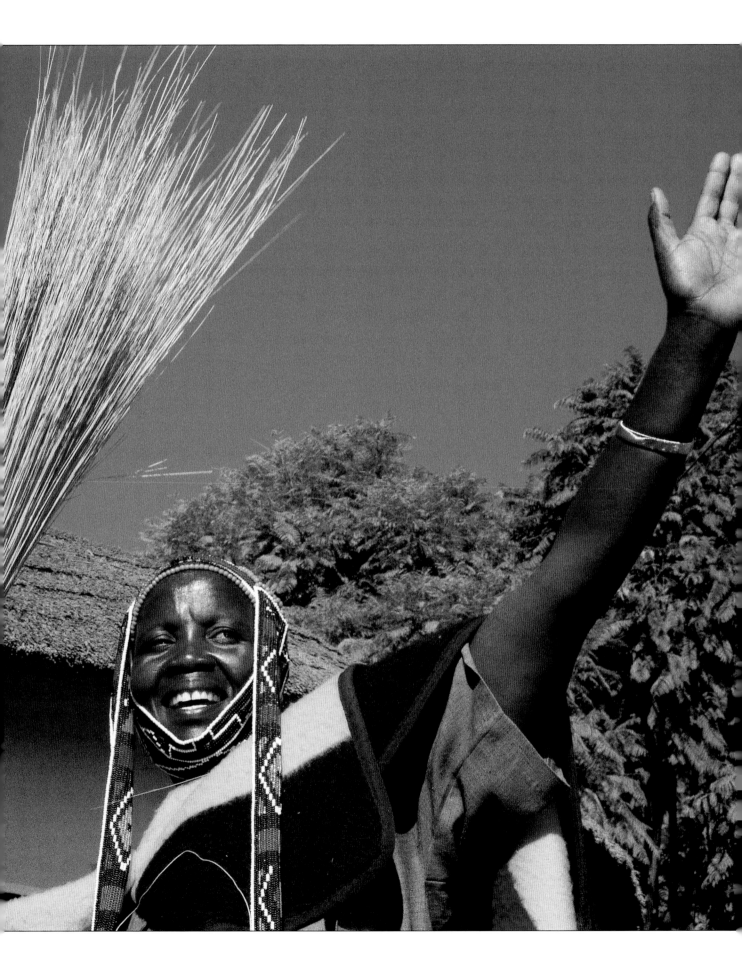

SOUTH AFRICA *Mamiza and the Zulu Basket Weavers*

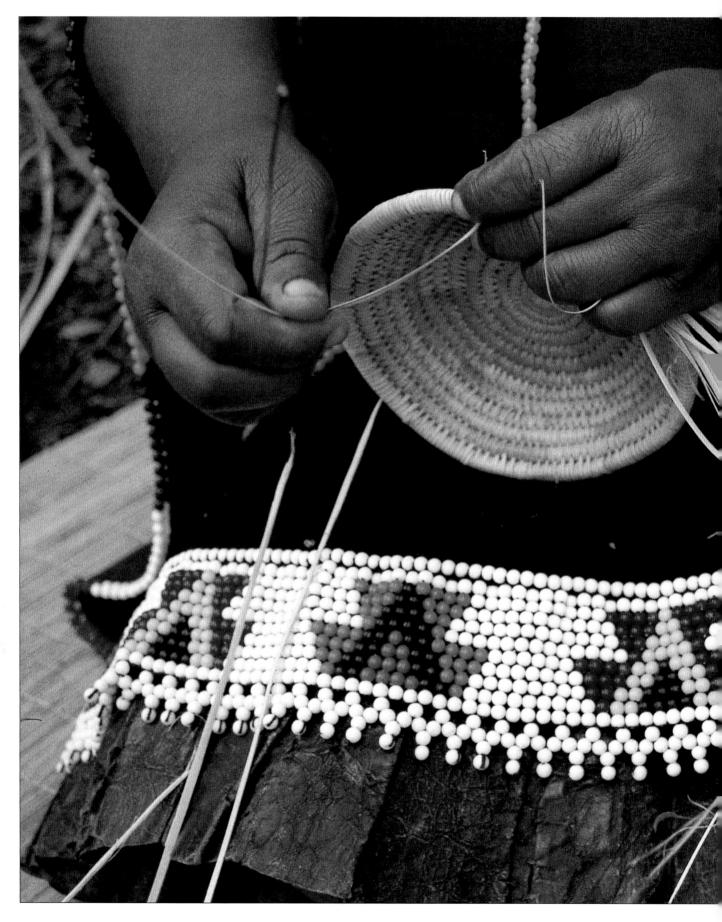

mother" and to the basket she is starting as "the embryo," which grows strand by strand into a "fetus."

It used to be that a Zulu woman remained a minor throughout her life, always under the guardianship of a man—her father, husband, uncle, or even eldest son—and did not work outside the home. Now Irene has her husband's permission to hold a job, at least until he finds one and maybe even longer. He is a pipe fitter looking for work in Newcastle, over three hours away. Other men have left Natal to labor in South Africa's mines and industries, leaving their wives to support their families.

Money is important to Irene, who is proud that her husband paid twelve calves as her bride price—"plus one extra because my father argued that I was his favorite daughter." Our interpreter tells us that an average calf is worth $135, and that thirteen calves is the going rate for a fertile woman under thirty. "Sons are seen as the strength of the nation, but daughters are seen as the strength of the family," says Irene.

As the strength of the family, Irene earns a salary from Dumazulu and additional income from selling her demonstration baskets at the resort's gift shop. Her income is all the money that she, her three sons, and three daughters have to live on during her husband's absence.

CAROL SUTTON, the energetic South African white woman who runs Ilala Weavers, buys Zulu girls' first mini-baskets and sells them under the brand name Oops, an acronym for Out-of-the-Ordinary Production System.

"Little girls who can barely reach high enough stretch up to put their baskets on the counter, then shyly ask if I will buy. By the time they reach mid-teens, they can help supplement their family's income, or even put themselves through school with the proceeds of their work," Carol explains as we sort through the miniature baskets, each about two inches in diameter.

Today, Ilala Weavers provides a local and export outlet for twelve hundred Zulu women basket makers who live within a 125-mile radius of the store. Carol provides both raw materials and orders, then pays cash on delivery plus a Christmas bonus of ten percent of the value of each weaver's baskets that year. In 1996, Ilala Weavers paid over $227,000 to Zulu crafters.

Carol is ebullient because an Ilala Weaver has just won a prize from the national biennial exhibition. "Sabena Mtetwa was competing against four hundred other South African artists. She is a widow, the sole breadwinner in her family, so the prize [$227] is an enormous amount of money for her. Sabena arrived dressed to kill in all her traditional finery. We met at a neighboring *kraal* (compound) with about twenty women, and then presented a framed certificate and the cash. She burst into tears. She has decided to spend part of her money to pay off her debt at the local store. The balance will be used to fix the roof of her house."

Sabena Mtetwa's niece, Hambephi Mtetwa, fifteen, took six months to complete a giant, intricately woven basket that sold for the same amount as Sabena's prize, enough to pay her school fees for the whole year.

CAROL, HER HUSBAND MIKE, and their twin sons who just graduated from university, now all work in the business. "Distances are too great for the weavers to come to us, so we go every day, deep into the rural areas, and unfold a table and chairs as an office.

"Last week an elderly woman very timidly showed us three baskets, the first she had ever made. They were beautiful and we paid her in crisp new notes. She threw the money in the air, holding out her hands to catch the bills as they fluttered. She told us this was the first money she had ever earned; tonight she could buy food instead of hoping others would have some to spare."

HAVING GROWN UP POOR, Nonhlanhla (Daphney) Zungu says, "It was a gift from God that my mother, without a cent in her pocket, taught me to make beautiful things from nothing. When I was young, I made six grass wastepaper baskets a week to sell."

Daphney teaches Zulu women how to make baskets and mats, knit, sew, and crochet, and grow food. She is a one-woman, self-funded job creation program. She lives in a simple cement-block house with her children.

Daphney's organization is called the National Multi-Skills Development Association and now numbers one thousand craftswomen in ten clubs located in Durban and the rural areas north of the city. Most members cannot read or write Zulu. Daphney, who finished Standard Eight, the equivalent of tenth grade, shares her education generously.

"Jobs recently evaporated for many black women in South Africa," Daphney explains. "Most Zulu women had been working as domestics until the minimum wage laws were passed, mandating that all employed people be paid at least one hundred dollars a month. That was far more than most employers were prepared to pay, and many women found themselves jobless. So I sat down to plan an organization that would help those women. They need to know how to stand on both feet and not rely on others.

Opposite, top: *Isichumo*, or beer baskets, are made of ilala palm leaves that swell when wet, making the vessels watertight. The diamond design represents a woman; the triangle shape, a man.

Opposite, bottom: Members of Daphney Zungu's National Multi-Skills Development Association relay bundles of grass they cut with machetes on a vacant lot in Durban; the grass will be used to weave mats.

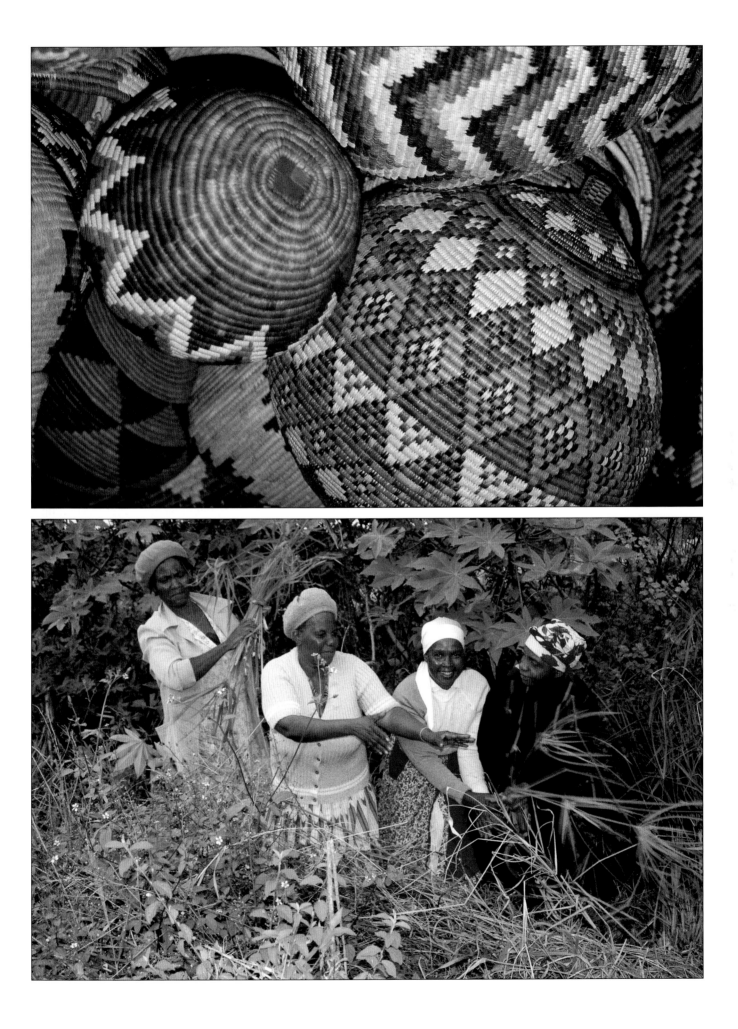

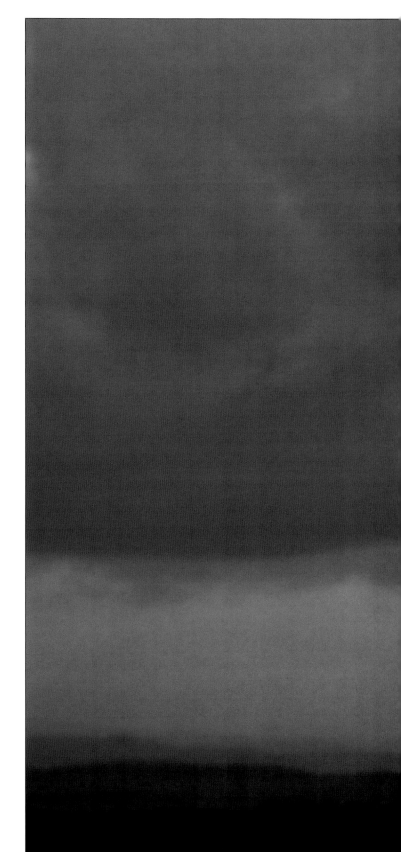

I love listening to South Africans speak. The Zulu language, as well as its cousin Ndebele, rumbles along in the most pleasing, melodious way. I listen to it the way one listens to music.

Besides the amazing click noises, there are combinations of consonant sounds that I have never heard in any Western language. Some words are begun with the pure consonant sound of a hummed "mmmm" or "nnnn" without an accompanying vowel sound (as in "Nnnn-de-bel-ly"). The most unlikely letters occur right next to each other: h and l, for instance, as in the place name Hluhluwe ("Hloo-hloo-ee"), where the h and l are separately pronounced on the way to the u. When we try it we stumble over our tongues, and the locals laugh.

Beyond the curiosities of the Zulu words, the spoken language is enhanced by the deep, soft use of the voice. And when Zulus speak English, they imbue that language with the same attributes—polishing, smoothing the words with their own linguistic style. Words slow down, draw out, become something else. Simple responses like "okay" and "yes" are softly sung, becoming "okaaaay" and "yehezz."

And the words themselves find their own usage. Just about anything we say might elicit a murmured "Izzz it?" Used like this, "Is it" might derive from "Is that a fact," but it is startling to hear it follow a statement like "I'm getting hungry." ("Izzz it?")

Even the English of white South Africans is sprinkled with pronunciations and phrases delightfully unfamiliar to our American ears. Just when we are becoming attuned, confident that we know the lingo, Carol Sutton phones from her basket shop to the busy Dumazulu Lodge to arrange for us to eat and then take some basket weaving photos: "Gordon, can't you swing a cat and make room for them at lunch? And then they need to take a hands-on picky."

. Dumazulu, South Africa

This page: The sun sets over KwaZulu north of Durban, where sugarcane fields give way to eucalyptus farms.

IN WEYA, A COMMUNAL AREA that the white-minority Rhodesian government established as a "native reserve" one hundred miles east of Harare, none of the women had ever painted before they met Ilse Noy in 1987. When Ilse, a German art teacher, told them painting could bring money, they thought she was fooling.

But in the end, Weya women earned more than money— they earned international acclaim with their vivid, animated picture stories of traditional Shona life, a life based on reverence for ancestors and a belief in spirits. The women's natural artistic talent catapulted them into the contemporary world art scene.

Evangelista Mungure, one of the first five students at the Weya Community Training Centre where Ilse Noy taught, leans forward, animatedly telling us how the women began to prepare for their first exhibition in November of 1987, and early the next year took the bus to Harare to attend their opening. Most of the women had never been to the monumental, marble National Gallery of Zimbabwe.

"It was so exciting!" Evangelista exclaims. "Mr. Mtasa, a government minister, opened the exhibition and introduced us. There was wine. Most of us sold our work that same evening. They put red stars on paintings to show things were sold, because buyers couldn't take them until the show was over three weeks later. President Mugabe talked about the Weya women's art on the front page of the Harare Herald the next day; radio and television reporters covered the show."

We ask if her own work sold that first night. "Yes, both pieces. A German named Helmut Osburn bought my first one for six dollars. The painting was titled *Whites in Zimbabwe*, and showed the story of our war for independence in 1980."

Evangelista was put in charge of sales for the Weya artists. One day when she went to Harare to make a delivery to the National Gallery, she met her mechanic husband-to-be, Lovemore. "He was fantastic. I liked him *very* much. He visited my family and paid a *lobola* (bride price) of $238 plus eight cows plus clothes for my mother and father. At our engagement party, we ate an ox, rice, and chicken, drank father's beer, played the drums, listened to tapes, and sang."

Six months later, they were married, and she moved from her village to Harare. Their son, Munyaradzi, whose name means "peace," was born the next year.

MARIAGORRET KAUNDO, Evangelista's sister-in-law, is thirty-five and creates appliquéd soft three-dimensional versions of the Weya paintings. One of Maria's appliqués describes in six panels the use of herbal medicine. A key to the images will be written on a note and tucked into a pouch hidden in the design: "*Musosowafa* is used for washing after people have buried the dead. *Nhanzva* is used by pregnant women to ease delivery. *Muuyu* is used to bathe a baby. *Mumvee* is used to create swelling in women's breasts and men's penises. *Mutamba* fruits are used for softening the skin. *Mutunduru* bark is pounded and used for love medicine."

Colorful fabric dolls enact a story in the panels of another of Maria's appliqués: "The old people are under a *murata* tree asking the spirits for rain. Here, women are packing the *rapoko* (corn) in containers. There is a hole in this rock for the *rapoko* to germinate; and they pour some water in the hole. Containers with *rapoko* must not be touched by young people, but only by the old generation. You can see these are old people only. After the *rapoko* germinates, they spread it on a rock to dry and then the old people grind it, working under a *muhacha* tree. After that, they take the ground *rapoko* and start brewing. Once the beer is brewed, they put it in molded clay pots. All this is done by old people, most of them women.

"In the last picture," Maria says, "the men have been drinking beer and they are urinating behind a tree. That is the end of the story of what is done in the forest under the *muhacha* tree. They dance and drink quite a lot, and get drunk, and sing some embarrassing types of songs, sometimes about men's and women's private parts. Afterward, it will rain. Sometimes it will rain heavily. But most of the time, it doesn't rain at all."

Married nineteen years ago ("early because of the war"), Maria has taught her daughter to do appliqué and her son to do Weya painting, a skill few men know.

WE DRIVE TO OLD MABVUKU across the arid savannah, past rocks balanced precariously on top of each other and stacked higher than the trees, which have lilac-pink blossoms or black bark and flame-colored flowers.

The front yard of Faina Shonge's house contains one leg of an electrical tower, daisies, laundry, and curious children. She removes her canvas painting apron, turns off her soul music tapes, and invites us to have tea. She brings a basin with a towel to the living room so we can wash our hands, then offers us fat slices of fresh, crunchy wheat-nut bread with butter. Half a sandwich served with sweet, creamy tea, makes a delicious, filling lunch.

Faina Shonge was among the youngest artists accepted to study art at the Weya Centre five years ago, before she

Previous pages: At sixteen, Faina Shonge was selected to study at the Weya Community Training Centre. Students thought the art teacher was joking when she said they could earn money from painting.

Opposite: Enesia Nyazorwe's son lives with his mother at Cold Comfort Farm, a craft-and-horticulture cooperative. Enesia was one of the first five painters trained at Weya.

131

Above, clockwise from top left:
Sections of Weya art illuminate
Shona myths, beliefs, and culture:
Enesia Nyazorwe's tin plate shows
a sharp-toothed *nanga* (healer) pour-
ing medicine from a bowl to cure a
sick person. • Faina's figure-filled
painting describes village life: sitting
among other musicians with indige-
nous instruments, this mother plays
the thumb piano. • Another of
Enesia's tin plates features a picnic
attended by an armadillo, giraffe,
hyena, leopard, and fox. • One of
Ilse Noy's two male students, David
Chigmira, explains, "Spirits awaken
from the dead and there is terror in
the village. A house is burning. The
witch riding the hyena has a snake
on its back."

For many rural Shona, spirits are everywhere and are responsible for all things. Protective ancestral spirits—dead relatives who had children and were properly buried—are benevolent. But we are hearing now about afflicting spirits, who were not buried properly.

Something more contributes to the women artists' feeling threatened: the idea of individual accomplishment, a concept so antithetical to the Shona value system that there is no traditional word for "individual." Ilse Noy writes, "Shona people use witchcraft as protection against the rise of powerful individuals," and since Zimbabwe is a patriarchy, "the step into individuality is bigger for women than for men. As soon as a Weya woman proved to be extraordinarily talented artistically, she often fell sick, feeling too different from the rest of the people and believing she was a target for witchcraft."

For some envious women, the solution did not involve the spirits. "When people discovered that Weya painters were earning money, they started copying. So we now have more 'Weya painters' who were not trained by Ilse Noy than who were," explains Florence Maposa, the twenty-six-year-old powerhouse who is marketing manager at the Zimbabwe National Handicraft Centre.

WE ASK LOICE how things are going for her now. She says, "I am renting one room for seventeen dollars a month and three of my children are with my mother in Weya. I pay everything for them because those three children are not my new husband's responsibility."

Loice earns more than her new husband—up to $212 a month. "I work all the time because I want my children to go to school. I have to pay for uniforms, books. Room and board cost $636."
 "You are about to have another child?"
 "Yes. My baby will come next month. I am going to name him Bob. This is my husband's baby. He will help me pay for this one."

"WOMEN HAVE ALWAYS BEEN INFLUENTIAL in Shona society," James Musiwacho, general manager of the National Handicraft Centre, tells us. "For example, my sister has the responsibility of counseling if my wife and I have difficulties. If I had daughters, my sister would tell them about womanhood; my daughter would tell her first if she wanted to marry, and my sister would be sure the prospective husband was from a good family.

"Many husbands seek employment in town, where their cost of living increases so they have not much, really, to send back. A large percentage of the men in town start new families. So the women are left working in the fields, building the houses, making handicrafts. Seventy-five percent of the crafts in Zimbabwe are produced by rural women," James says.

Florence Maposa joins in, "When a woman gets twenty dollars, she doesn't buy beer or cigarettes, she buys food, clothes, and education for her children. So when customers buy products made by craftswomen in Zimbabwe, they make a big difference."

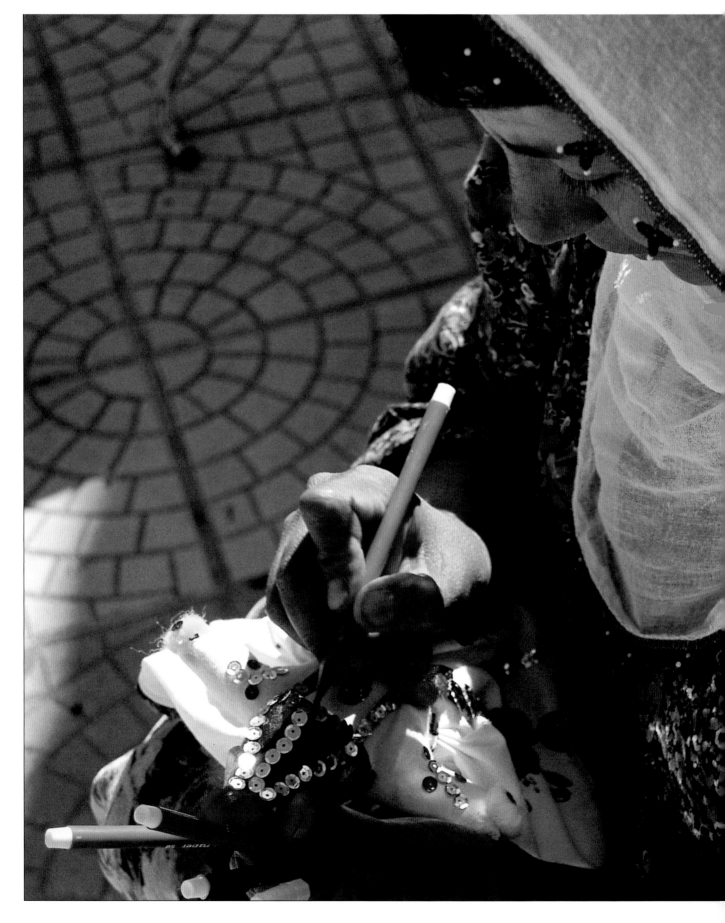

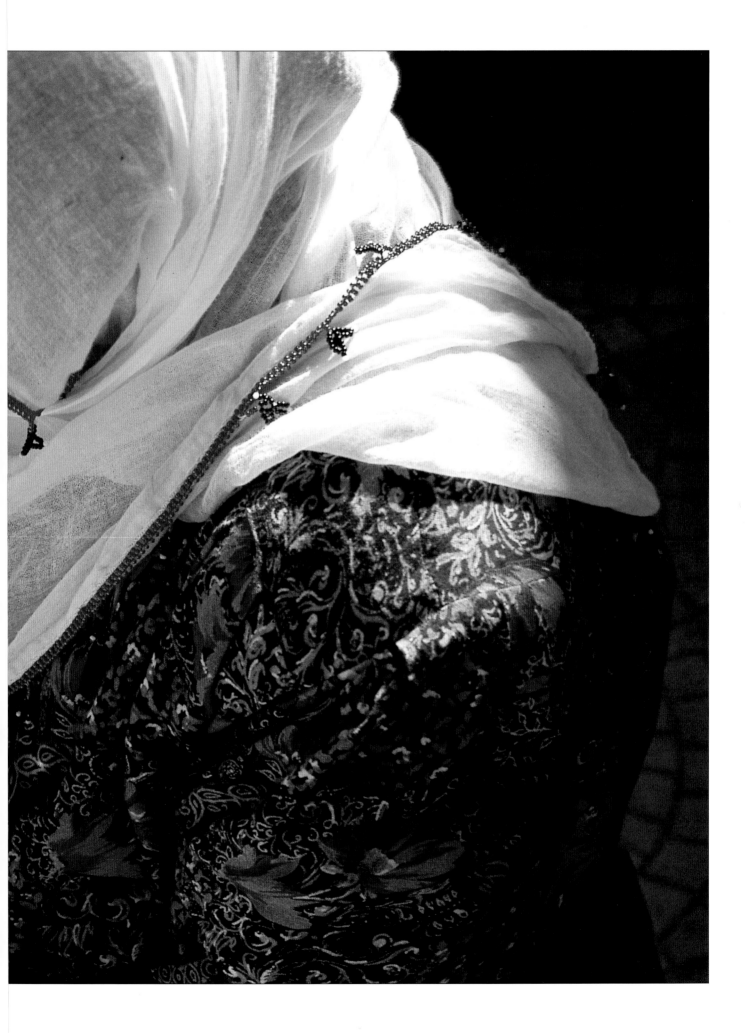

admits, "Sometimes there are conflicts. Sometimes the women get cold shoulders and don't talk with each other."

Ayşe is twenty-eight and has two daughters, ages eight and nine, who already play at making dolls, but Ayşe would rather not teach the girls. "I want them to take sewing or embroidery courses instead, so they can create dowries," she says emphatically. Ayşe hopes that by focusing on her daughters' dowries, she will save them the embarrassment she suffered before she was married, when, instead of having made her dowry, she had to buy it. Most Turkish mothers start to make dowry items when their daughters are two years old, and the daughters begin to help when they are eleven or twelve, crocheting, embroidering and sewing dust ruffles, laces, pillow slips, towels, and curtains. Before the wedding, a bride displays the treasures she and her mother have created, and neighbors admire, "So much! Such quality and artistry!" That did not happen to Ayşe, who recalls painfully, "I did not have time to make my own dowry pieces before I got married. I was too busy making dolls. I didn't feel happy about buying; I could have made things that were more beautiful." Shame permeates her words.

NONE OF THE WOMEN in the room is idle while we talk. Before our eyes, they start and finish dolls. It takes about an hour to make one. In the winter when there are no tourists, the women sit together talking and sewing for hours, each producing nine or ten dolls a day.

A doll cooperative was formed a year ago to promote Soğanli as a craft center, broaden the market, and wholesale to vendors at other tourist sites. At the underground city of Kaymakli, a tourist attraction twenty miles away, vendors sell dolls from Soğanli that they claim to have made themselves. This is very disturbing to the Soğanli dollmakers, but their reaction is judicious: "The cooperative is new. We will see how they do."

They cannot afford to lose business to outsiders. A doll sells for three dollars, but raw materials cost a dollar and the doll cooperative gets sixty cents. The modest $1.40 net profit is barely enough to buy daily necessities, but once food is paid for, the women work toward a bigger goal: their children's education.

Every Soğanli mother we talk to hopes her children will leave this village to continue studying after completing the local primary school. "We invest in gold bracelets, which we can easily convert to tuition and book money later," the women tell us.

HATICE GÜVEN, who lives up the road, invites us to lunch. At her house, we sit on floor pillows in a room that serves as dining room, family room, work area, and bedroom. It is furnished only with a bed for the parents; at night, Hatice's children, whose quilts are folded and stacked in the corner during the day, will sleep on the floor where we are about to have lunch.

Hatice spreads a cloth over our laps and brings serving trays of food with a fork for each of us. There are olives, cucumbers, a cooked tomato-and-egg dish, just-baked bread that can be spread with white cheese or butter, and fried potatoes mixed with onions and bell peppers. Turkish hospitality always involves tea; Hatice's hot apple tea is presented in little glasses.

During lunch, we learn that Hatice came to Soğanli, her groom's village, in 1979 and learned to make dolls. We admire a giant doll Hatice made years ago. To our astonishment, she reaches over and cuts off both its knitted hands, then ties one on each of our cameras. "There," she says, "that will protect you from the evil eye."

Hatice has three children now, and volunteers that she used an IUD to space them eight years apart. "It is irresponsible to have children you cannot feed and educate," she tells us. "We are lucky that the government makes birth control available."

She dreams of sending her two daughters away to continue their schooling, "because only with education is self-sufficiency possible." She proudly tells us what she has been able to do for her son, Bilgin (whose name means "learned"): "He is in a town down south living with his grandmother and going to secondary school. I send his food from here. Tuition and book expenses are steep, but within reach if I have good luck and plan well." Her daughter Gülsen, fifteen, has been making dolls for three years. She shares her mother's hope that one day she will finish secondary school. Her toenails are colored with henna, and she wears *salvar*, a silky, jewel-colored, harem-style pant-skirt. Gülsen pulls a little cardboard box from her pocket. The box, which she carries everywhere, holds yards of beautiful, cobwebby edging that she will apply to the domestic linens of a romantic, distant future. Despite her talk of selling dolls and going on to school, Gülsen is crocheting her dowry and dreaming about marrying a village boy her family will select for her.

We ask her mother what dreams she has for her own life. "My future will be good if the children are well, happy, and self-sufficient," she says. And if her dream comes true for her children, what would she like for herself? Hatice smiles, "I would like to live in a world where everyone's children are as well, happy, and self-sufficient as mine."

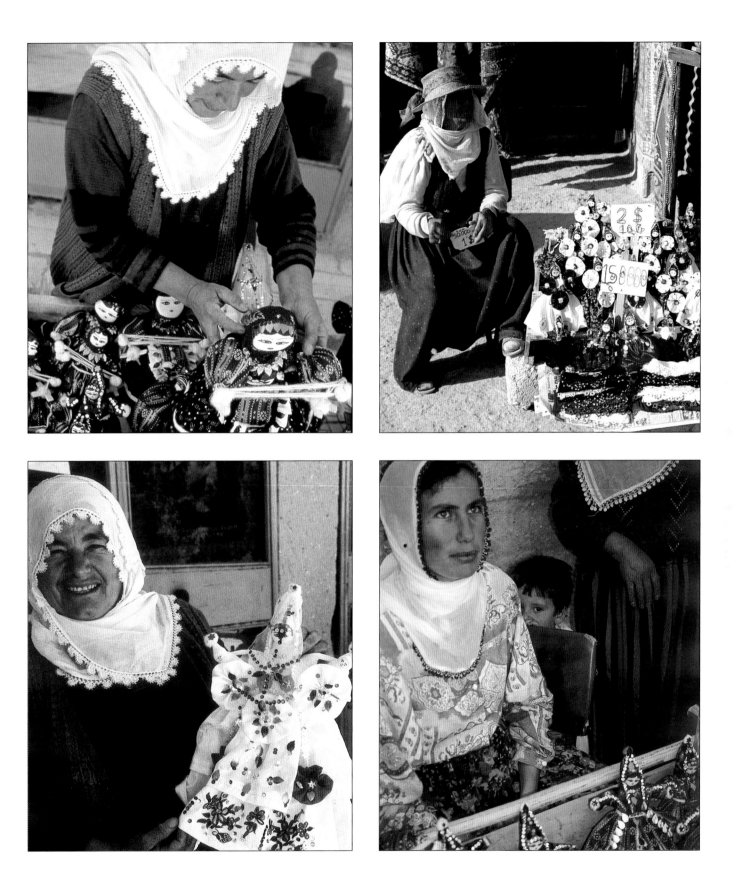

Above, clockwise from top left: There are fifty stone houses in Soğanli—and fifty dollmakers; who would have imagined that Döndü Ablak's homework assignment would inspire a cottage industry. • At the underground city of Kaymakli, twenty miles away, competitors sell dolls from Soğanli that they claim to have made themselves. • Cemile Ablak reports that when doll-buying tourists stopped coming during the Gulf War, Soğanli women learned to knit gloves, socks, and sweaters to sell to residents. • The vendors in Soğanli's doll market speak a few words of many languages—just enough to sell to tourists from virtually any country.

"Toby, Toby! Buy my baby!" "Toby, see this baby. Toby! Here!" I guess I made a mistake when a sweet-faced young woman asked me my name—and I told her. Now the clamor is deafening; everybody up and down the line is paging me.

"Paola, buy my baby." "Paola, my baby!" Good! I'm not the only one to have divulged my name. What a powerful sales tool these vendors have now; it is hard to ignore your own name at that decibel level.

The dolls are hardly babies, with their rouged faces and sequin-bedecked costumes. But they are showy! They are all so much alike, the prices identical—how to choose? On which seller will I bestow my three dollars, and whom will I disappoint?

A pretty young girl at the beginning of the gauntlet has been calling to me, but I walk past to take a closer look at someone else's work. When I get to the end of the row, there she is again! She has picked up her little "shop" and hustled it ahead to have another crack at me. Looks like I've bought myself a doll.

·Soğanli, Turkey

This page: Typically, female dolls are dressed in glittery clothing and carry spinning implements or babies, but a few dollmakers are test marketing male dolls.

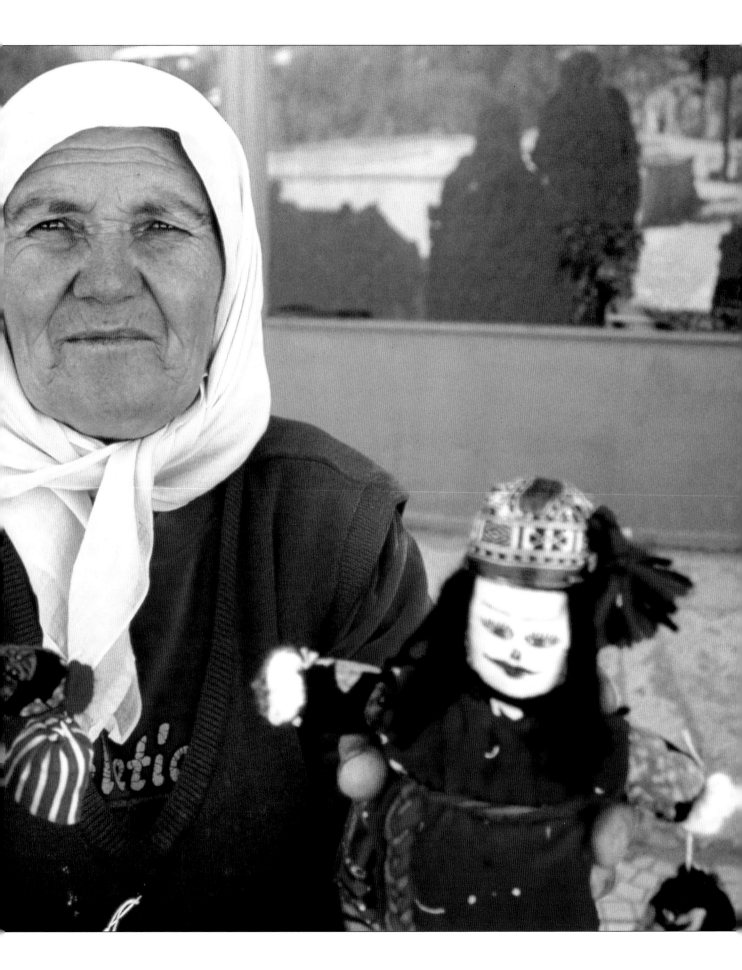

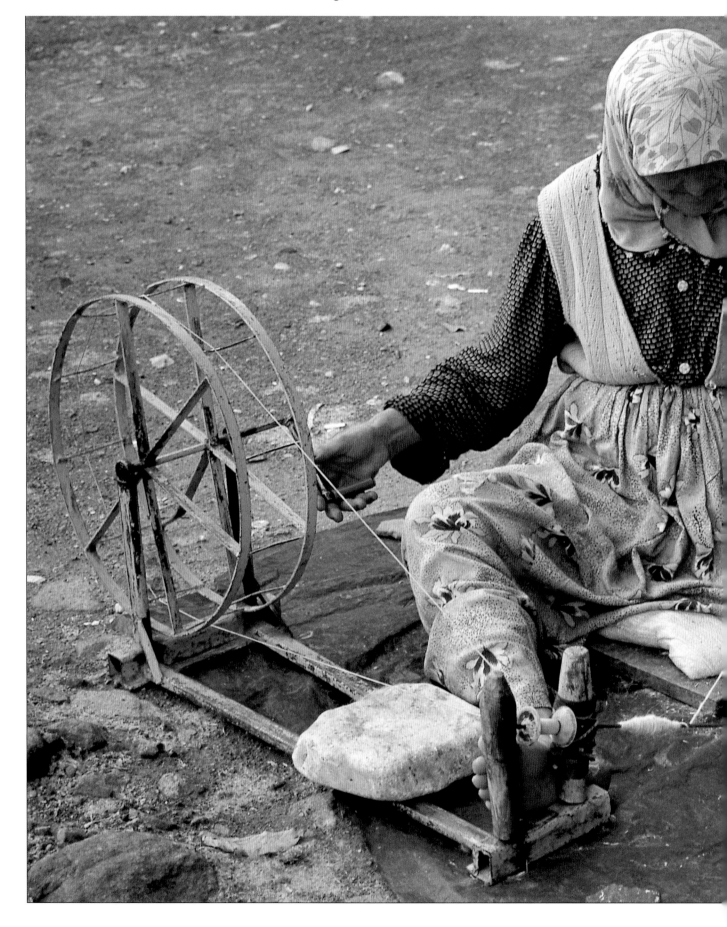

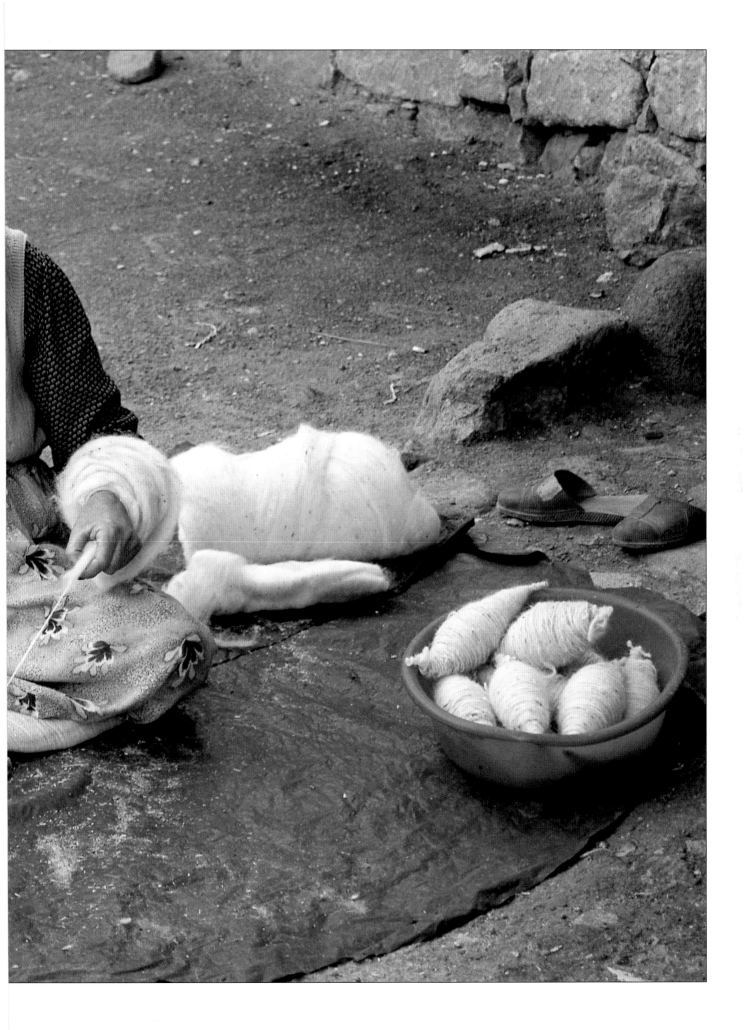

can work together as loom partners in the weaving shed. School does not start until next week, so Saffet's seven-year-old daughter sits next to her mother, blowing juicy, pink gum bubbles.

Saffet's nails are dark with henna, which prevents them from splitting from working with the wool day after day. Saffet and Hafize knot their rug in the same way their ancestresses, the Gordes, did three thousand years ago. Şerife explains, "DOBAG pays by the knot, and a seven-by-ten-foot carpet can contain over 600,000 knots, so you can understand why they need the henna."

In the Turkish countryside, only women make carpets, but men make them in the cities as well as in Iran. Nomadic women set the precedent, according to Şerife, whose Yörük family was nomadic before settling in Yuntdağ, near Izmir, one hundred fifty years ago. One of her most cherished heirlooms is the carved whorl of her mother's spindle, which her grandmother and great-grandmother before her also used.

The weavers at the two looms are married, variously, to a carpenter, tailor, farmer, and shepherd. Some husbands in the village farm tomatoes, corn, cotton, or sunflowers, and from the roaming stock, we guess that some raise cows, sheep, and goats. When the men are not in the fields, they spend whole days sitting in the teahouse while their wives spend seven or eight hours a day weaving.

What do their husbands think of the idea that men get to relax but the women do not? "They think weaving is nice because it brings in money," someone says. "They are proud because the weaving is beautiful," says another. "Our husbands want us to weave all the time," contributes a third, "but we do take a year off after our babies are born."

ERMINE DUDU ŞAHIN owns the weaving shed where the women are working. She is unusual because her parents arranged for her to be married at age fourteen to a boy she grew up with. Most couples marry after the man has completed compulsory military service, but Dudu lived with her parents while her husband completed his tour of duty. Now, thirty years later, she describes her husband as handsome and funny. "We love each other. We make each other laugh all the time." They seldom have time to relax, although they might roast a lamb and have a picnic during the spring festival. But on a daily basis, she is "very happy" and "wouldn't change anything."

Dudu's first child was born when she was seventeen. Like other Turkish women, who value marriage and mothering to the virtual exclusion of other lifestyles, Dudu tells us, "I live for my children and do not think about myself."

Her two sons now live in Çanakkale, thirty miles away. She visits them often. Neither is yet married, but Dudu says, "Because my husband and I are happy, I want my sons to have happy marriages, too."

Her dream daughter-in-law would, she says, "love my son, be clean, beautiful, and honest." She thinks these attributes may be difficult to find in one mortal, but hopes to find her sons "good wives, arrange engagement ceremonies, and finish all the work for them to get married." She looks forward to being a grandmother and may stop weaving to make time for her future grandchildren, although retirement is iconoclastic among the women of Süleymanköy. Many DOBAG weavers work until they are sixty, and Dudu is only forty-four.

Dudu has a kitchen garden inside her walled yard, with grapevines and walnut and apple trees. At the door of her immaculate house, we remove our shoes. On the floor of her living room is an expensive machine-made rug. She owns a television set, a tape player, and a telephone. "My husband calls me five times a day," she laughs. "He likes to hear my sound." Dudu and her tailor husband seem to be proof that, as someone tells us, "although Americans marry the person they love, Turks love the person they marry."

What do Dudu and her husband do for fun? Dudu giggles. "We make love."

"THE VILLAGE BELONGS to the women during the day; its spaces are their workrooms," Şerife says. As we walk through the Süleymanköy streets, we come upon a group of women sitting in the lane. Several spin wool with their feet. Some have round trays on their laps and are separating the wheat from the chaff. Three interrupt their dowry embroidering to draw straws and determine whose wedding will occur first. Fatma Kaya, who traveled to Norway as a DOBAG demonstration weaver, leans on her garden gate, telling stories about her trip. Other women dye wool in the yard next door; it dries in the sun, still snarled with the chamomile sticks whose yellow stain turns blue wool to green.

ŞERIFE IS TAKING us to meet another Dudu, Dudu Öztoprak, who turns out to be a storyteller. "It was 1950 in Süleymanköy. Everyone agreed the baby was going to be born that night. The mother had been having labor pains all day. Finally, her husband returned from the fields, lined the cart with blankets, and urged her to lie down. He yelled at the horses to gallop faster along the country roads and prayed they would get to the doctor in time. After having four daughters, surely this baby would be the long-awaited son. The road was rough. The horses were lathered. The ride seemed endless.

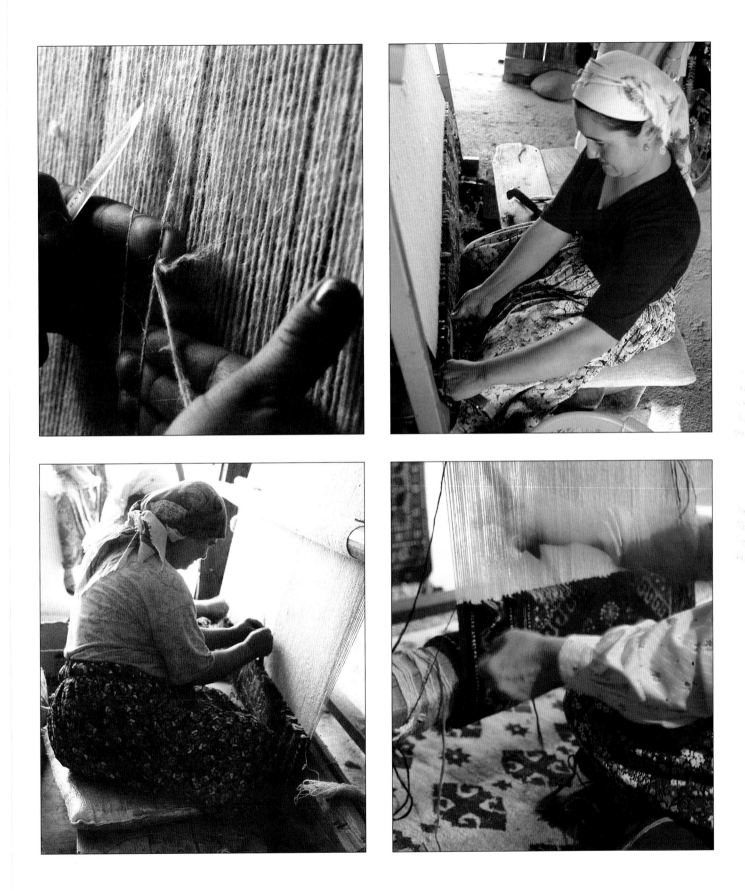

Above, clockwise from top left: Looping the yarn around the warp threads, weavers knot their rugs the same way their ancestresses, the Gordes, did three thousand years ago. • Synthetic dyes ruined the rug market, but in 1981, DOBAG weavers' use of natural dyes reversed the downward spiral. • Cennet Deneri clips the wool, then compresses new knots against the edge of the carpet that rises on the loom as she works. • Hafize Aydin applies henna to her fingernails to prevent them from splitting in the course of handling wool yarn every day.

hangtag. The DOBAG rugs' quality is so high that Marmara University guarantees them for two hundred years.

Before leaving the cooperative, each woman picks up a new carpet order and buys the materials she needs to complete her next assignment. She purchases wool sheared in the spring from live sheep reared on the surrounding hillsides—the only kind that meets DOBAG standards. "Wool sheared at the end of the summer is only good for stuffing mattresses," Şerife explains. "Even our members who are shepherds' wives buy carpet wool from DOBAG, since a single shearing from ten sheep provides barely enough wool to make a square yard of rug."

TWO CHILDREN HAVE SAT all morning on the rolled carpets in the DOBAG hall and are now cooling their heels in the wool dock. They are cousins, daughters of weavers Dudu Vural and Bahriye Arcam. It is hard to wait, especially today, which is market day in Ayvacik. Often the weavers take their rug money directly to the market to buy harnesses, thread, beads, clothing, and food. But not today. Today, Bahriye and her daughter, Nurdane, will go to the market to buy a blue primary school uniform just like the ones children wear all over Turkey. And Monday, Nurdane will go to school for the first time in her life.

We accompany mother and daughter to the weekly tented street market. Sheep bawl from the trucks. Chickens peck at the street. Sellers compete for attention for their stalls full of toys, shoes, nuts, eggplants, chilies, and cheese.

Nurdane selects her uniform. Then, filled with excitement, she bunches up the outfit she has dreamed of and joyfully buries her face in the blue cloth.

Opposite, top: While Süleymanköy men spend time in the fields and teahouses, the women use the village streets to spin, separate wheat from chaff, and sew dowry embroideries.

Opposite, bottom: Weaver Dudu Öztoprak hopes to have earned enough to buy land and build a house for her son before he gets married. Perhaps his house will be like hers.

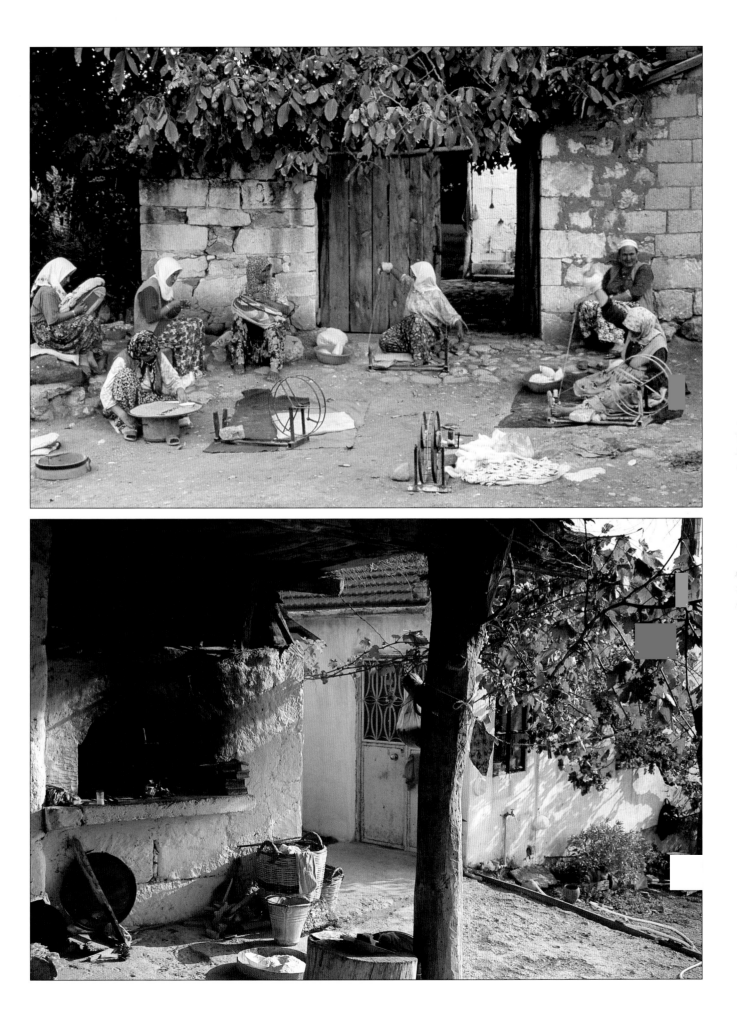

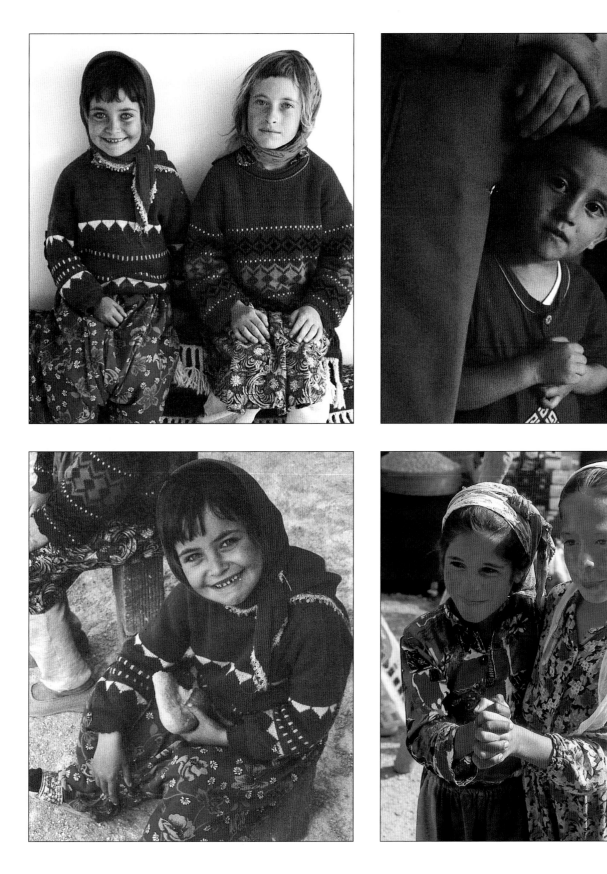

Opposite: Young girls all over Turkey wear royal blue cotton primary school uniforms.

Above, clockwise from top left: Nurdane Arcam, left, and her cousin wait on a rolled carpet for their mothers to complete their business at the DOBAG depot. • Children often watch while the knots in their mothers' newly finished carpets are counted; the number of knots determines the price. • Two friends dance while their mothers shop at the market in Ayvacik. • Nurdane enjoys a snack before her mother buys her the uniform she will wear when she goes to school for the first time in her life.

"Oh, please come and see my house. We'll have tea."

That sounds just great, so Dudu leads us away—Paola and me, Şerife, Özlem (an interpreter fast becoming a friend), and one of the weavers, a beautiful young woman, wife of a schoolteacher, with a little daughter.

Dudu starts the tea while we take a look around the Şahin family home, and then settle into the divans and cushions of the main room—a simple, spotless, quiet place. The conversation is relaxed and idle, unlike the purposeful talk of interview sessions. The kettle boils, the tea appears, perfuming the room with apples and cinnamon, and we settle even more comfortably into our lazy little respite. It feels a bit as if we're cutting class, with all the other weavers still hard at it in the shed. The talk is of life and love—Dudu is so in love with her husband, Özlem has a beloved whom her parents detest, Şerife has been disappointed—the need for translation doesn't slow us down a bit.

And then the conversation does slow down, so I offer, "Shall we dance?" I'd made all the weavers laugh when I ad-libbed a faux belly dance to their singing earlier, so now we all laugh again. And then lovely Leyla slips a tape into the player and fills the room with Middle Eastern rhythms and minor-key melodies. She is some dancer! The sensuous, sinuous moves are punctuated by spurts of rollicking, jolly, up-tempo hip-waggling, and then like gunshots, the most amazing finger-snapping sound effects—a different sort of hand trick that I feel sure nobody in America can do. Paola is heartbroken that she can't master it.

Everybody up, we all must learn to belly dance. Well, I am no Leyla, but nonetheless, this is a hoot, bumbling my middle-aged self around the room with visions of Salome and Theda Bara undulating in my head.

Şerife, who isn't up to the exertion just now, lies back on the divan and pops another chocolate into her mouth.

· Süleymanköy, Turkey

This page: After turning in their rugs on Fridays, DOBAG weavers take their money to Ayvacık's weekly market to buy thread, beads, clothing, food, and horse harnesses like these.

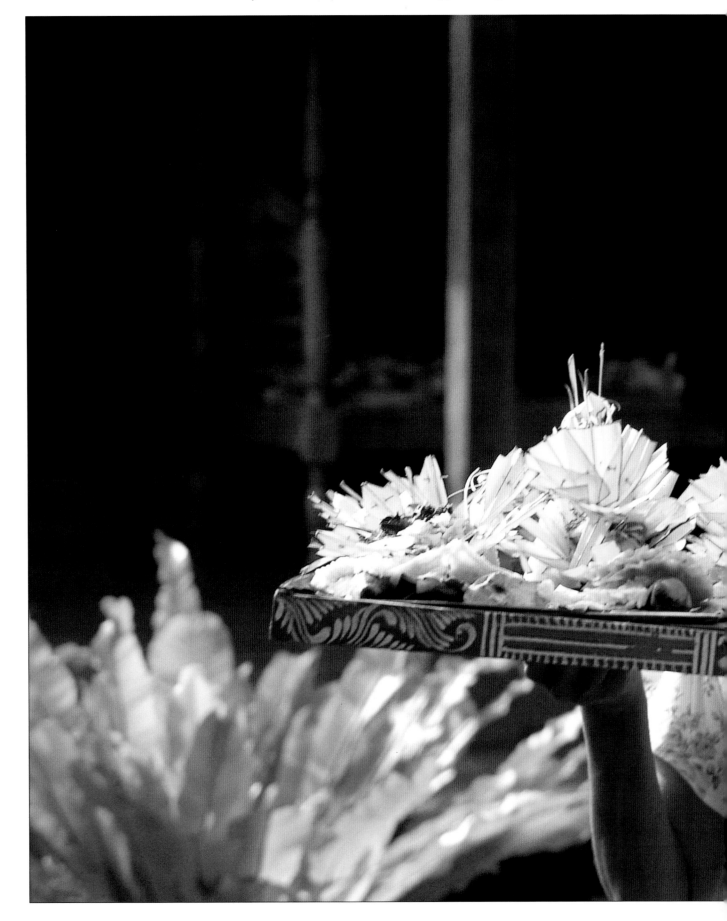

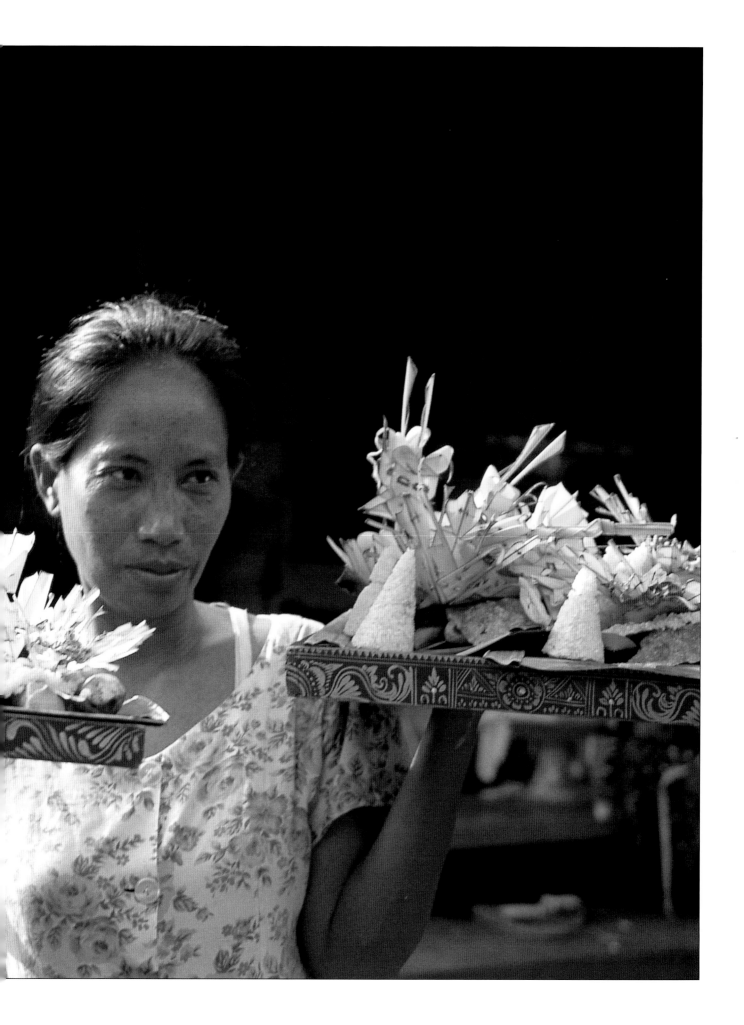

EVERY MORNING BEFORE BREAKFAST, each woman on the island of Bali conducts a series of rituals with beautiful offerings created from coconut palm fronds, flowers, rice, and betel nuts. She puts her offerings inside her home and outside around the village, in both high and low places to petition the heavenly gods above and placate the demons below. She sanctifies them with fire and water by lighting incense, wafting its smoke over each offering, then flicking drops of holy water from a fragrant white flower. This ritual requests prosperity from the gods and maintains the harmonious balance between the divine, human, and natural worlds. "If things are out of balance, it is apocalypse," a Brahmin woman tells us.

Traditionally, Balinese women spent half of every day making offerings. The act of creation suffused them with the maker's spirit and was part of their gift to the gods. But allocating so much time to the offerings is impossible for many women now because they have jobs. Yet they are still personally responsible for maintaining tradition. Their solution is to buy canang (daily offerings), in the market from the Brahmin women.

IDA AYU NYOMAN SAYANG, who is called Dayu, is giggling like a little girl, sitting with a friend in the Ubud market; in front of them large flat baskets are brimming with nasturtium blossoms and hydrangea petals. Both women are Brahmins, the priest caste, who make and sell the offerings to other Balinese women on this Hindu island.

Dayu tells us, "Ten women from my village now make offerings for sale. My mother was the first. I learned how to make canang as a child by watching and copying what she did. When I was in the sixth grade, I began to go to the market with her on Sundays. I left school and worked there full time after that year. I am now thirty-five, so that was a long time ago."

Dayu gets up at six, before anyone else in her household, dresses, skips breakfast, collects her products, and takes them to Ubud on the bemo (public bus). Her mother, who lives in the next village, precedes her to the market; some women arrive there as early as midnight.

While Dayu is gone her woodcarver husband, who works at home, takes care of their daughter, three, and son, six. After selling until early afternoon, Dayu returns home to create more products for the following day. Usually her husband does the cooking ("Last night, for example, he fixed eggplant for dinner, with rice. I love that!"), but if dinner hasn't been prepared, Dayu cooks, and then continues making offerings until midnight.

We ask how much she earns from her eighteen-hour days. "Daily sales average four dollars," she says. "But by the time I pay for a round-trip bemo ticket, flowers, palm fronds, and perfumed water, I am left with a dollar sixty." A restaurant manager later tells us that forty cents will buy only a simple meal for one person.

Dayu earns more than her husband does each month: fifty dollars compared to his twenty dollars. "It's not a problem for him that I earn more," she says. "We have separate monies but a mutual understanding that we will both contribute to our expenses."

Her husband's full name is Ida Bagus Putu Sunantra, but he is called Aji, which means "father," just as Dayu means "mother." "Aji puts in money for ceremonies and food. A kilo of rice costs forty cents and then there are vegetables. We decide together how to spend our money. The amount we have is not enough—there is nothing left for extras. My son needs twenty cents for food at school. Elementary school tuition is free but students need uniforms."

One day we go home with her from the market. En route, we drop off her mother who still lives in the village where Dayu grew up. When Dayu was married, she moved in with her husband's family, as wives do here.

Aji's family compound is near flooded rice fields that reflect the clouds as if there were sky, not earth, under the seedlings. Dayu disembarks from our van and carries her bundles of raw materials on her head, leading us down a dirt lane through flowering bushes.

Her husband quickly dresses their naked three-year-old daughter in a pink polka-dot sundress to welcome the visitors. Their six-year-old son camps on the deck of the house to the right to inspect Dayu's bundles. An uncle smokes, perching with us on the porch floor to chat. Aunts and nieces come to greet us. Two men carve wood sculptures, hunkered down on the porch of the house to the left. Across the courtyard is the ceremonial house. A path leads to the family temple, which has walls but is open to the sky. Unlike most temples we have passed that are already decorated for the coming holiday, it is empty.

Dayu weaves coconut palm fronds as we talk, and her daughter, who sits silently behind her, copies her every move. "If you're a good student, you can learn in ten minutes," Dayu promises. We try diligently to sew palm leaves with tiny pins of bamboo.

Dayu confesses, "I would rather have my daughter go to school than work with me in the business. I hope these children can eat, get good educations, and take care of me when I get older. I hope my daughter will marry and live nearby, just as I live close to my mother and can visit easily and often."

Having worried openly about the fact that she has nothing to offer us, Dayu has arranged with her extended family to borrow coffee and packaged cookies, which she presents on a painted tray. Each cup of coffee has a dirty, pink plastic lid and, as far as we know, there is no water here to make coffee except in the muddy ditch near the road where we have seen people bathing and washing laundry. But it would be a terrible affront to refuse to partake of her proudly offered, generous hospitality.

Dayu tells us she first saw her husband passing along the road. "He just looked nice to me. There is no matchmaking here. You see each other, like each other, and just take it." Her wedding seven years ago was one of the highlights of her life. It took place in the family temple "with lots and lots of offerings that the elderly people and the young people all helped make for the ceremony. The old men made the bamboo altars and the meat sate for the wedding. I wore a *kebaya* (lace shirt) and sarong."

Other important events for her were her children's rites of passage. "First haircut rites occur in the ceremonial house after children are three months old. My husband shaved my child's head that morning, as purification. A specialist who works closely with the priest created the offerings, which were everywhere. The priest's assistant came and made blessings for my child.

"The happiest time of my life was when I was young and didn't know anything yet; my mother would come back from the market and give me money. The saddest time is now; we are having a Galungan holiday and I don't have enough money. I am angry because my husband won't share his money when I need it." Handsome Aji, who overhears Dayu share this confidence with strangers, stomps out of the courtyard.

As if to defend Aji, his uncle bounds into the conversation. "For the holiday, Aji will cook traditional ceremony food. He will slaughter a pig tonight, chop it up with vegetables, and make a feast." Compared with the daily rice diet, pork is a delicious luxury. Will the pig be slaughtered in the temple? "No, pigs are only slaughtered in the temple for village temple ceremonies. Galungan is celebrated in the family temple."

The uncle then shows us his fighting cock, which he has trained for mortal battle. Although the law prohibits cockfights, spilling cock blood in the temple on a holiday is allowed and is considered a sacrifice.

Galungan, the holiday that welcomes ancestral spirits to earth for a ten-day visit, is two days away. Festival offerings are never purchased, although individual ingredients often are. Working wives rise at four in the morning for

days to prepare Galungan offerings, which are far more elaborate than *canang*.

Back in the Ubud market there are stalls and vendors that sell hibiscus and frangipani blossoms. There are baskets of edible offering ingredients: hard-boiled eggs, fruit, cookies colored with neon pink and green food dye. All offering materials come from the earth (flowers, leaves, fruit, grain, fowl) and will be transformed by cooking, frying, cutting, mixing, and assembling to please the ancestors' senses of taste, smell, and beauty.

Balinese people combine ancestor worship with Hindu beliefs and animism. Here, the word "ancestors" is not reserved for ancient relatives. It includes anyone who has died and had a cremation ceremony, an event so elaborate and expensive that bodies are often buried for a few years in graves until the families can afford the cremation that will liberate the spirit. Thus, some families will celebrate Galungan by taking food and flowers to the cemeteries. But most will fill their household temples with the lavish offerings.

In Bali, opposites are believed to derive meaning from their complements. Black and white define each other; good and evil are equally necessary.

A central theme in Balinese cosmology is the combination of male and female principles in the creation of life. Black represents the feminine, red the masculine; combined with white, the two symbolize the unity of the universe.

Not surprisingly, gender roles are distinct, even in creating offerings. Men do not make daily offerings unless their wives are menstruating, in which case husbands must take over.

Men have their own Galungan assignments. Like Aji, the men slaughter the pig. Men also build the bamboo altar and *penjor* (arch) that decorate the front of every house. Women make *penjors* only if their husbands are dead. But women always create the *sampians*, which are ornamental cages of bamboo and flowers that swing from the top of the *penjors*. And each woman decorates her husband's bamboo altar with a *lamak*, a patterned banner woven of leaves that in some districts are embellished with sequins, embroidery, and tassels.

Two nights before Galungan, the night is rent with the screams of pigs. The air is otherwise silent, humid, and close.

The next morning there is the usual natural hum: roosters crowing, crickets chirping, birds singing. Today, women will finish their work on their holiday offerings. We visit families where the women are filling tables and trays with

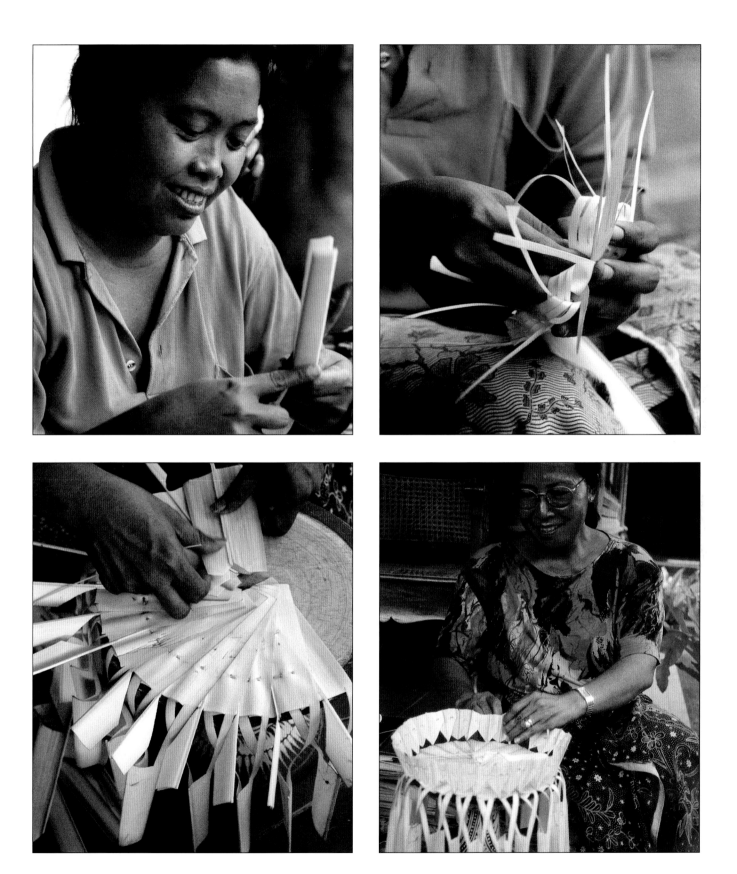

Above, clockwise from top left: Dayu starts making *canang* (daily offerings) by cutting palm fronds into strips. Her three-year-old daughter, whose hand is visible behind Dayu's ear, watches every move. • Dayu next shapes the strips into loops and pinwheels, and secures them with tiny pins cut from bamboo spines. • Ni Wayan Murni finishes the leafy base for what will become an offering pedestal stacked with fruit that is decorated with flowers. • Murni has run businesses most of her adult life, but only now is she learning the offering crafts that have long occupied most Balinese women.

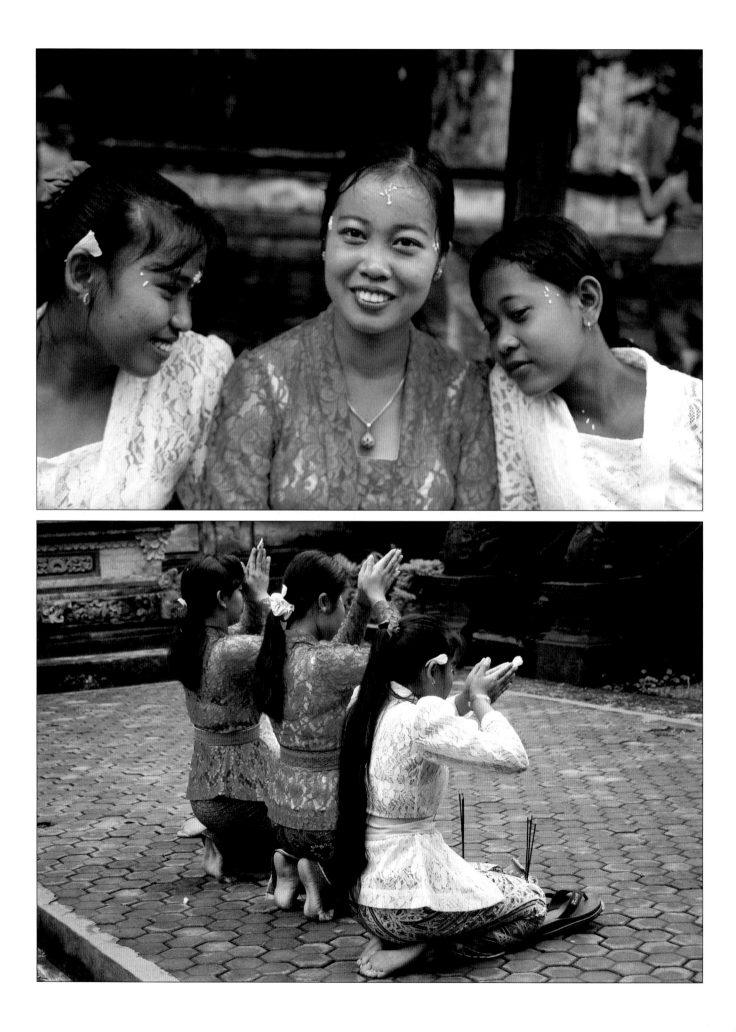

sculptures composed of bananas, oranges, leaves, flowers, fringes of fronds, cookies, cakes. Their daughters have braided leaves into origami-like shapes. Groups of women have stacked pyramids of fruit on red pedestal plates. By evening, all the women heap the altars in their family temples with offerings of breathtaking beauty.

WE ARE TOLD THAT Balinese women have long been laborers, but until about twenty-five years ago, men did not seek jobs; they worked in the rice fields. Women typically held the purse strings, which caused some friction as men entered the work force. Recently, tourism has provided more paid employment for both sexes.

Ni Wayan Murni has been in the tourist business most of her life. As a young woman in the 1960s, Murni was the first vendor to sell sarongs on the beach when Australian and American hippies first discovered Bali. She used her proceeds to open Murni's Warung in Ubud, which is now a popular, contemporary three-level restaurant with a boutique full of gifts, crafts, and other treasures that she buys all over the Indonesian archipelago. She also owns Murni's Houses, an enclave of cottages on the hill in the Campuan section.

On the afternoon before Galungan, while her father finishes the bamboo altar outside the wall that surrounds the family compound, Murni sits on her porch making offerings. Her life has always revolved around business and she has not, until now, made time to learn the craft that has long occupied virtually all other women on the island. "I made a choice this year that I would take two weeks off to learn this art. It is time." She and four women on her staff put the finishing touches on two hundred holiday offerings, enough for all her enterprises and her home.

Murni reminisces about other Balinese celebrations. "Tooth filing is usually done between puberty and age fifteen, but my parents couldn't afford it. In our religion, it is believed that filing must be done before you die. We file the top of our teeth so they are smooth and even. If no filing takes place and your teeth remain sharp, you are assumed to be a demon after death. So here I am, a grandmother, and my tooth filing ceremony just occurred! It took three months to prepare for the celebration, which itself took four months and was attended by almost three hundred people in total. We built temporary kitchens to feed fifty guests every day."

Murni will begin her Galungan celebration at home. "In the morning, we will pray in our temple, which includes an altar for Vishnu, the sun god, plus altars to our dead ancestors. My stepmother died two months ago and has not yet been cremated, so later in the morning we will take offerings and visit her in the cemetery."

At Murni's family temple, her helpers are placing tier upon tier of offerings: apples, pink jambu fruit, eggs, cakes, cookies, meats carved into filigree, layers of flowers, cones of rice, spices, vegetables. There are swags of the ubiquitous black-and-white checkered fabric. There are perfect pyramids of fruit. Surely, we think, the ancestors will be delighted.

ON GALUNGAN, Balinese women arrive to help us dress properly in traditional attire. We are given kebayas and sarongs, complete with sashes that must separate the upper body from the lower, less pure parts. We are asked to adhere to the rule that women who enter the temple must wear these sashes—and must not be menstruating.

Hobbled by sarongs that wrap around us three times, we gratefully avail ourselves of the ramp that runs up the center of the steep hillside steps of the village. We assume the ramp is to help women walk gracefully, since only small, shuffling steps are possible. Later we discover that Balinese women do not need any help and that the ramps are built for motorcycles.

After family services, there will be visits to the village temples and perhaps to Pura Besakih, a cluster of ancient shrines that comprise the most sacred temple in Bali. Already, women parade to the moss-covered temples wearing sarongs and pink, teal, blue, green, yellow, or red lace kebayas, each carrying a tower of offerings on her head. We watch the priests bless the trays and then stick a few kernels of steamed rice on each woman's forehead to bless her with fertility and abundance. Since the offerings have served their purpose, these beautiful food plates are now taken home to become family feasts. The Balinese will share this meal with their visiting ancestors.

ALL BEDS IN BALI face the sacred mountain, Gunung Agung. Pura Besakih, the holiest temple, is there. We visit Besakih on Galungan afternoon after driving through the corridor of magical penjors that arch across the road in front of every house. We follow the Balinese men, all dressed in pure white shirts and sarongs with gold satin sashes. The Balinese women effortlessly carry offerings on their heads. We climb up the stairs, up the mountain, to the inner temple where throngs pray under the red, black, and white umbrellas that symbolize Brahma, Vishnu, and Shiva, the trinity that creates, maintains, and destroys the universe and is responsible for the cycle of life on earth. Under each fierce dragon statue, around each muscular golden lion, are stacks of floral offerings: bouquets wrapped in leaf cornucopias; blossoms heaped in containers woven of palm.

JUST AS GALUNGAN is a "visiting holiday" for ancestors, visiting is the afternoon activity for those who live on

Opposite, top: Women must wear kebayas (lace blouses), sarongs, and sashes to enter the village temple where a priest applies sticky rice to bless them with fertility and abundance.

Opposite, bottom: Women sanctify their offerings with fire and water: they waft incense smoke over each offering, then flick drops of holy water from white flowers.

167

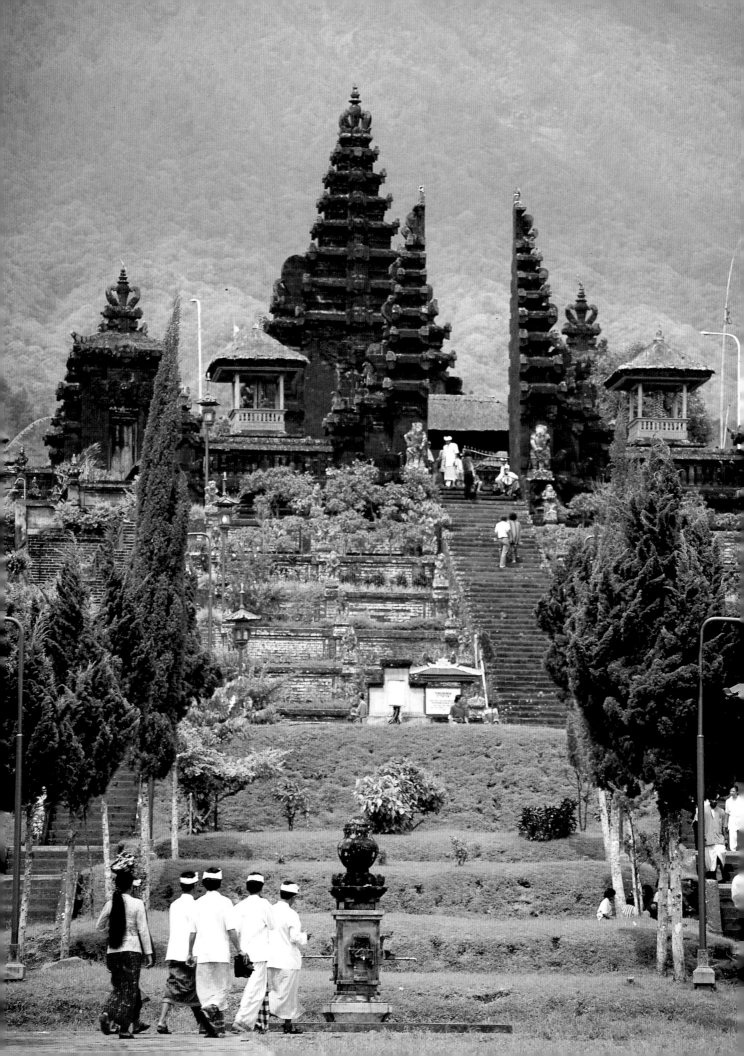

Opposite: The afternoon of the holiday, the Balinese visit Gunung Agung, the sacred mountain, and climb to Pura Besakih, the holiest temple on the island.

Above, clockwise from top left: *Penjors* (bamboo arches) decorate the front of every house in Bali during Galungan. • The market in Ubud is full of vendors whose baskets contain hibiscus, frangipani, and marigold blossoms that are destined to become Galungan offerings. • Men build the *penjors* and women create the *sampians* (end tassels) of bamboo and flowers. • After offerings are presented, they have served their ritual purpose, and the beautiful trays of food are taken home for family feasts.

169

earth. Families and friends sit by the side of the road to watch motorcycles carrying lovers (all wearing traditional holiday clothing, some balancing a bird cage containing a fighting cock) and families (always father in front, infant in the middle, mother in back). They are headed for a relative's house, or to have a picnic in the arboretum or a walk in the palace gardens. Hoards of motorcycles pass family temples decorated with umbrellas whose dangling tassels dance in the breeze, with festoons of checkerboard cloth, with streaming ice-cream-colored prayer flags, with *penjors* and *lamaks*.

The motorcyclists pass offerings placed by the streams, near the lakes, and in the rice paddies to thank the gods for the fertility of the earth and life-giving water. They pass offerings on the ground in front of buildings, on the sidewalk, and in the street to appease the demons and keep them from disturbing the harmony of the universe. Everywhere they look, offerings.

Opposite: Galungan is a "visiting holiday" for both Balinese and ancestors. After finishing the rituals in their home and village temples, people ride motorcycles to call on friends and relatives.

Ubud is a delightful town—this Balinese cultural center tucked into the foothills and ravines below the island's central mountains—but we yearn to go exploring. We need to see Galungan as it is celebrated in the countryside, and to photograph holiday decorations all over the island.

Our guide for this excursion will be Wayan, who drives guests around for our hostess, also named Wayan. The name means "first-born," so every family has a Wayan, either a girl or a boy, if they follow custom. Then the next child is named Second in Balinese, and then Third and Fourth. With the fifth child the naming process starts over again with Wayan.

Our guide Wayan is dressed for the holiday. Yesterday he was in jeans and a polo shirt, like a nineteen year old anywhere, but today he is wearing proper Balinese attire: a white shirt/jacket with Nehru collar, a sarong of gold-colored cloth, and a white cotton square, diagonally folded and tied around his head with the corners pointing up in front.

The road out of town is a narrow, undulating, paved strip passing between walled family compounds and curving around crumbly stone temples and figures of heroes, gods, and demons. Each family home consists of a cluster of little buildings, or bales, for various functions—sleeping, cooking, washing—a family temple, and one or two freestanding shrines. The bales all have peaked roofs of thatch or tile, peeking up over the compound wall.

We drive through rice country, endless waves of terraces sculpted in graceful curves in a hundred shades of green. Then, suddenly, we have arrived at a village—a true traditional one like those of Balinese days long past, where Wayan lives with his grandparents.

The holiday decorations bestow a delicate, fairy-tale look to the village, bamboo penjors standing fifteen feet tall all along the way, then arching over and dangling fragile confections of flowers and palm leaves above the path.

There is a community pavilion, open-sided and thatch-roofed, with a performance platform at one end where a pair of gamelan instruments rests. Wayan remembers when he and other youngsters used to spend long afternoons here, trying in vain to make real music on those bamboo xylophones. Off to the side, perched on a row of sawhorses, is a Barong costume. We are delighted to imagine the little boys struggling around under the two-man shaggy lion/dog getup. Barong is an important figure in Balinese mythology. He is guardian of the people, so he is one of the recipients of abundant Galungan offerings. In the traditional play, Barong is the good guy, a mythical defender protecting the hero from evildoers.

At Wayan's grandfather's compound, one of the few we have been asked to step inside, the four or five bales are utterly simple and alike, built on raised platforms and open on one side. In one of them, Wayan's grandmother stands at a table working on her Galungan offerings. She is beautiful, and appears to be very old; she wears a sarong and sash, and is barefoot and bare breasted, in the old tradition. In another bale sacks of rice and other family necessities are stored, along with grandfather's fighting cock, who waits under his basket for the hour of his holiday duel at the temple.

. Ubud, Bali

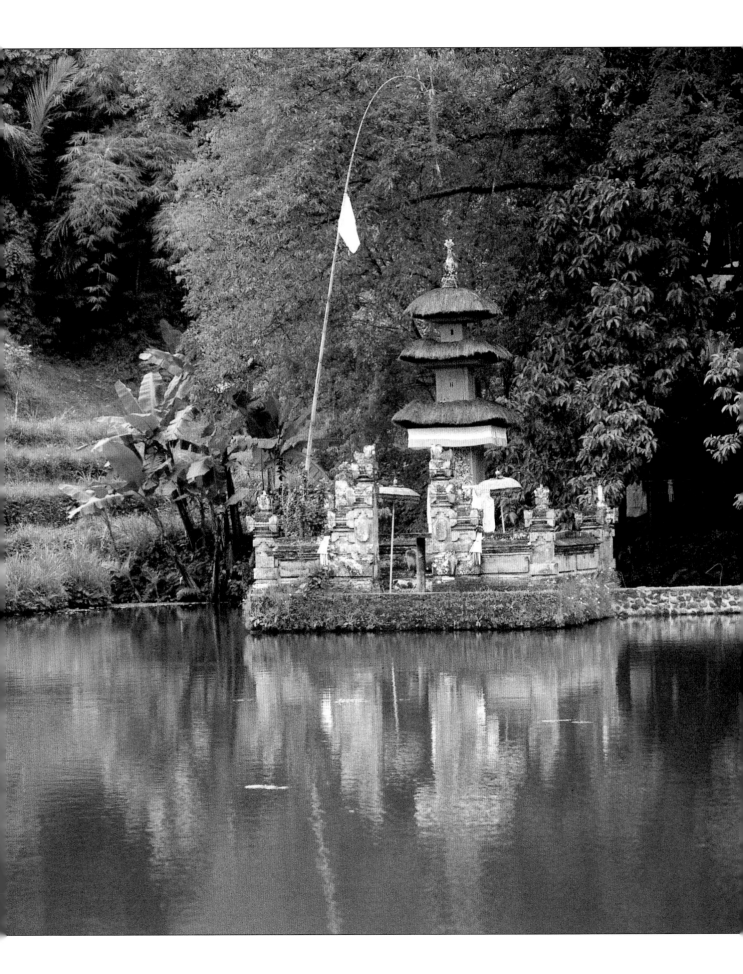

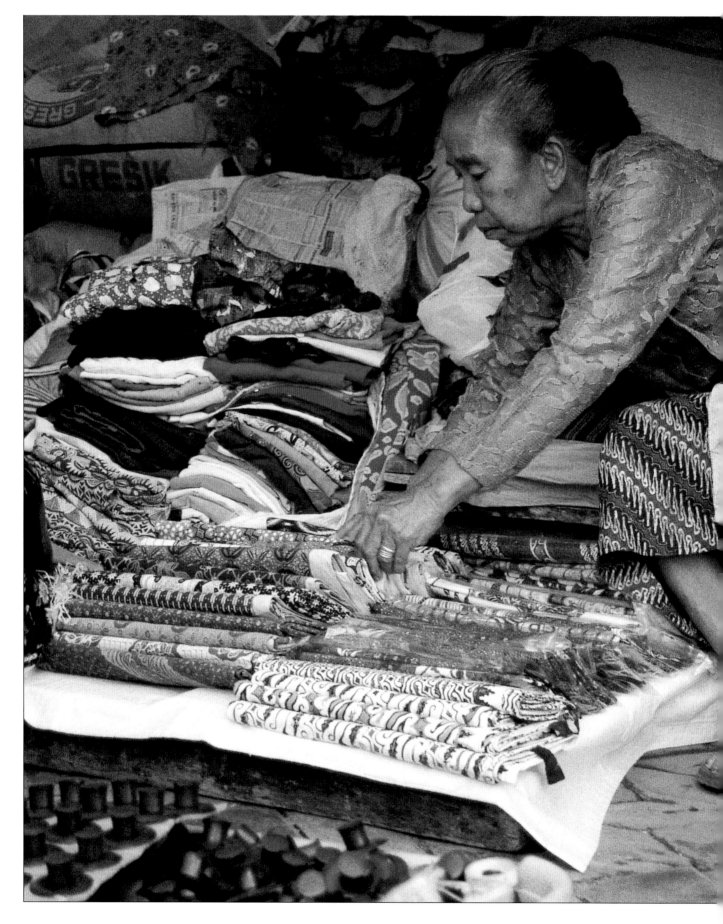

INDONESIA *Two Batik Artists*

War II. She was not allowed to sell from a permanent location, so she moved her inventory from place to place each day, hoping to position herself near major arteries. But there was little traffic because there was no gasoline. Business hours were short due to curfews. Sometimes she had no money to buy merchandise to sell; sometimes customers had no money to spend. Frequently, she had to barter cloth for food for her family.

In 1953, she and her husband opened a real shop. Their daughter, Rahayu, helped there after school when she was old enough. After Rahayu was married in 1969, she began to make batik at home to sell to retailers. Nine years later, when her father died, she began to work full time in her family's stall and grew the enterprise into the operation it is today.

By all standards, her business is a success. She owns a factory in Pekalongan that prints the designs she creates. Her shop, Toko Sri Djaja, is reputed to be one of the best in the city's batik market, Pasar Klewer. When Mrs. Suharto, the first lady of Indonesia at that time, invited ambassadors' wives to her annual coffee morning in Jakarta, where she showcased the country's finest crafts, Mrs. Rahayu's fabrics were always exhibited.

This daughter of an itinerant vendor, high school graduate, and single mother of four, has built a house worthy of a magazine feature. We interview her there at breakfast, because she must open the shop at ten. White marble halls open onto a small private lake in the backyard. Birds sing from hanging cages. Her parrots speak reputable Indonesian. There is an aviary of peacocks. A father-mother-daughter team works for her as gardener, housekeeper, and cook. We are served sugary miniature pancakes and feel very pampered.

Later, when we visit her at the batik market, we find that Mrs. Rahayu's work environment is as clamorous as her home is calm. The batik market is surrounded by people selling sausages, prickly rambutan fruit, plucked chickens in buckets, bananas, whistles, paintings of Javanese puppets rendered in metallic pigments on calfskin. *Becaks*, bicycle taxis that look like strollers for adults, jockey in the street. As we arrive, a torrential rain floods the area without warning and sends everyone scurrying for cover.

Inside, the dim batik market is jammed with buyers, beggars, and vendors. A strolling singer carries a tin cup, microphone, and boom box. A woman struggles upstream with a tray of glasses: coconut milk and rice tea served with lemon slices. The market has two hundred fabric stalls. Goods are hung, piled, shelved. Displays reach the ceiling and sellers use hooks on sticks to get hangers down from high places. Some sell from elevated

stalls surrounded by stacks of batik. Darkness is broken by hot green neon lights. Sweat pours off our noses and chins, making rivulets under our clothes.

Astonishingly, Mrs. Rahayu looks cool and elegant. She unfolds sheer silk batiks; some are *tulis* (hand drawn) and others *cap* (stamp printed), but all are drizzled with gold. Fabrics neatly wrapped in clear plastic are stacked on three sides of the counter all the way to the ceiling. "A word-of-mouth reputation for good service and fair prices has been critical to our success. Many shops here have good merchandise," Mrs. Rahayu admits, "but our shop has good customers." In total, those good customers spend two thousand dollars on an average day; Mrs. Rahayu's net profit is ten percent.

Have women always been associated with batik in Java? "Most batik stores are run by women, who are known for selling and negotiating," she tells us. Although two of her three assistants are men ("I have supervised them for fifteen years; it does not cause resentment."), her third assistant is her mother, now seventy-two. Mrs. Rahayu hopes that her own daughter will come into the business, although Rini, sixteen, has not yet shown an interest.

We ask Mrs. Rahayu to show us her favorite batik pattern. "Sido Mukti, the most expensive batik in the shop. Enough yardage for a sarong and stole costs sixty-four dollars. It is a classic design used for weddings," she says. It is a fitting favorite, since this fabric seems to symbolize Mrs. Rahayu's life: its name means "becoming prosperous and well respected."

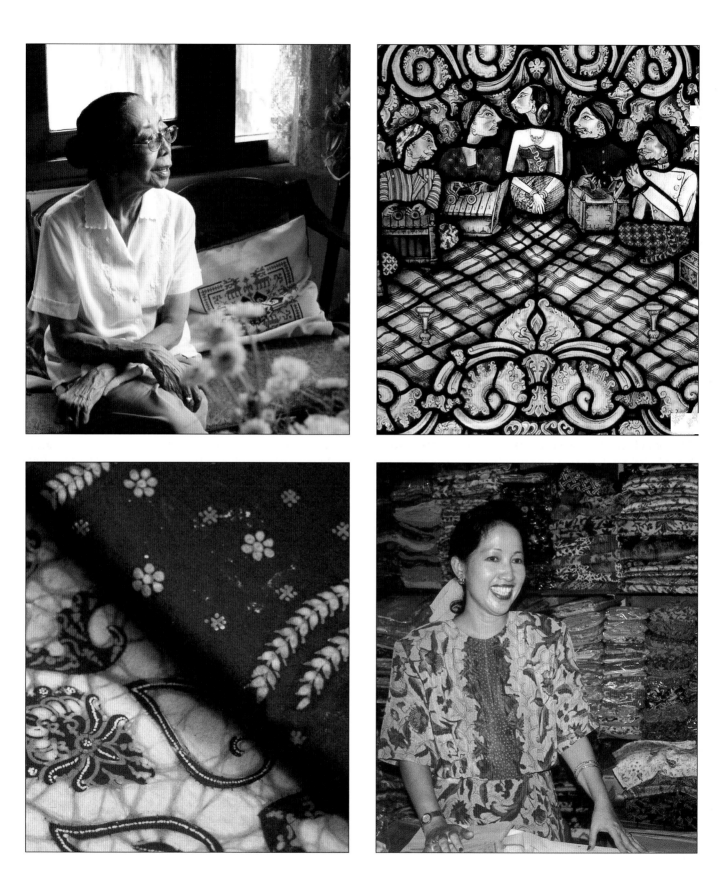

Top, left and right: Mrs. Praptini's profile echoes the bone structure and bearing of the royalty shown in the stained-glass windows at the palace.

Bottom, left: Mrs. Praptini's royal batiks are all hand drawn on white cotton dipped in natural dyes she makes herself; some patterns require twenty-seven immersions.

Bottom, right: Mrs. Rahayu's boutique, Toko Sri Djaja, is stacked to the ceiling with batiks, each in its own glossy wrapping.

Following pages: Mrs. Rahayu sells her own designs as well as royal batiks and hand drawn, stamp-printed, and silk batiks, all drizzled with metallic gold.

179

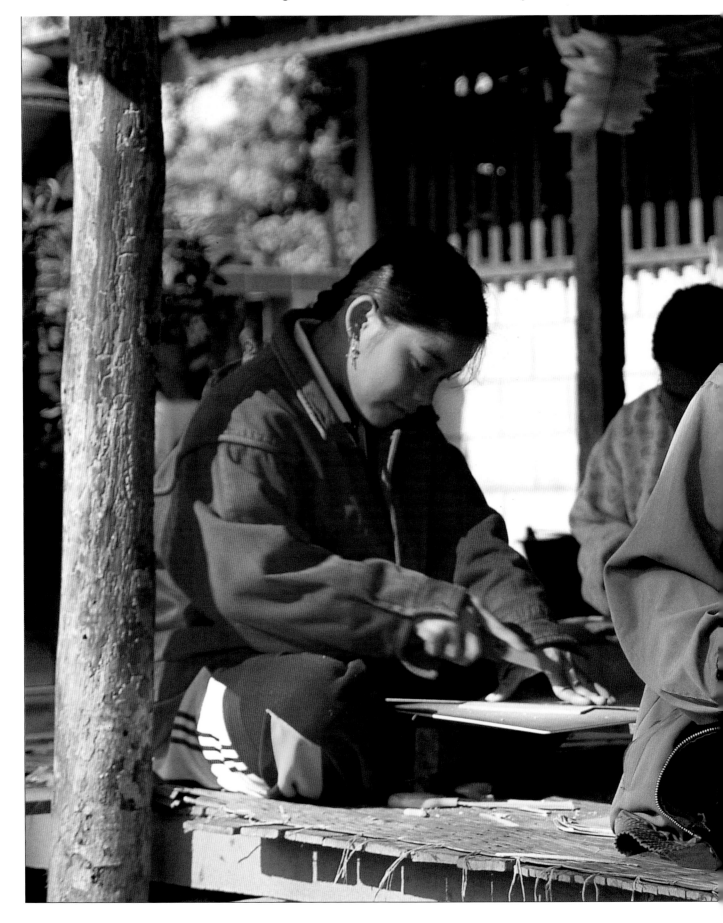

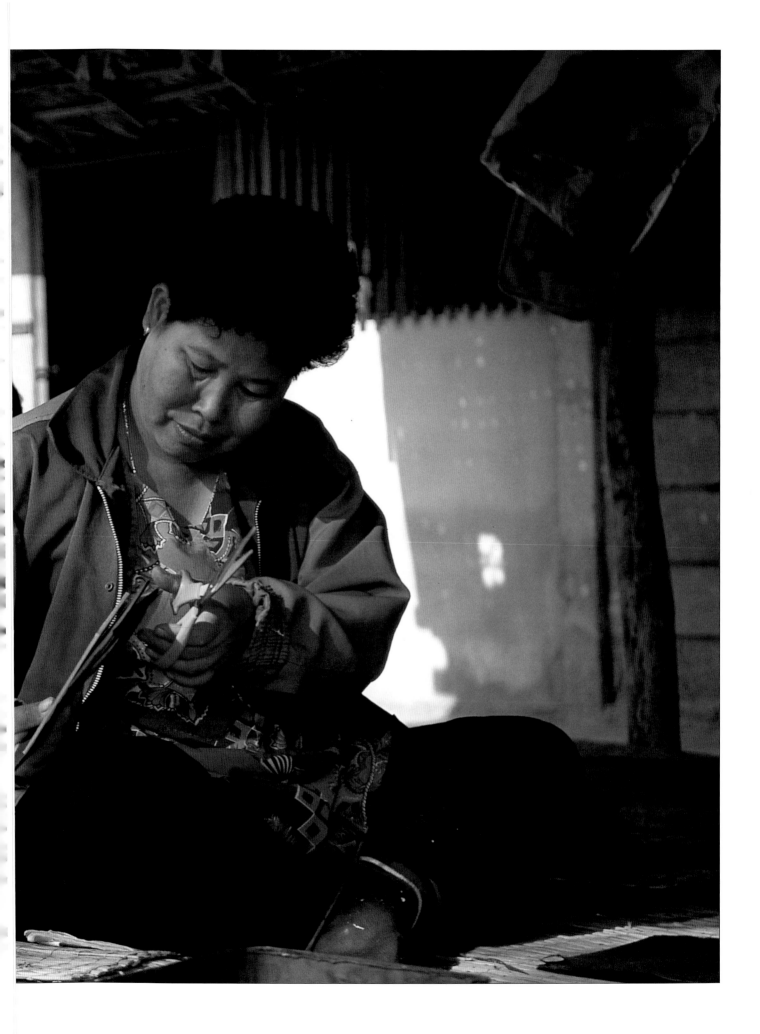

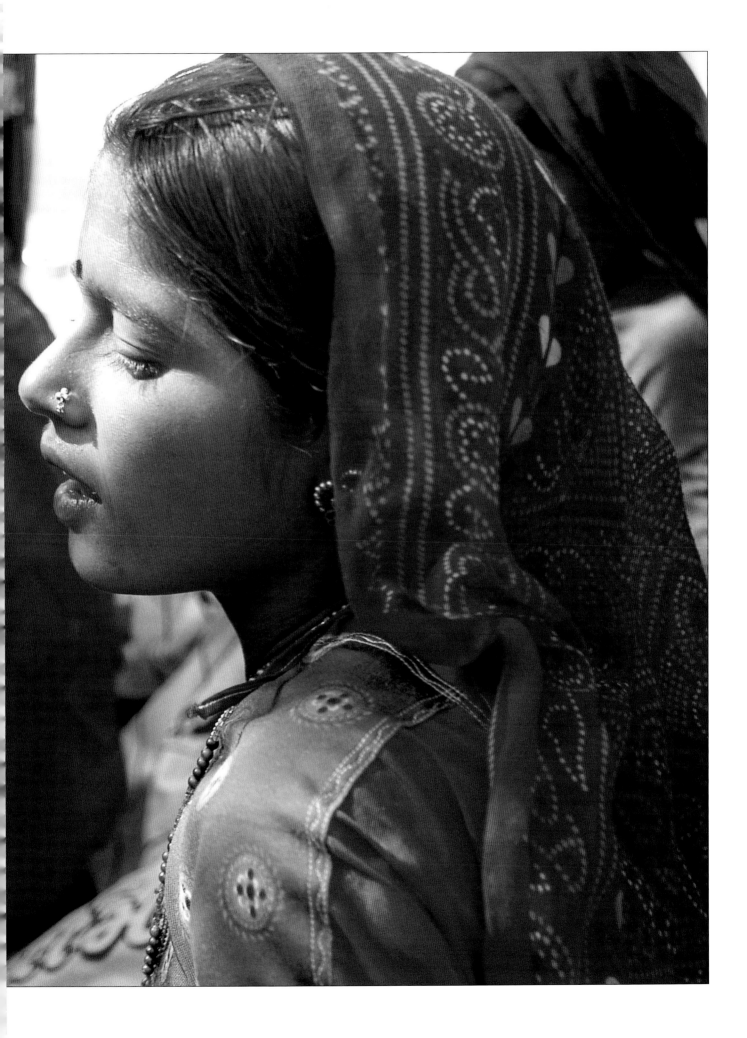

group owns some land in the village of Nokhania," she tells us. Because they cannot afford to irrigate the land to grow crops, the group sells milk and embroidery, which women can make even during their menstrual periods when they are not allowed to do other work. Another way both men and women earn money is by digging pits that are never used. Still, the government pays men a dollar a day to excavate, and women get sixty-six cents a day for that work. Today is payday. The women are here doing embroidery while they wait for the government paymaster to come.

Mothers and children stand so close to us that we cannot move. They stare, and we stare back. The women's clothes are splashes of brilliant magenta, orange, red, green, blue. Their tight, silken, backless bodices are dotted with flashing mirrors. The blouses serve as bras, so the bosom area is shirred and embroidered. Every gathered, voluminous skirt contains yards and yards of fabric.

We smile. Some of the women laugh; others look serious, proud, fearless. Interpreter Mona is not nearby so we mime our request to take pictures. As soon as our flashes light, young boys dance and scream to make the cameras wink and ignite again.

After they feel more comfortable with us, the women sit on the ground to embroider, unfolding little silk scarves that hold tiny, glittering spangles. Although the Rabari used to use shiny, naturally occurring mica chips, now they buy mirrored sequins in the market. Their fingers fly as they whipstitch the glitter.

In this short time, Mona has held a meeting up the road and recruited the entire group to join SEWA. "I looked at their work. They are very, very skilled. The work is A level, clean, done without an embroidery hoop, even in this wind. It will sell."

We wonder how she convinced them to join so quickly. "I asked if they have a convenient way to get raw materials—no—if there were traders or organizations working with them—no—and if they wanted to sell—yes. I explained that if they became members, SEWA would help them market their embroidery. They said, 'Yes, you are educated. You can help us.' Next week, I will return to hold a meeting and explain the other benefits: training, healthcare, child care, financial services. Whatever service they need will cost five rupees (fifteen cents). People do not want charity."

THIRTY SODHA TRIBAL WOMEN are gathering for a SEWA meeting in Kharadia, with the double agenda of forming a second craft group and selling embroidery to Mona. Late afternoon sun shining through the jewel-toned saris makes the women into butterflies. Their arms are covered with white bangle bracelets. When I raise the camera, the women hold their veils in their teeth to keep their faces covered. These Muslims have never seen a woman who wears pants and short hair, so they assume I am a man and cover themselves. Mona tells them that American women sometimes wear jeans and cropped hairstyles. The Sodha women relax. They offer us tea, which is carried from a hut in saucers. The invitation to drink from a saucer means we have been welcomed as family.

Age and dress distinguish Udekorba Danaji Sodha, the leader of the SEWA embroidery group that began two years ago. She is fifty, but is edentulous and looks as if she is eighty. Udekorba believes she should lead the newly forming group in addition to the old one. Mona says that she has not been a strong leader. "You went to SEWA training sessions alone, without telling anyone else to attend. That made the sessions totally useless."

Mona explains to Udekorba and the group that Mankorba Naranji Jadeja, thirty-five, who ran SEWA's training program in the village for six months, has achieved master status as an embroiderer, has demonstrated her strength in leadership, and has won people's respect. She will lead the second group.

Udekorba protests. She argues and yells, not about to give up easily. The crowd yells, too, taking sides. Mankorba motions the women to silence.

Mona tells them that unless all the women work together and help each other, she will not return to this village. Mona holds the trump card: not only is she a university graduate, which means she has much to teach, but she represents the only access to the market. When the Sodha women joined SEWA, they severed relationships with the usurious local traders.

The new group is formed. Women pay the five-rupee membership fee and sign the record book with thumbprints. Later, because they do not read or write, their thumbprints plus a picture will become their SEWA bank identification.

Next, the women present their embroidery to Mona, whose assistant pays in cash. Quality is consistent because SEWA has trained the less proficient embroiderers to meet a high standard. The prices, which range from one to four dollars, reflect the amount of work in each piece. The women count the bills carefully; some smile.

As the sun goes down, the women's husbands, who have been watching the proceedings from afar, climb off the fence across the road and head home.

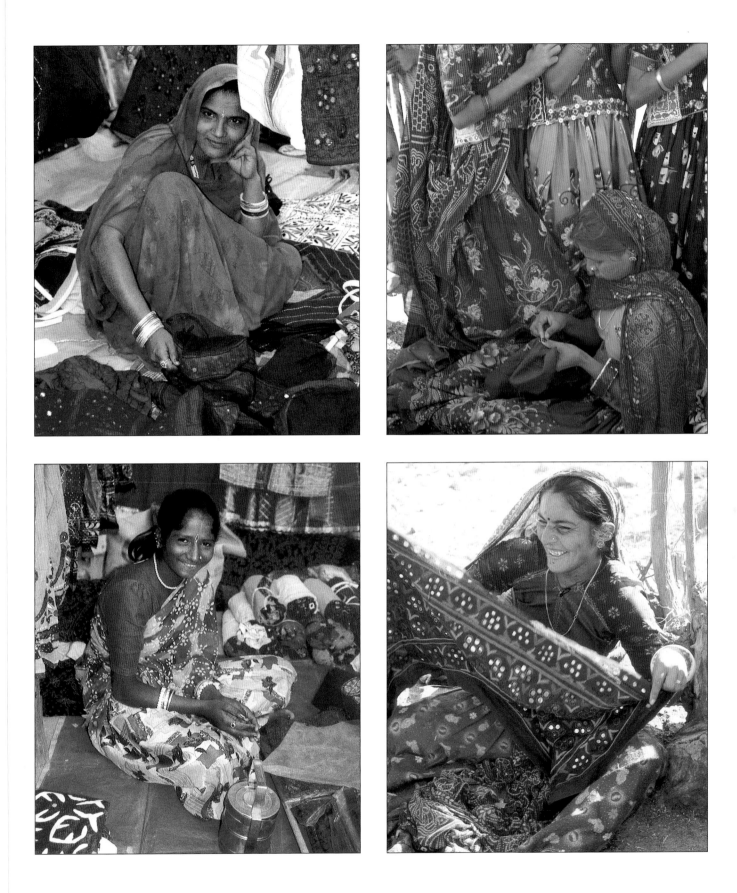

Top and bottom left: At night in downtown Ahmadabad, embroiderers set up corridors of stalls lit by kerosene lanterns; shoppers can choose from brightly colored, glittery clothing.

Top, right: Rabari women have been digging pits and doing roadwork all week; now they make mirror embroidery while they wait to be paid.

Bottom, right: Mirror embroidery glints like raindrops. For desert people like this Rabari tribeswoman, rain can be both miracle and, if it comes with monsoon force, catastrophe.

Afterward, she searched for work and "did agriculture and made peanut oil to sell." But it was clear that she had to find a more reliable way to earn a living. Although Jat men can have up to four wives, widows are not considered marriageable. Hawabai knew she would be on her own for a long time.

Now thirty, Hawabai and her children live in her brother-in-law's house, but she pays her family's expenses. Although she learned embroidery when she was twelve, she has only been selling her work for seven years. Each month she earns about nineteen dollars from embroidery and eighteen more from roadwork.

Her village, Kunakhia, has electricity, but it is certainly not modern. While her sister-in-law shines aluminum dishes with gritty dirt she scoops off the ground, we keep Hawabai company as she grinds chilies between two rocks. Her family used to have only millet bread and chilies to eat, but by selling embroidery through SEWA, Hawabai can now afford to add buttermilk to their diet and, on alternate days, *kedgeree* (rice with lentils), eggplant, potatoes, or onions.

Her days are marathons. "I get up at six and cook millet bread. Every two or three days, I take a bath. I own one cow and two bullocks and I take them to the field before I report at eight for roadwork. The children come with me, then walk back to the village for school. I work until five with an hour's recess. After work, I feed the animals and cook dinner. I embroider from eight o'clock to midnight every night. On Sundays, I clean the house, clean the children, layer mud on the floor, and wash clothes.

"There is never time for leisure," she says. "What gives us joy is to sit together, embroider and talk."

DURING OUR CONVERSATION with Hawabai, the village men try to get Mona's attention. Last week Mona asked them to sign documents agreeing to let their wives open bank accounts. Now Mona and the men surround the hood of the jeep where the papers lie flapping in the wind. The men have never had bank accounts themselves and are leery. "Is it possible to get the money out?" they ask. Mona explains, cajoles, argues, smiles, encourages, and flatters them out of their worries. Her clinching argument: "I, myself, will guarantee that you can withdraw the money. I will co-sign with you." The men are impressed. They sign.

SEWA VICE PRESIDENT Lalita Krishnaswami is also director of economic development for the organization and a director of its Mahila Bank (Women's Bank). She serves us tea in her simple basement office at SEWA headquarters in Ahmadabad.

"SEWA is the largest union in India, with over 200,000 members—all women, all self-employed. They make handicrafts such as quilts, weaving, embroidery; they are handcart pullers, junksmiths, vegetable vendors, waste pickers, firewood collectors, salt rakers, toy makers and used-garment dealers .

"The biggest difficulty for self-employed women was lack of access to credit. So we had a meeting. Four thousand women came. We asked for ideas. One woman got up and said, 'Though we are poor, we are many. Why can't we have a bank of our own?' Right there, each woman gave ten rupees, so there were over a thousand dollars right away; over six months that became almost three thousand dollars.

"As usual, we had a problem with the government, which said we could not have a bank for illiterates. 'It's suicidal,' said the bureaucrats, 'they can't even write their names to register the charter.' Our bank directors included tradeswomen: block printers, agricultural workers, incense-stick rollers. It was true, they could not write. They had never held pencils. That night, no one slept. The fifteen directors sat up all through the night, practicing, and they learned to write their names. The next morning, they walked in and signed the registration papers. The Mahila Bank, the Women's Bank, became official.

"The bank is a cooperative—owned, managed, and used by sixty thousand women. The bank will accept a woman's jewelry as collateral for a loan and give her sixty percent of the value in cash immediately. A woman can pay five rupees and get insurance against accidents, riots, debt. The bank will give her a home loan because this is considered to be a capital investment in her workplace. The women know that, through the bank, they are loaning their own money to other women, so they are not about to write off bad debts. If a payment is late, a neighbor woman goes to the debtor to see if she can help. Maybe the woman has sick family members, or just can't get to the bank, or maybe she is in trouble with money."

We ask Lalita how SEWA women have been affected by greater financial independence.

"Confidence is one thing. You know, here, a woman never says her husband's name."

"What does she call him?"

"Nothing. Maybe 'my children's father.'"

"Why?"

"How can you say your husband's name? He is so much somebody. I am an educated person with two master's degrees but when I got married at twenty, I did not call my husband by his name, either. When women first come to SEWA and we ask them to say their husbands'

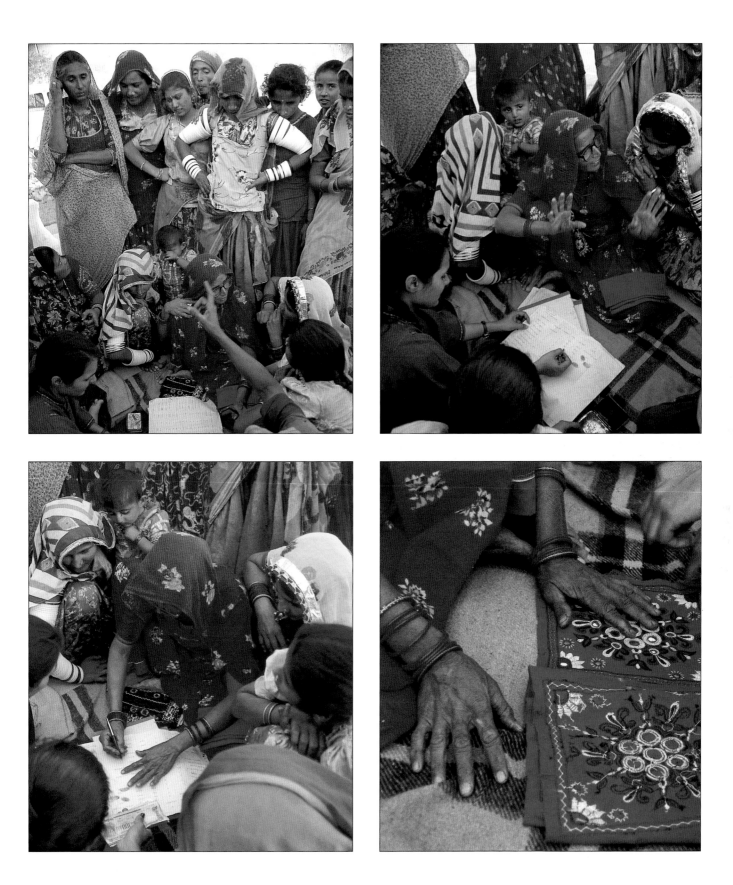

Above, clockwise from top left: Udekorba Danaji Sodha, president of the first SEWA embroidery group in Kharadia, waves her arm angrily, fighting for leadership of a second group that's being formed. • Naranji Jadeja Mankorba agrees to be president of the new group; a natural leader, she has run the SEWA training program for the past six months and earned respect and power. • In her new role, Mankorba presents embroidery to Mona Dave, who heads SEWA's Kutchcraft project—if the work is good quality, Mona will buy at a fair price. • Mona pays, and Mankorba, the only woman who can read and write in Kharadia, signs the receipt book with a pen; illiterate women sign with thumbprints.

211

*"We are poor women in a hostile land
With no food in our bowls.
Droughts come often and unemployment is rife.
We have neither land nor work.
Our houses are as small as our hands
And our needs are many.
We are women, illiterate women,
Coming together to make a union….
We are illiterate, but what of that?
We challenge everyone with our strength."*

*SEWA organizing song
(translated from Gujarati)*

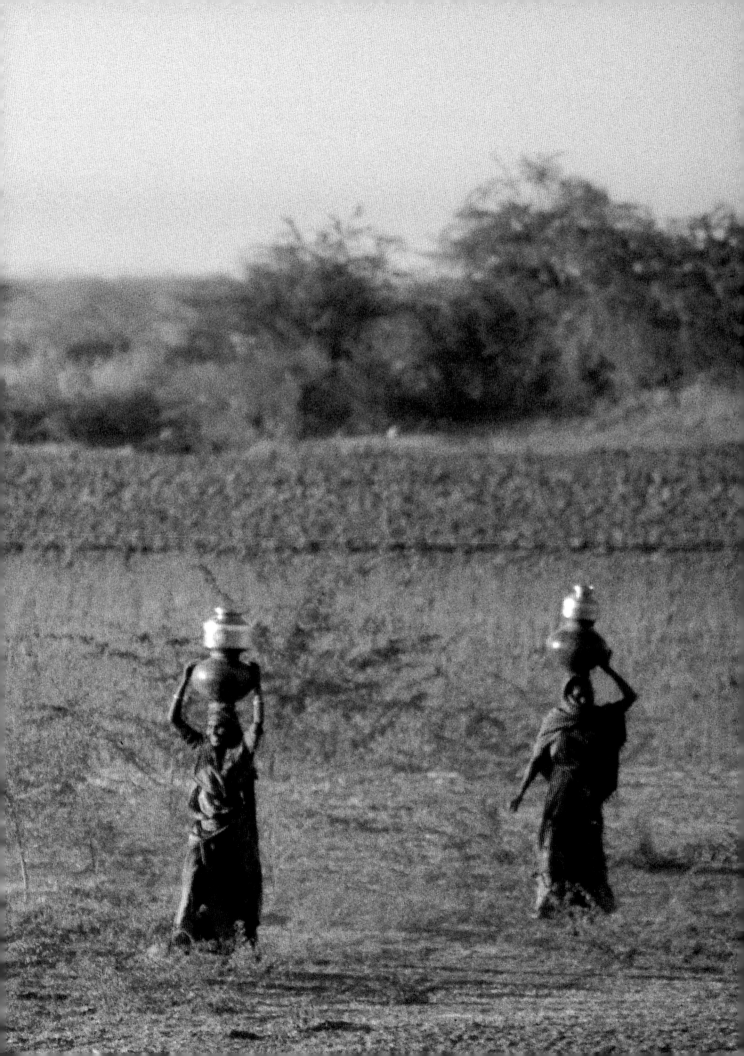

Previous pages: Gujarati women fetch water in the early morning.

Above, clockwise from top left: Thirty Sodha embroiderers participate in the outdoors SEWA meeting; until recently, many women in this Muslim village did not leave their houses. • A Rabari woman from Nokhania has decorated her hands with patterns of henna. • While we photograph Rabari girls and boys, Mona assesses their mother's embroidery talent and invites them to join SEWA's Kutchcraft project. • Jat children are better nourished now: Hawabai Ibrahim sells enough embroidery that she can add buttermilk and vegetables to her children's diet of **bread and chilies.**

names, they laugh and giggle. They are so shy they don't even say their own names.

"But after a while, very gradually, the women start feeling confident. They get a little respect from their family. The children begin to view their mothers differently. Domestic violence can be reduced. Everywhere, economic stability is the major factor that lowers birth rates: if extreme poverty is alleviated, families don't need so many children to earn money. Each change creates new possibilities for change."

Lalita tells about a woman describing the Mahila Bank. "One sister talks about money as grains of wheat: if the grains are scattered, you don't know how much you have; if they are in a bag, you can lift it and feel the weight."

Each year, thousands of SEWA members attend the bank's annual meeting. Collectively, these women now hold $404,000 in working capital. And when that is all in one bag, you can feel the weight.

CONCLUSION: CRAFTSWOMEN CHANGING THE WORLD

POVERTY IS DAILY REALITY for most of the craftswomen we visited. They do not see themselves as poor; they simply believe that life is hard. Many make less—and few make more—than one dollar a day, which is the amount the United Nations defines as international income-poverty. A dollar a day does not support a family in any economy.

Poor as they are, the craftswomen in this book are virtually unanimous in their determination to improve the future for their children. Many work twelve to eighteen hours a day earning money, cooking, and taking care of their homes and children. Some juggle as many as five income-generating projects, at least one of which is a craft.

Many of them get surprisingly little financial help from their husbands. Women, according to the United Nations Development Programme, provide the primary support for a quarter of the world's families and the sole support for another quarter.

In Zimbabwe, women head a third of the households. In Poland, women head a quarter of them, although husbands support the particular families we visited. In Soğanli, Turkey, husbands do not earn any cash but provide food for their families by doing subsistence farming. In fact, in every country we visited, although marriage was the only acceptable lifestyle, and it might be expected that husbands would contribute, often wives were the breadwinners.

Many wives support their families because their husbands are sick or old or because they died of natural causes. In India, Guatemala, Bolivia, Zimbabwe, and Thailand, we saw ample evidence for the medical research that shows that women everywhere live healthier, longer lives than men.

In Guatemala, most of the craftswomen head their households because their husbands were killed or disappeared during three decades of civil war. Other women in Guatemala are "seasonal widows" whose husbands travel to the coast to seek agricultural work during planting and harvest months. In South Africa, Zimbabwe, and Thailand, husbands leave their villages to seek employment in cities, and in Bolivia, husbands seek work in adjacent countries whose economies are more robust. Many of these men do not get jobs at all; if they do, they earn so little that they have nothing left to send home after paying their living expenses. Some send stipends to their families or return to help out periodically. Others start new families and never come back.

Some women find themselves supporting their families because their cultures allow men to spend their own money on personal pleasures. Florence Maposa, marketing manager of Zimbabwe's National Handicraft Centre, told us, "Husbands buy cigarettes and beer; women buy food for their families." Observing the situation in most developing countries, the World Bank states: "It is not uncommon for children's nutrition to deteriorate while wristwatches, radios, and bicycles are acquired by the adult male household members."

Where polygyny is still practiced, men often find it impossible to support their multiple families. This is common among certain Muslim, Shipibo, Ndebele, and Zulu families—and in Zimbabwe, where one wife in six is married to a man with at least one other spouse.

For all of these reasons, many craftswomen have no choice but to be the engines that will propel their families from poverty—or at least, to try.

THE FIRST THING MOST CRAFTSWOMEN buy with their income is food for their children. Often, they can only afford to make incremental nutritional changes. In India, women told us that they served millet bread and ground chilies every day until they earned enough to buy buttermilk, eggplant, potatoes, and onions to serve once a week, and then, as their income grew, on alternate days.

Perhaps the most important social legacy craftswomen will leave is a better educated next generation. As more girls attend school, the chances increase of subsequent generations attending school. A mother's education determines her children's—education begets education.

WE WERE CURIOUS ABOUT how craftswomen who had no formal education became so committed to schooling. We discovered that craft group leaders, often the only women in their villages who have had even a few years of schooling, serve as models for what education can do. In India, an embroidery group president had finished the second grade; in Peru, a pottery group president had an eighth-grade education. Their leadership allowed craftswomen to see that education makes people more effective, and that even a little education can increase the ability to see beyond the way things are.

Although primary education is free in the countries we visited, books, school supplies, uniforms, and transportation are onerous expenses that escalate as children reach higher grades. In South Africa, a woman who makes beaded jewelry invests two months' income to buy two pairs of school shoes and two uniforms for her fourteen-year-old son. In Peru, the first Shipibo woman in her village to send children to college was frantic about the school and living expenses for four years of school for her three children in the city; at a frugal dollar and a half a day, the tab will be more than six thousand dollars.

Although these craftswomen carry the optimistic hope that more schooling promises a better future for their children, there are no guarantees. In Harare,

Opposite: A weaver in Zimbabwe carries fresh cabbage home for supper. Women like her are a centerpiece for the United Nations' ten-year campaign to reduce poverty worldwide, because the money they earn is invested in their children.

219

When I think about the lives of the village women we've met, I wonder how it must feel to live in primitive surroundings within today's high-tech world. Such a jumble of contrasts these people must face! Much about life in their villages hasn't changed in a century. But then, there are startling changes, too.

As we travel, we constantly notice and compare the differences in rate and degree of change among indigenous communities. All have had some exposure to "the modern world" and all have been affected by it, but differently. The Rabari people we met, out in the western Indian desert, have had so little contact with the likes of us that they crowded around us to stare and touch; any prior contact with Westerners has rubbed off very little. There are carpet weavers in Süleymanköy, Turkey, who sometimes get all the way to Oslo, Osaka, and San Francisco to demonstrate their art. Then they return to rustic, dusty little Süleymanköy, where daily life continues as always. The people of Bali have had their world drastically upended by the twin booms of tourism and commercialism, and yet they hold fast to their religious and cultural traditions. The Kuna Indians sometimes leave their San Blas Islands; some have gone all the way to Europe for education, then have returned. Most of them make their way from time to time, by boat, plane, bus, and pickup, to busy, noisy Panama City.

World travel and commercial trade will eventually make us a homogenous people, I think. But for now, the various corners of the world change and update themselves, sometimes eagerly and sometimes unwillingly or inadvertently, in odd little spurts. How is it determined what modern methods, conveniences, and attitudes will be adopted, and what will be left just as it has always been—at least for a while longer?

In a world of accelerating cultural rub-off, how long will these handicrafts survive? How long will the fragile indigenous cultures that spawned them produce people willing to pursue them? Every woman we met yearns for her daughter to find a "better life," but we wonder if there will be room in that life for a village craft. Will a young woman with the education to qualify her for a better-paying job find time to sit down at a loom and weave a rug in her grandmother's tradition?

We are thankful for our opportunity to make friends in these few communities now, before further homogenization occurs, because they are surely changing and losing bits of their special color week by week. We are also intensely grateful that there exists a small universe of dedicated specialists collecting, documenting, and teaching the arts of the world's craftswomen. They are professionals working in museums, universities, and galleries and in the field, and members of volunteer organizations; some are themselves indigenous artisans. Because of the work of these cultural conservationists, we dare to hope that, though the world continues to change, we will not be bereft of the traditional crafts we love.

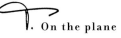

T. **On the plane**

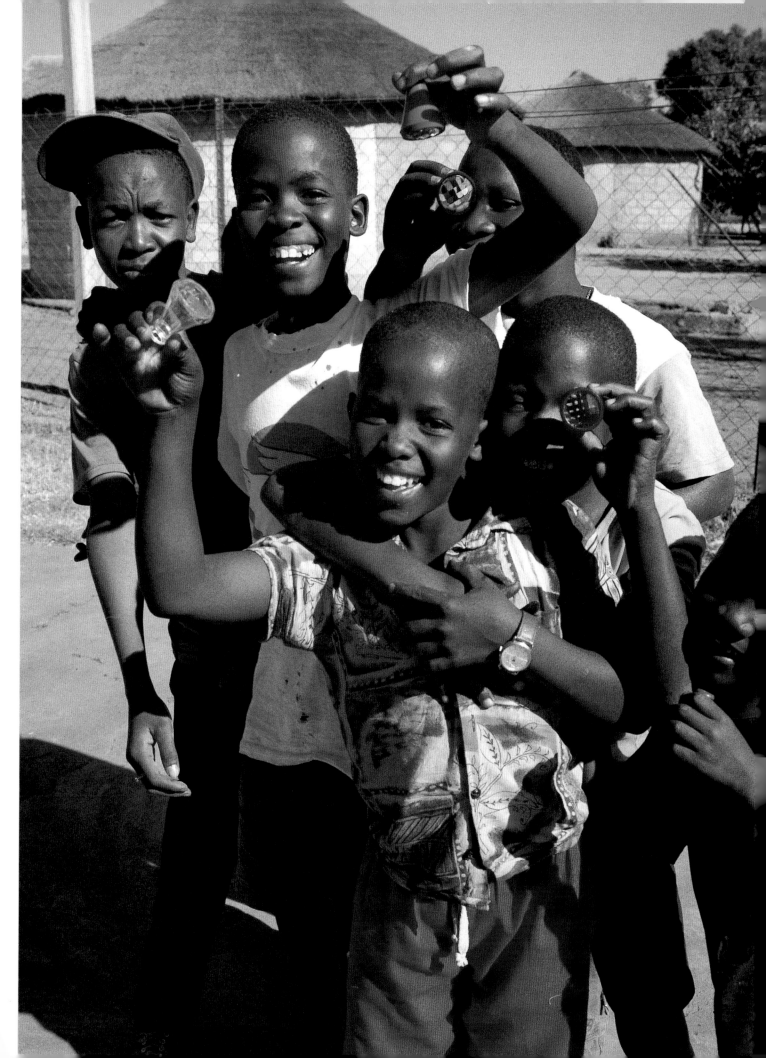

RESOURCES FOR ACTION

HOW CAN YOU HELP enhance the craftswomen's efforts to improve their own lives? Here are some strategies:

* Locate and purchase handcrafted products like those in this book. Some sources of these products are marked ❖. For further information on where to buy these crafts visit www.inherhands.com.

* Patronize retailers who post the Fair Trade Federation symbol—and ask other outlets how much of the retail price goes to the producer.

* Contribute to institutions that help artisans buy raw materials and generate income—specifically micro-credit and craft-marketing organizations.

* Learn how international development and trade policies affect indigent artisans and, if you do not feel they are fair and effective, lobby the policy makers.

* Contact the people and organizations marked ❂. It is they who helped make this book possible and are most knowledgeable about its craftswomen and crafts.

* Read some of the books, articles, and reports that we found most helpful during our research.

INDIGENOUS HANDICRAFT AND FOLKLIFE
Contacts

❂ Aid to Artisans,
331 Wethersfield Avenue, Hartford, CT 06114;
tel: 860-677-1649; fax: 860-676-2170;
email: atausa@aol.com;
web: www.aid2artisans.org

❂ Crafts Center,
1001 Connecticut Avenue NW, Ste. 1035, Washington, DC 20036;
attn: Elizabeth Houde, Executive Director;
tel: 202-728-9603; fax: 202-296-2452;
email: info@craftscenter.org

Cultural Survival Quarterly,
221 Prospect Street, Cambridge, MA 02139;
tel: 617-441-5400; fax: 617-441-5417;
email: csinc@cs.org;
web: www.cs.org

Fair Trade Federation,
P.O. Box 698, Kirksville, MO 63501;
Cheryl Musch, Executive Director;
tel: 660-665-8962;
web: www.fairtradefederation.com

❂ The Folk Art Gallery,
1321 Fourth Street, San Rafael, CA 94901;
attn: Sharon Christovich;
tel: 415-925-9096;
email: folkart@wco.com;
web: www.thefolkartgallery.com

Global Exchange,
2017 Mission Street, Room 303;
San Francisco, CA 94110,
attn: Deborah James;
tel: 415-255-7296; fax: 415-255-7498;
email: gx-info@globalexchange.org;
web: www.globalexchange.org

Museum of Craft and Folk Art,
Landmark Building A, Fort Mason Center, Laguna and Marina Boulevard,
San Francisco, CA 94123;
tel: 415-775-0990

❂ Museum of International Folk Art,
Camino Lejo off Old Santa Fe Trail, Santa Fe, NM 87501;
tel: 505-476-1200; fax: 505-476-1300
web: www.moifa.org

❂ National Museum of African Art,
950 Independence Avenue SW, Washington, DC 20560;
tel: 202-357-2700

National Museum of Natural History,
10th and Constitution Avenue NW, Washington, DC 20560;
tel: 202-357-2700

National Museum of Women in the Arts,
1250 New York Avenue NW, Washington, DC 20005-3920;
tel: 202-783-5000

Oxfam America,
26 West Street, Boston, MA 02111-1206;
tel: 617-482-1211

PEOPLink,
11110 Midvale Road, Kensington, MD 20895;
tel: 301-949-6625;
email: comments@peoplink.org;
web: www.peoplink.org

Phoebe A. Hearst Museum of Anthropology,
103 Krober Hall, University of California, Berkeley, CA 94720-3712;
tel: 510-643-7648

Textile Arts Council,
M.H. de Young Museum, Golden Gate Park,
San Francisco, CA 94118;
tel: 415-750-3627; fax: 415-750-7692;
email: tac@famsf.org

The Textile Museum,
2320 S Street NW, Washington, DC 20008-4088;
tel: 202-667-0441

Further Reading
Barber, Elizabeth Wayland
Women's Work: The First 20,000 Years
New York: W. W. Norton & Company, 1994

Burenhult, Goran
Traditional Peoples Today: The Illustrated History of Humankind, Continuity and Change in the Modern World
New York: Harper Collins, 1994

Crabtree, Caroline
World Embroidery: 25 Original Projects from Traditional Designs
Devon, England: David and Charles, 1993

Etienne-Nugue, Jocelyne
Talented Women
Paris: UNESCO, 1995

Glassie, Henry
The Spirit of Folk Art: The Girard Collection at the Museum of International Folk Art
New York: Harry N. Abrams, 1989

Herold, Jacqueline
World Crafts
London: Lark Books for Oxfam, 1992

Kahlenberg, Mary Hunt, ed.
The Extraordinary in the Ordinary: Textiles and Objects from the Collections of Lloyd Cotsen and the Neutrogena Corporation, Works in Cloth, Ceramic, Wood, Metal, Straw, and Paper from Cultures

Throughout the World
New York: Harry N. Abrams, 1998

Kennett, Frances
Ethnic Dress: A Comprehensive Guide to the Folk Costume of the World
London: Reed Consumer Books, 1994

Morris, Walter F., Jr.
Handmade Money: Latin American Artisans in the Marketplace
Washington, DC: Organization of American States, 1996

MICROENTERPRISE LOANS
Contacts

❂ Freedom from Hunger,
1644 Da Vinci Court, Davis, CA 95617;
attn: Claire Thomas, Vice President/Development and Public Affairs;
tel: 530-758-6200, 1-800-708-2555; fax: 530-758-6241;
email: info@freefromhunger.org;
web: www.freefromhunger.org

Global Volunteers,
375 E. Little Canada Road, St. Paul, MN 55117;
tel: 800-487-1074

Office of Microenterprise Development,
Economic Growth Center, Global Bureau, USAID,
1000 16th Street NW, Washington, DC 20036;
tel: 202-712-1140

World Bank, Consultative Group to Assist the Poorest,
1818 H Street NW, Washington, DC 20433;
tel: 202-477-1234;
fax: 202-522-3744;
web: www.worldbank.org

Further Reading
"Closing the Gap"
The Economist, September 2, 1995, 74

Creevey, Lucy
Changing Women's Lives and Work: An Analysis of the Impacts of Eight Microenterprise Projects
London: Intermediate Technology Publications, 1996

Danaher, Kevin, and Muhammad Yunus
50 Years Is Enough: The Case Against the World Bank and the International Monetary Fund
Boston: South End Press, 1994

Jhabvala, Renana, and Jane Tate
"Out of the Shadows: Homebased Workers Organize for International Recognition"
Seeds 18 (1996): 1–23

Kodish, Marilyn, ed.
Pearls of Bangladesh: The Workers and Borrowers of Grameen Bank
Washington, DC: RESULTS Educational Fund, 1993

Opposite: Ndebele boys in Waterval, South Africa, enjoy the dragonfly viewers we took to thank them for sharing their mothers' time and attention.

❖ National Multi-Skills Development Association,
P.O. Box 411, Shakasraal 4430, South Africa;
attn: Daphney Zungu (mats)

❖ Ndebele Bead Women,
P.O. Box 44231, Waterval B 0466, South Africa;
attn: Annah Joannah Mahlangu (beadwork)

❖ Rural Crafts,
31 Tyrwhitt Avenue, Shop 42e, Mutual Gardens, Rosebank 2196,
Johannesburg, South Africa;
attn: Matilda Mashaba;
tel: 27-11-880-96512; fax: 27-11-442-7691
(beadwork and baskets)

Further Reading
"An African Success Story"
The Economist, June 14, 1997, 47

amaNdebele: Signals of Color from South Africa
Tubingen: Ernst Wasmuth Verlag, 1991

Asante, Molefi Kete
The Book of African Names
Trenton: Africa World Press, 1991

Cameron, Elisabeth L.
Isn't S/He a Doll? Play and Ritual in African Sculpture
Los Angeles: UCLA Fowler Museum of Cultural History, 1996

Clinton, Hillary
"African Odyssey"
Vogue, June 1997, 186

Coob, Charles E., Jr., and James Nachtewey
"The Twilight of Apartheid: Life in Black South Africa"
National Geographic 183, no. 2 (February 1993), 66–93

Courtney-Clarke, Margaret
Ndebele: The Art of an African Tribe
New York: Rizzoli International Publications, 1986

Eliade, Mircea
"Schembe"
In The Encyclopedia of Religion
New York: Macmillan, 1993, vol. 13, 239–40

Fisher, Angela
Africa Adorned
New York: Harry N. Abrams, 1984

Haskins, Jim, and Joann Biondi
From Afar to Zulu: A Dictionary of African Cultures
New York: Walker and Company, 1995

Knight, Natalie, and Suzanne Priebatsch
Art of the Ndebele: The Evolution of a Cultural Identity
Atlanta: Atlanta International Museum, 1998

Levinsohn, Rhoda
Treasures in Transition: Art and Craft of Southern Africa
Parklands: Delta Books, 1984

Morris, Jean
Speaking with Beads: Zulu Arts from Southern Africa
London: Thames and Hudson, 1994

Peoples of Southern Africa
New York: Facts on File, 1997

Powell, Ivor, and Mark Lewis
Ndebele: A People and Their Art
New York: Cross River Press, 1995

"Where Terror Reigns in South Africa:
In KwaZulu Province, Free Speech Is Still a Contested Issue"
New York Times, June 26, 1996, a8

THAILAND
Contacts
❖ EcoAccents,
2570 Superior Avenue, Fifth Floor, Cleveland, OH 44114;
attn: Eric Ludwig, President;
tel: 1-888-295-9297; email: eric@ecoaccents.com;
web: www.ecoaccents.com (exclusive distributor of mulberry-paper
products in the United States and Canada)

❖ Grassroots HQ Company, Limited,
3/31 Samlan Road, Tambon Phrasing, Amphur Muang, Chiang Mai,
Thailand 50200;
attn: Henry Quick, Co-Directors;
tel: 66-53-81-4717; fax: 66-53-81-4719;
email: ghq@loxinfo.co.th (batiked mulberry paper-covered gift items)

Hill Tribe Products Promotion Center,
21/17 Suthep Road (near Wat Suandok), Chiang Mai 50200, Thailand;
tel: 66-53-277743 (for Hmong and Lisu products; center is under the
patronage of His Majesty The King; profits go to hill tribe welfare pro-
grams)

♻ NAPAC (Thai-Australian Northern AIDS Prevention and Care Program),
Shinawatra Building, third floor, 14-10 Huai Kaeo Road, Chiang Mai,
Thailand 50300;
attn: Dr. Usa Duongsaa;
tel: 66-53-211454; fax: 66-53-212743

❖ Royal Folk Arts and Crafts Center,
adjacent to Bang Pa-In Summer Palace, Bang Sai, Ayutthaya Province,
Thailand;
attn: Colonel Kasem Chatsathienpong, Deputy Director

Further Reading
Altman, Lawrence K.
"AIDS Surge Seen in China, India and Eastern Europe"
New York Times, November 4, 1997, a10

Bevrdeley, Jean-Michel, and Hans Hinz
Thai Forms
New York: Weatherhill, 1980

Campbell, Margaret, Nakorn Pongnoi, and Chusak Voraphitak
From the Hands of the Hills
Hong Kong: Media Transasia, 1981

"Counting the Cost"
The Economist, September 23, 1995, 26

Hmong Art: Tradition and Change
Sheboygan, WI: John Michael Kohler Arts Center, 1986

Lewis, Paul, and Elaine Lewis
Peoples of the Golden Triangle: Six Tribes in Thailand
London: Thames and Hudson, 1984

Milinson, Jane, Nancy Donnelly, and Ly Hang
Hmong Batik: A Textile Technique from Laos
Seattle: University of Washington Press, 1997

Newman, Thelma R.
Contemporary Southeast Asian Arts and Crafts
New York: Crown, 1977

Peterson, Sally N.
"From the Heart and the Mind: Creating Paj Ntaub in the Context
of Community"
Ph.D. diss, University of Pennsylvania, 1990

Report: Aids Case in Thailand
CDC Region 10, Chiangmai: Department of Communicable Disease
Control, Ministry of Public Health, 1996

The Royal Project of Folk Arts and Crafts for Farmers
National Council of Women of Thailand under the Royal Patronage of
Her Majesty the Queen, 1984

Some Splendid Crafts of the SUPPORT Foundation of Her Majesty
Queen Sirikit of Thailand
Bangkok: Siam Society under Royal Patronage, 1994

"Translating Experience and the Reading of a Story Cloth"
Journal of American Folklore, January–March 1981, 6–36

Warren, William, and Luca Invernizzi Tettoni
Arts and Crafts of Thailand
San Francisco: Chronicle Books, 1996

"Women and AIDS"
NAPAC Newsletter (Thai-Australian Northern AIDS Prevention and Care
Program) 3, no. 2 (April–September 1996)

TURKEY
Contacts
Return to Tradition,

3319 Sacramento Street, San Francisco, CA 94118;
attn: Bill McDonnell; tel: 415-921-4180; fax: 415-921-6024 (natural
dyed rugs)

❖ S.S. Soğanli Turizm Gelistirme Kooperatifi, c/o Sevim Karabiyik,
P.K. 81, 50400 Urgup/Nevsemir, Turkiye;
tel: 90-384-341-4482; fax: 90-384-341-5991 (dolls)

❖ S.S. Süleyman Köy Tarismal Kalkinma Kooperatifi (DOBAG),
Şerife Atlihan;
Muhtar Tahsin Sahin Sok., No. 15/17 D.2 Salacak, TR 81140
Uskudar-Istanbul; tel: 90-216-343-1222;
email: atlihan@superonline.com

Further Reading
Anderson, June.
Return to Tradition: The Revitalization of Turkish Village Carpets
San Francisco: California Academy of Sciences, 1998

Ditmer, Joanne
"Magic Carpets: Brilliantly Hued Rugs Coveted on Two Continents"
Denver Post, May 11, 1998, 10f

Glassie, Henry
Turkish Traditional Art Today
Bloomington: Indiana University Press, 1993

Iten-Maritz, J
Turkish Carpets
Tokyo: Kodansha International, 1997

Kinzer, Stephen
"Where Faith Infuses the Rock"
New York Times, August 31, 1997, section 5, 6

Thompson, Jon
"A Return to Tradition"
Hali 30 (April 1986), 14–21

Udesky, Laurie
"Innovative Co-Op Helps Weavers Earn Their Keep"
Turkish Daily News, February 16, 1996, b1

ZIMBABWE
Contacts
❖ National Handicraft Centre,
Corner Grant Street and Chinhoyi Street,
P.O. Box 66210, Kopje, Harare, Zimbabwe;
attn: James Musiwacho, Manager;
tel: 263-4-721816; fax: 263-4-721815 (Weya painting)

❖ Smithsonian Institution Museum Shops,
600 Maryland Avenue SW, Washington, DC 20560;
attn: Elysa Blacker, Buyer;
tel: 202-357-1300; fax: 202-287-3080

Further Reading
Beach, David
The Shona and Their Neighbours
Oxford: Blackwell, 1994

Eliade, Mircea.
"Shona Religion"
In The Encyclopedia of Religion. New York: Macmillan, 1993, vol. 13,
295–98

Noy, Ilse
The Art of the Weya Women
Harare: Baobab Books, 1994

Ponter, Anthony, and Laura Ponter
Spirits in Stone: The New Face of African Art
Glen Ellen: Ukama Press, 1997

Winter-Irving, Celia
Stone Sculpture in Zimbabwe: Context, Content and Form
Harare: Roblaw, 1995

Opposite: Widowed weavers throughout the
Guatemalan highlands support their families
because the thirty-six-year civil war caused the
death or disappearance of many local men.

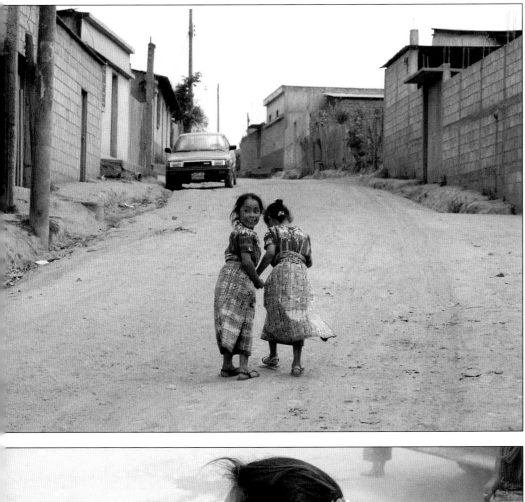

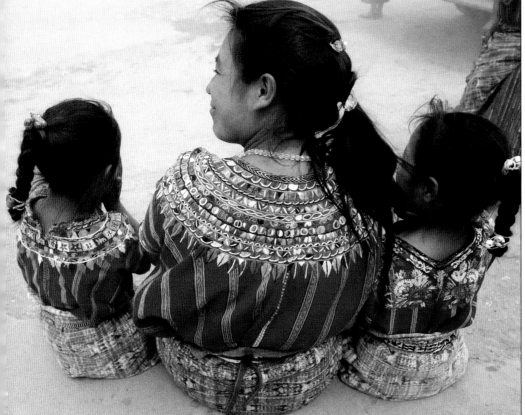

Top: Irma Leticia and Gladys Maribel, Irma Bajan's little girls, walk home from school in Patzun, Guatemala.

Bottom: The girls and their mother wait for a bus to visit their grandmother in the village where Irma Bajan was born.

Opposite: Painted strips of mulberry paper fly in the breeze in a village in northern Thailand. When dry, they will be cut and mounted on cardboard picture frames.

Above: Jat women in Gujarat, India, wash their aluminum dishes with gritty dirt they scoop from the ground; it polishes bowls to a shine.

ACKNOWLEDGEMENTS

We are grateful to the ninety craftswomen who shared their stories so generously and welcomed us into their lives; to the interpreters who made understanding possible; to the six people who gave us continuous guidance and encouragement: Alev Lytle Croutier, Stephen Huyler, Nina Smith, Tim Tuttle, David Hill, and Judith R. Joseph, Joseph Publishing Services; to Gianfranco Monacelli, our publisher, and Andrea Monfried, our editor; to our book designer, Joseph Guglietti—and to the experts and friends all over the world without whom this book would not exist:

Thomas Aageson, Christine Albertini, Krishna Amin-Patel, June Anderson, Şerife Atlihan, Adam Bartosz, Allen Bassing, David Beatty, Linda Beeman, Leah Ben-David Val, Constance Beutel, George Beylerian, Elysa Blacker, Barbara Blackwill, Bill Bonnell, Hedy Buzan, Ben Nighthorse Campbell, Kimberly Carter, Phisak Chakkaphak, Joan Chatfield-Taylor, Colonel Kasem Chatsathienpong, Mirai Chatterjee, Helen Chin, Freddy Flores Choque Jr., Sharon Christovich, Leslie Claxton, Linda Clever, Andrea Cohen, Diane Colasanto, Julio Benitez Colman, Ron Colnett, Father William Coy, Claudia Craig, Bonnie Dahan, Mona Dave, Betsy Davis, John Alfredo Davis, Juan Delgado, Ozlem DemiNoopan, Cennet Deneri, Emel Domagracci, Hlenge Dube, Kenneth Duncan, Usa Duongsaa, Nancy Dutton, Janet Echelman, Clara Malcco Enriquez, Roger Valencia Espinoza, Georgia Evers, Dotty Ewing, Dianne Feinstein, Zenobia Ferrufino, Allison Field, Peggy Flynn, Anita and Miles Forsyth, Judy Frater, Estelle Freedman, Caryl Garcia, Valerie Gardner, Yaritza Gavidia, K. Gengenbach, Mike Gianturco, Henry Glassie, Peter Glusker, Kathy Hammer, Sally Havens, Haydar Haykir, Caroline Heath, Chris Hedge, Lucie Hempstead, Abby Hill, Suki Hill, Bonnie Himberg, Jerry Horovitz, Sinifisela Inhlanhla, David Inocencio, Khatri Alemohmad Isha, Ben Jacobsen, U. P. Jadia, Chris Jannes, Jack Jannes, Neil Jannes, Judith Jaslow, Pascale Jeambrun, Paula Jeppson, Tina Joemat, Margaret Kadoyama, I Wayan Kamar, Leah Kaplan, Sevim Karabiyik, Vincent Khuzunayo, Gary Kinley, Srisakul Kliks, Andy Kohut, Tuangthong Kreuatongsi, Susan Krieger, Tom Kruse, Ilhan Kucuk, Iris Litt, Sally Lovett, Kathy Lowry, Jing Lyman, Graciela Magan, Dinah Mahlangu, Florence Maposa, Katherine Martin, Matilda Mashaba, Norman Mauskopf, Father Thomas McBride, Bill McDonnell, Guinness McFadden, Stephanie McNair, Harriet McNamee, Lyn Messner, Kristin Miller, Linda Miller, Juan Carlos Montano, Mark Moran, Sharon Moran, Gunlaya "Tui" Muangmoon, Karen Mulvahill, James Musiwacho, Happy Bongiwe Mvuyane, Reema Nanavaty, Grieta Ndala, Arlene and Clark Neher, Malgorzata Oleszkiewicz, Bonnie Oliver, Luis Ovando, Michal Pavlas, Ann Peden, Linda Pei, Gail Perkins, Erroll Pires, Cynthia Pitt, Victor Policci, Janice Porter, Barbara Prag, Kavita Ramdas, Caroline Ramsay, Peter Randle, Nancy Reeder, Jana Kopelentova Rehak, Linda Rehor, Faye Richardson, Robert Ridgley, Songnam Ritwanna, Bill and Eliza Roberson, Julie Freund Roth, Karen Ruckman, Robin Ryan, Nina Sabnani, Jyotsana Sagara, Roxana Salinas, Joanne Sandler, Rob Sangster, Scott Sangster, Maria San Miguel, Leena Sarabhai, Ratna Sarkar, Margot Blum Schevill, Beth Schroppel, Kristin Seeman, Judy Sellars, M. Iman Setiadji, Zenneth Thembile Shabangu, Beena Shah, Marianne Shallenberger, Mohd. Bashir Shariff, Ritu Sharma, Minette Siegel, Jeed Skelton, Clare Brett Smith, J. Weldon Smith, Vey Smithers, Alicia Solomon, Liz Spander, Molly Sterling, Susan Sterling, Eva Stevetka, Graham Stewart, Marge Stewart, Paul Sutherland, Carol Sutton, Takeongsak Suvanadat, Ben Svasti, Paunja Taamsri, Angina Thacker, Claire Thomas, Mera Thomas, Amina Tirana, Mark Udall, Miguel Urrutia, Roger Valencia, Maria Elvira Velasquez, Maria Luz Villavicencio, Eleanor Vincent, Susan Walters, Cynthia Wardell, Nevada Weir, Thelma Willemsen, Nancy Williams, Lynn Woolsey, Ivy Young, Maria Luisa "Tiki" Yzaga, Daphney Zungu.

Opposite: In 1968, Trifonia Balderrama de Encinas of Tarata, Bolivia, shared her home with a Peace Corps volunteer who helped local women market traditional doll purses.

Following pages: In Chuinimachicaj, Guatemala, mothers sometimes rub babies' faces with sprigs of rue, an herbal plant, to protect them from evil.

Closing page: Ida Ayu Ngoman Sayang's daughter, age three, learns to create floral offerings by watching her mother at home in central Bali, Indonesia.

237

The authors support the nonprofit organizations
below, whose work helps poor women all over the world
enhance their families' futures. Please support them, too.

**Association for Women's Rights
in Development**
www.awid.org

Global Fund for Women
www.globalfundforwomen.org

Freedom from Hunger
www.freefromhunger.org

The Crafts Center
www.craftscenter.org

Women's Edge
www.womensedge.org

Aid to Artisans
www.aidtoartisans.org

The authors welcome your comments and invite you to
visit the project web site, www.inherhands.com

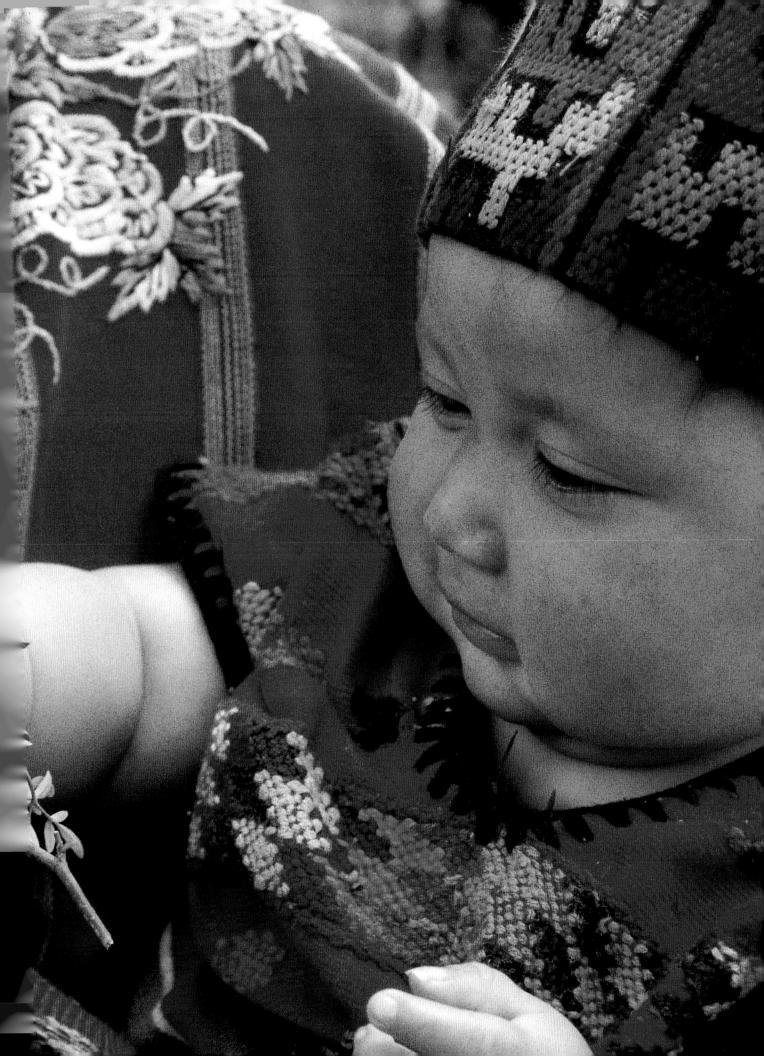

IN HER HANDS

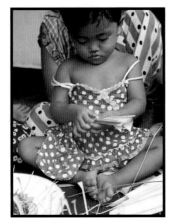

Published in the United States by powerHouse Books,
a division of powerHouse Cultural Entertainment, Inc.
37 Main Street, Brooklyn, NY 11201-1021
telephone 212 604 9074, fax 212 366 5247
e-mail: info@powerHouseBooks.com
web site: www.powerHouseBooks.com

Second edition, 2004

Library of Congress Cataloging-in-Publication Data

Gianturco, Paola.
 In her hands : craftswomen changing the world / by Paola Gianturco and
Toby Tuttle ; foreword by Alice Walker.-- 2nd ed.
 p. cm.
Originally published: Huntington, N.Y. : Monacelli Press, 2000.
Includes bibliographical references and index.
 ISBN 978-1-57687-184-3 (Pbk.)
 ISBN 57687-184-3 (Pbk.)
 1. Handicraft--Developing countries. 2. Women artisans--Developing
countries--Interviews. I. Tuttle, Toby. II. Title.
 TT127 .G53 2003
 745'.082'091724--dc22

 2003018487

Paperback ISBN 978-1-57687-184-3

Separations, printing, and binding by Pimlico Book International, Hong Kong
A complete catalog of powerHouse Books and Limited Editions is available upon request;
please call, write, or see her hands on our web site.

10 9 8 7 6 5 4 3 2

Printed and bound in China